ORIENTALISM'S INTERLOCUTORS

D1313490

OBJECTS/HISTORIES

Critical Perspectives on Art,

Material Culture, and Representation

A series edited by Nicholas Thomas

ORIENTALISM'S INTERLOCUTORS

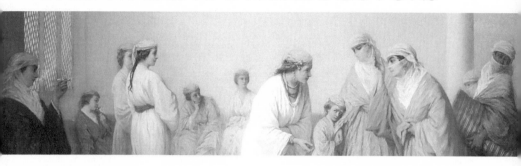

PAINTING, ARCHITECTURE, PHOTOGRAPHY

EDITED BY JILL BEAULIEU AND MARY ROBERTS

Duke University Press *Durham and London* 2002

© 2002 Duke University Press

All rights reserved

Printed in the United States of America on acid-free paper ♾

Designed by Amy Ruth Buchanan

Typeset in Perpetua by Tseng Information Systems, Inc.

Library of Congress Cataloging-in-Publication Data

appear on the last printed page of this book.

CONTENTS

LIST OF ILLUSTRATIONS

ACKNOWLEDGMENTS

A number of the papers in this book originated from a symposium entitled "The Oriental Mirage: Orientalism in Context" held at the Art Gallery of New South Wales, Sydney, in February 1998. This event was held in conjunction with the exhibition "Orientalism: Delacroix to Klee" curated by Roger Benjamin, Ursula Prunster, and Mounira Khemir. The symposium was jointly funded by the Art Gallery of New South Wales and the Centre for Cross-Cultural Research. We gratefully acknowledge the financial support of the Centre for Cross-Cultural Research for the provision of a teaching relief grant that enabled us to edit this collection. Special thanks to Nicholas Thomas, the editor of this series, "Objects/Histories," for his invaluable advice and support at all stages of this project. We would also like to express our thanks to Roger Benjamin, who has been crucial to this project as an advisor. His suggestions have helped shape the parameters of this publication. Thanks also to Ken Wissoker, Leigh Anne Couch, Rebecca Johns-Danes, and Fiona Morgan at Duke University Press for their meticulous preparation of this manuscript for publication. The support of colleagues in our respective departments has been sincerely appreciated: the School of Cultural Histories and Futures, University of Western Sydney, Nepean; the Art Theory Workshop, Canberra School of Art, Australian National University; the School of Fine Arts, Classics and Archaeology, University of Melbourne; and the Department of Art History and Theory, University of Sydney. Finally, sincere thanks to our contributors for the high quality of their papers and their commitment to this project.

ORIENTALISM'S INTERLOCUTORS

Jill Beaulieu and Mary Roberts

Zeïneb . . . stamped her foot and said . . . that the portrait must be done according to her wishes, or—not at all. I could not risk the "not at all."
—Mary Adelaide Walker, 1886[1]

To introduce new viewing positions on the map by listening to historically repressed voices complicates any neat framing of the canon, engages it in an unfamiliar and uncomfortable dialogue and resituates it.
—Zeynep Çelik, 1996[2]

Rethinking Interlocution

Zeïneb's interdiction that her portrait be painted "according to her wishes" concludes a lengthy dispute between this Ottoman patron and the English amateur painter Mary Adelaide Walker inside Zeïneb's summer palace on the Bosphorus in Constantinople. The forthright intervention of this Ottoman harem woman ensures the production of a harem portrait that no Westerner will be allowed to see and that, with its hybrid mix of Eastern and Western fashion and conventions of picture making, bears little resemblance to harem paintings in the Western Orientalist tradition. Walker protests her sitter's requests, revealing her own investment in notions of the exotic harem, but her objections are unequivocally dismissed.

A critique of the Western harem stereotype is implicit in this dialogue because the artist's Western preconceptions are inappropriate in the creation of Zeïneb's portrait. Zeïneb assumes the prerogatives of a woman

of her elevated social standing in Ottoman society by unequivocally stating her conditions for its production: the English painter is providing a service in her household. Nonetheless, this Ottoman princess's intransigence comes as a surprise to a reader familiar with Western fictions of the compliant odalisque. That it should surprise us reveals the extent to which Western notions of the odalisque have saturated our understanding of this period, even in those postcolonial accounts critical of this Western mythology. Taking account of this harem dialogue ensures that the universalizing hold of this Western cultural preoccupation is diminished; it emerges as a viewpoint that was contested, not only from a postcolonial vantage point, but also at its historical moment of inception. As such, this interchange exemplifies the historically repressed voices that Zeynep Çelik argues should be introduced into the study of Orientalist visual culture to unsettle our assumptions and to resituate the canon. How are we to make sense of such counternarratives and alternative images made in dialogue with Western cultures at the height of European territorial imperialism? What place should they hold in a history of Orientalist visual culture? How would the inclusion of historically repressed voices cause us to reshape the terms of analysis of Orientalism? Such questions motivate this publication.

In this anthology authors address these issues by examining forms of cross-cultural exchange that have been largely overlooked in the study of Orientalist visual culture. In the first half of this book authors examine indigenous and diasporic visual cultures that adapted European conventions of visual representation. This is accompanied in the second half by a reconsideration of marginalized voices and subjectivities *within* Western Orientalism, in particular the work of women Orientalists, but also forms of masculine subjectivity articulated via Orientalist imagery that run counter to the more familiar heterosexual norms. Through a consideration of the conflicting determinants of gender and race, authors reveal the instability of colonial authority.

Our emphasis on divergent forms of cross-cultural dialogue is indebted to a shift in emphasis in recent years in the interdisciplinary field of postcolonial studies. This is a shift from a focus on Western discursive constructions of the "Orient" as hegemonic to an engagement with Orientalism as heterogeneous and contested.[3] In her analysis of literary Orientalism, Lisa Lowe has been one of the most cogent advocates for this reframing of Orientalism. She encapsulates its significance: "By fore-

grounding heterogeneity I do not mean to obscure the fundamental difference of power between colonizers and colonizeds. Rather, I wish to open spaces that permit the articulation of other differences—themselves incongruous and nonequivalent—not only of nation and race but also of gender, class, region and sexual preference."[4] As a result of the dual focus in our book on indigenous responses and questions of gender, essays in this volume facilitate this "articulation of other differences" within the sphere of visual culture. As a consequence, the univocality of the West is fractured into a plurality of voices with divergent and conflicting allegiances, and "Orientals" are recognized as participants in the production of counternarratives or resistant images, rather than solely as mute objects of representation. Essays in this volume register this diverse and contested history of cultural representation and at times the profound incommensurability of viewpoints. Thus, in this book interlocution operates through its varied semantic resonances of dialogue, response, and interruption.

This emphasis on Orientalism as a disparate and disputed set of discursive constructions constitutes a significant change in how Orientalism is understood, and although its impact has already begun to be felt in art history, its effects are still incompletely registered. Since its initial transposition into the discipline through Linda Nochlin's groundbreaking essay "The Imaginary Orient,"[5] the early Saidean model has been the most influential paradigm for analysis. Rejecting an approach that secured aesthetics as a domain that is autonomous from colonial politics, Nochlin critically analyzed the visual languages of Orientalist painting and their relationship to the promulgation of colonial stereotypes. In doing so, she established many of the key terms by which Orientalist art continues to be analyzed. Her essay highlighted the processes of exclusion and concealment that naturalized and secured the privilege of the Western subject to observe, judge, and fantasize about Islamic cultures. Nochlin also examined the intersection of gender politics and Orientalism through processes of projection, identification, and distancing in colonial fantasy.

In recent years a number of art historians and curators have nuanced, recast, or called into question the exclusivity of this emphasis on the politics of Western domination.[6] In her important article of 1996, "Colonialism, Orientalism and the Canon," Çelik heralded the potential impact of this significant new direction for the study of visual culture: "The voice of certain alterities, kept silent by the valorized culture, begins to enter

the dialogue, thereby complicating the meanings and contextual fabrics of the art objects and disrupting inherited historiographic legacies."[7] A number of recent art historical publications have taken up the challenge Çelik so clearly articulated. And they share a sense that a reexamination of marginal voices within Western Orientalism must be accompanied by inclusion of the responses of indigenous painters and collectors. For instance, Julie Codell and Dianne Sachko Macleod's anthology redefines relations between art and empire by examining the Easternization of Britain through a dual focus on interventions by colonized people and the transformation of British aesthetic concepts through the colonial experience.[8] Two major exhibitions (the first in Sydney in 1997, the second in Williamstown, Massachusetts, in 2000) contributed to the critical reassessment of Orientalism by examining its regional manifestations.[9]

An examination of Orientalism in Australia and America complicates any neat binary division between East and West by addressing the specific currency of ideas about the "Orient" in regional Western cultures. In the nineteenth century America had very little direct political engagement with the East; as a consequence, "Getting Oriented"[10] was a process of positioning oneself in relation to European cultural traditions as much as defining oneself in relation to the East as exotic other. European Orientalism was both studiously emulated by American artists and modified in light of local cultural considerations.[11] The Sydney exhibition examined the ambivalent position of Orientalism in nineteenth-century Australia, where artists embraced a European ideology of dominance and yet, in their distinctive position as colonials within the British Empire, were also seen as "'not quite' possessing mastery."[12]

As well as investigating the heterogeneity of Western Orientalism through its regional manifestations, the Sydney exhibition addressed indigenous painting and collecting practices. Indigenous collecting was at the center of the exhibition because its nineteenth-century section was based on the Najd collection by a distinguished Saudi businessman. In his essay for the catalogue, Roger Benjamin made questions of indigenous collecting pivotal to the conceptual focus of the exhibition by exploring the practice of collecting as an expression of cultural identity. Examining both the contemporary and historical dimensions of this issue, Benjamin analyzed the collecting priorities of Khalil Bey in Second Empire Paris and Mahmoud Khalil in Cairo after the First World War, among others. He proposed that alternative indigenous self-images were and are articu-

lated through these collections.[13] Contemplating such a revisionary history of collecting Orientalism introduces new criteria for interpreting this art and its relationship to identity formation—issues that Benjamin explores further in his study of Maghrebin painters in this volume.

These art historians and curators have prized open the field, not just adding to the canon by examining Orientalism at the margins, but calling into question entrenched assumptions about the parameters and limits of Orientalist visual culture. And yet the impact of this shift in emphasis still remains to be extensively registered in art history and visual studies and its impact on central terms in the debate has not been sufficiently theorized. Through a rigorous engagement with the central terms in which Orientalism has been understood, authors in this volume take up this challenge to rethink Orientalism and its interlocutors within the sphere of visual culture. This results in a profound resituating of the Western canon and a rethinking of the central terms of analysis.

By addressing the hybrid aesthetics of indigenous and diasporic cultural responses to Western Orientalism, authors in the first half of this book revise and nuance our understanding of terms while also deploying new ones. This engagement entails the reassessment of the visual modalities of Orientalism and the politics of interpretation. For instance, l'effet de réel, which, as Nochlin alerted us, operated in academic Orientalism as a powerful mode of naturalizing a Western viewpoint by dissimulating its processes of bringing into being,[14] takes on a new significance when used by Islamic artists, as Çelik and Benjamin argue, as a corrective to Western misconceptions of their cultures. This approach asserts the multivalence of visual languages and their susceptibility to reappropriation.

In these essays there is also a recasting of Orientalism's "imaginative geography." As Said has argued, arbitrary geographic distinctions between familiar and exotic space is integral to Orientalist discourse, and this "poetics of space" mirrors the processes of identity formation that establish distinctions between Europe and its "others."[15] In the realm of art this imaginative geography was played out through distinctions between the Orient, inscribed as a site for the European artist-traveler to collect the raw materials, and Europe as the site of reception for an exotic vision presented to gallery audiences. In this way European centers are privileged as interpretive sites. Essays in this volume disturb such neat divisions of Orientalism's "imaginative geography" by emphasizing the ways different indigenous interventions reconfigure how the discursive

terrain is understood. Authors in this volume shift the geographic focus to encompass Algeria, Morocco, and Turkey as sites for reception for Orientalist painting. Different audiences for visual cultures emerge when indigenous cultural histories are acknowledged. For instance, Roger Benjamin's essay addresses the distinct audiences for Mohammed Racim's art in Paris and Algiers.

The semantic resonances of interlocution as inter-locus, between localities, come into play as various authors emphasize the work of non-European artists, architects, and photographers trafficking between European and non-European contexts and addressing local indigenous concerns or redressing Orientalist stereotypes in metropolitan Western centers. For instance, Çelik analyzes the photograph albums Sultan Abdülhamid II sent from Constantinople to the United States in 1893 to refute Western misconceptions of the Ottoman Empire. Mark Crinson's essay also examines a trafficking between cultures and a reassessment of the Western centers, this time in the contemporary context of postcolonial Britain, where the diaspora mosque is interpreted as a challenge to Britain's "imaginary nation-space." For Crinson, one of the effects of the diaspora mosque is to forge a transnational form that challenges the host culture. Through these essays, indigenous and diasporic visual cultures emerge as actively engaged in a spatial politics of reappropriation, negotiation, and resistance.

The papers in the second half of this volume, through a focus on the issue of gender, reveal the internal inconsistencies *within* Western Orientalism. Authors examine the multifarious ways discourses of sexuality traverse and intersect discourses of race. Here the formation of Orientalist visual culture between locations is addressed in relation to the formation of gendered subjectivities.

Until recently the contribution of women artists to Orientalism has been virtually absent from the field. Reina Lewis's book *Gendering Orientalism* has been groundbreaking in this respect.[16] It is an analysis focused on Western representations of Oriental femininity, encompassing case studies of European women as producers and interpreters of these paintings. What underpins Lewis's analysis is an acknowledgment of the simultaneous radicality of women's Orientalist representations vis-à-vis Western gender relations and their complicity with imperial politics. It is the axiomatics of imperialism that allow the Western women Lewis studies to claim an authoritative position to look, to represent, and to

judge. A series of strategic and shifting alliances inflected by gender and nationality as well as race enable the pragmatic articulation of Western feminine individualism through Orientalist visual culture. Lewis's analysis of Charlotte Brontë's *Villette* is exemplary in this respect. Lucy Snowe's encounter with a painting of Cleopatra in a gallery in Brussels in Brontë's novel is the paradigmatic trope for the resistant female spectator. Snowe responds to the painting with a critical eye, disdainful of the odalisque's lazy pose and improprieties in dress and the negligent disorderliness of her environment. In this reading, the fantasy space of promised (heterosexual and male) sexual fulfillment is transmogrified into an untidy domestic realm, as Snowe simultaneously critiques masculine fantasy and the Oriental woman. Snowe's claim to authority is premised on dismissing masculine fantasy while negatively reasserting the otherness of the Oriental woman. As a consequence, Brontë's resistant female reader contests gender relations within Western culture while leaving Orientalist categories intact. For Lewis, this trope emerges as a particular historical inscription of "women's problematic and partial (but not necessarily oppositional) access to colonial representation."[17] Lewis's study ensures a radical rethinking of the historical formation of the resistant female subject; however, the focus of her analysis remains primarily on Western femininity and the reception of the work of women's Orientalism in Britain and France.

The two essays in this book that analyze the work of women Orientalist painters shift the focus of this debate by shuttling between the Orient and Europe as sites for the production and reception of women's Orientalism. The effect of this shift in emphasis is to introduce different audiences and different ways of writing the spatial history of women's Orientalism. Deborah Cherry achieves this through her study of nineteenth-century feminist artists traveling between Algeria and London. She emphasizes the coming into being of feminist subjectivities through the experiences of travel and the complicities of a radical sexual politics at home and colonial politics abroad. The picturesque landscapes of these traveling feminists emerge as implicated in the epistemic violence of imperialism while also registering its destabilizing effects. Mary Roberts also engages in a reassessment of gender and spatial politics by addressing the dialogue between Ottoman and English women in the production of harem portraits in Constantinople; as a consequence, her essay enables a rethinking of the position of indigenous women in Orientalist

visual culture. In Roberts's essay indigenous women emerge not just as an abstract category that structures masculine fantasy or Western female subjectivity; instead, the harem women she analyzes are actively engaged in the production of an aesthetically hybrid self-representation addressed to local cultural considerations that profoundly challenge the values of the Western artist.

Hollis Clayson extends this inquiry into the relations between gender and Orientalism through a reassessment of the formation of masculinity. Nochlin, Olivier Richon, and others have highlighted the ways a heterosexual masculine subject was interpellated through fantasies of control and sexual fulfillment premised on processes of identification and distancing from stereotypical representations of Eastern despotism.[18] In this essay, Clayson opens up the question of the formation of masculine subjectivity qua Orientalism for further examination, with some surprising results and unexpected identifications with feminine figures and male passivity.

Through their analysis of gender and Orientalism the essays in the second half of this book shift the focus to a different kind of interlocution that renders visible the heterogeneity of Western Orientalism through the reassessment of previously unquestioned assumptions. This results in the revision of familiar Orientalist stereotypes, particularly those inscribing the East according to the priorities of heterosexual masculinity. Focusing on diversity within Western Orientalism, all three essays in this section engage the ways gender can reaffirm, redefine, or disrupt the discursive construction of Orientalism.

Acknowledging the heterogeneity of Orientalism requires new approaches to writing its histories that allow for "the articulation of other differences." In response to a recognition of heterogeneity, Ali Behdad has called for a mode of local criticism that "attempts to account for the complexity of Orientalism's dispersed and discontinuous modes of domination."[19] The diverse range of historical and contemporary case studies and the distinctive theoretical engagements in this book exemplify Behdad's mode of local criticism. There is no singular methodology that underpins the essays in this volume. Instead, essays engage in various debates, for instance about indigenous agency, postcolonial identity, masculine subjectivity, and the formation of feminine and feminist subjectivities through cross-cultural encounters. One of the things that binds the essays in this volume is a motivation to test the limits of various theo-

retical propositions through the analysis of archival sources that reveal other perspectives, other interlocutors within Orientalism. These essays also share a focus on cross-cultural and intercultural dialogue as central to the formation and contestation of Orientalist visual cultures and a commitment to expanding the parameters of analysis by calling into question the central terms in the debate.

The Interlocutors

In different ways, Zeynep Çelik's and Roger Benjamin's essays provide a unique contribution to the project of reexamining Orientalism by analyzing indigenous responses to Western cultural forms. In each of their case studies, Çelik and Benjamin focus on hybrid aesthetics and how hybrid styles can be interpreted. Approaching Orientalism from the perspective of a cross-cultural dialogue and cultural contestation, the authors read the works as an assertion of indigenous identity and, in some cases, nascent national identity. Their case studies profoundly shift how Orientalism is understood. As Çelik states, "When the Oriental artists and intellectuals speak and begin shaping the terms of the debate, the Orient as represented by the West sheds its homogeneity, timelessness, and passivity and becomes nuanced and complicated. It can no longer fit the frozen categories."

Çelik's four case studies in "Speaking Back to Orientalist Discourse" demonstrate the diversity of strategies of "speaking back," which include contesting and redeploying Orientalist stereotypes. Her diverse examples include the paintings of Osman Hamdi, the photographic albums Sultan Abdülhamid II presented to the United States in 1893, North African architecture, and Assia Djebar's interpretation of Delacroix and Picasso's paintings of *Les Femmes d'Algers*. This range of case studies highlights the varied experiences of and responses to colonization.

In "Colonial Tutelage to Nationalist Affirmation: Mammeri and Racim, Painters of the Maghreb," Benjamin examines the work of these two Algerian painters who both incorporate Western-style painting traditions in their art. Benjamin characterizes Azouaou Mammeri's painting as a model of emulation, arguing that it exemplifies indigenous mastery of mimetic realism in the service of contesting negative Orientalist stereotypes. Mohammed Racim's art, in contrast, is characterized as "indigenous neotraditionalism," a unique expression of national identity that

combines the Persian and Mughal miniature traditions with Western perspectivalism.

The assertion of identity in the cultural forms examined by Benjamin and Çelik is based on two main factors: contesting received Orientalist stereotypes (most notably in Osman Hamdi's paintings of women and of Islamic worship and in the photograph albums given to the United States by the Sultan in 1893) and reexamining an "apparent visual equivalency" from the subject position of a cultural insider, thereby articulating a different agenda of production and reception.

Both Çelik and Benjamin argue that the work of indigenous artists can be interpreted as an expression of cultural difference despite its visual similarities to Western Orientalism. Given the strong Western influence in Mammeri's paintings and the positive perception of his work by the French colonial administration, Benjamin claims that it is easy to see Mammeri as a "Francophilic imitator" and the ideal subaltern subject of the French policy of association. Benjamin augments this interpretation by focusing on the indigenous cultural history of Mammeri's chosen subject matter and the artist's staunch advocacy of his own cultural traditions. These elements and the recent enthusiastic reception of Mammeri's works by art experts from the Arab world enable Benjamin to argue that a participatory gaze, informed by specific cultural associations and memories, replaces the touristic Orientalist gaze.

The indigenous manipulation of Western codes is evident in a return to an idealized past. Fathy's architecture encompassed the dual influences of Egyptian vernacular and French modernism in its search for authenticity and an appropriate national style of architecture. Çelik claims that Fathy's emphasis on the vernacular (premised on Orientalist exoticism) can be read as "his own search for authenticity . . . [a] pioneering drive to return to a past of purity, decontaminated from the ills of rapid change." Çelik links Fathy's search to broader national claims for cultural authenticity through a resistance to the "universalizing power of Western technology." Drawing parallels between Fathy and Frantz Fanon's analysis of the "native intellectual" as a passionate defender of national culture, Çelik characterizes Fathy's resistant hybridity as expressing the desire to be national despite its similarities to Orientalist exoticism.

Benjamin too argues that Racim's work redeploys the familiar convention of Orientalist painting to present views of the Orient as untouched by Western presence. Racim depicted the time before European invasion

and heroized the enemies of the Europeans: the corsairs. His images of Barbarossa, other Raises, and the Andalusian Caliphs are characterized by Benjamin as Racim's "imaginary counternation." Thus he argues that the "cosmopolitan moderate" Racim shared allegiances with the "nascent Algerian nationalism of the day." Benjamin suggests that this heroization and the imagined erasure of contemporary colonial reality have sustained an Algerian nationalist interest in Racim's miniatures since the war of independence.

Çelik and Benjamin demonstrate that an examination of indigenous art results in a revision of unquestioned assumptions about the political significance of the visual language of Orientalism. Analyzing the alternative "truth claims" of indigenous artwork, Çelik and Benjamin demonstrate that the "reality effect" of mimetic realism is no longer exclusively in the service of colonial ideology. When indigenous art forms are interpreted in the context of their cultural histories, the visual stylistic equivalences between East and West mask profound interpretive differences. In uncovering these cultural differences, Çelik and Benjamin disclose a visual language of resistance to colonization.

While Benjamin and Çelik discuss how indigenous responses to Western cultural forms articulate cultural difference and indigenous identity, Mark Crinson's analysis of mosques in postcolonial Britain calls into question the formation of cultural identity of diasporic Muslim communities that have to negotiate from within the British nation-state.

Crinson's study of three diasporic mosques in Britain contribute to a redefinition of "Muslim space." In various ways, his study complicates the presumption that cultural identity can be transplanted intact, whole, or indeed that mosques allow the practitioners to preserve their "identity and authenticity" in a foreign country. In his first case study on the re-appropriation of Leitner's Orientalist mosque by the local Muslim community in Woking, Crinson revises the notion of Muslim space as a fixed cultural form. He focuses instead on the transitional and translational processes at work in diasporic cultures. Emphasizing postcolonial culture's dialectical relation to history, he establishes that this diaspora mosque, which came into being without change to the building's physical fabric or its function, operates to reclaim colonial history and to reinvent the sign through transformation from Orientalist to diaspora mosque. In his second case study Crinson further challenges the notion of Muslim space as the repository of a pre-given, singular Muslim iden-

tity by examining the Central London Mosque as a strategic ecumenical response to the diverse needs of its clients: representatives of the Muslim nations in Britain. Thus its generalized architectural forms (which could be read as romantic Orientalism) are instead interpreted as an attempt to forge pan-Islamic symbolization, which avoids factionalism within the diasporic Islamic communities. This is the *inter*national articulation of diaspora culture: a notion of Muslim space "at the borderline between cultures." In his third case study, Crinson challenges the prevalent assumption that the diaspora mosque would take its place without changing its host culture. To the local residents protesting the Mohammedi Park Masjid Complex, it posed "an unfamiliar and threatening reorientation of space, an 'alienation' of British land in the metropolitan 'center.'" Thus this mosque, which from one point of view can be interpreted as a transplanted traditionalism, is also read as a challenge to Britain's "imaginary nation-space."

Crinson rejects a notion of Muslim space defined by a typology of transplanted practices. This model is governed by prescribable boundaries and carries assumptions of unchanging identity and authenticity. Furthermore, architecture becomes an inert container for Islamic ritual practices. Challenging this sociological interpretation of Muslim space, Crinson invokes Homi Bhabha's notion of the "Third Space," which emphasizes "the *constructing* of culture and the *inventing* of tradition in the very articulation of the sign." The diaspora mosque as an articulation of "Third Space" defines a liminal culture, a culture in-between. The diaspora mosque becomes central in redefining Muslim space in terms of the mutability of identity. What Crinson suggests in his three case studies is that diaspora mosques signify an identity that is historically, spatially, and temporally contingent.

Deborah Cherry also addresses questions of identity formation; her focus, however, is on the relationship between the formation of feminist subjectivity and the politics of landscape representation in the context of colonial Algeria. Through an analysis of the ambivalent intrication of feminism and colonialism, interlocution takes on a further dimension in her essay, "Earth into World, Land into Landscape: The 'Worlding' of Algeria in Nineteenth-Century British Feminism." As Cherry states, her concern is "less with 'interlocution' as speaking back, to, or against Orientalist discourse, and more with interlocution as speaking within, which destabilizes and decenters colonial authority."

This emphasis on "speaking within" is aligned with the challenge issued by black feminists in recent decades to reexamine the relationship between nineteenth-century Western feminism and colonialism. As Gayatri Chakravorty Spivak claims, the task is to "situate feminist individualism in its historical determination rather than simply to canonize it as feminism as such."[20] Cherry takes up this challenge to resituate Western feminism within the history of racial politics by analyzing the landscape art of British feminists in Algeria. By examining British feminism, imperialism, and visual culture from a number of theoretical frameworks, Cherry shifts the art object from "a product of ideology" to "a product of epistemic violence."

For Barbara Bodichon and her feminist friends, who regularly spent their winters in the French colony, Algeria was a space of freedom and adventure that inspired their creative endeavors and facilitated a productive exchange of ideas. In their writings the notion of a feminist militant subject was created in relation to (and as distinct from) the indigenous Algerian woman; their painterly interests, however, were focused more on the genre of picturesque landscape than on the social circumstances of indigenous women. The British women celebrated the sensory pleasures of nature in numerous travel accounts, letters, sketches, and landscape paintings. Although their landscape paintings are not the expected subject matter of militant feminists, Cherry argues that these artists also participated in the "worlding" of Algeria.

Drawing on Spivak's interpretation of worlding to describe the operation of imperial cartographies, Cherry emphasizes the process of double inscription of the land, reminding us that worlding involves both the violent physical impact of imperialism and the inscription of colonial cartography in visual culture. Cherry focuses on the hybridized landscapes of Bodichon, which epitomize the colonial inscription of Algeria. Bodichon perpetuated the practice of incorporating Western pictorial conventions in her paintings of the North African landscape, thereby bringing the foreign within the domain of the familiar. Citing Bhabha's analysis of the workings of colonial authority, these Western pictorial conventions are read as "rules of recognition," which are defined as "those social texts of epistemic, ethnocentric, nationalist intelligibility which cohere in an address to authority." Bhabha argues that colonial authority is dependent on the visibility of these rules of recognition. The violence of imperialist possession implicit in Bodichon's landscape paintings is then further ex-

plained in reference to Jacques Derrida's notion of framing. Arguing that the frame is much more than a border or container, Derrida claims that "framing . . . is a field of force, a violent enclosing which subjects both the inner field and the boundary to the pressures of restraint, demarcation and definition." Cherry claims that Bodichon's romantic pictorial views emphasizing sensory pleasures enact the Derridean enframement through a violent erasure of "the trauma of colonization."

Yet it is not only the epistemic violence of the imperial project being registered here but also its uncertainty and precariousness. Calling into question any certainty about the transfer of authority into the colonial context, Cherry notes a potential subversion of Western pictorial conventions. And yet, as she argues, "If the hybridity of these images signals something of an instability in colonial authority, nevertheless, the pictorializing of Algeria in feminist writings and images was intimately part of the cultural violence of imperialism and the imperialist violence of culture."

In contrast to Cherry's focus on the ambivalent articulation of feminist subjectivity in colonial Algeria, Hollis Clayson takes up the challenge to rethink Orientalism and masculine subjectivity through her case study of Henri Regnault. Clayson treats Orientalism as a vehicle for Regnault's imaginary escape and as a screen for the projection of his frustrations over army life and lack of military action during the Franco-Prussian War of 1870–1871. In "Henri Regnault's Wartime Orientalism," Clayson contrasts two exemplars of Arab masculinity evident in *Execution without Trial* and *Hassan and Namouna* and unexpectedly associates the languidness of the reclining Moor to the discourse of militarized masculinity. Although Regnault yearned for frontline fighting, the Orientalism that he identified with is not that epitomized by the Moorish executioner in *Execution without Trial:* "athletic barbarity, decisiveness, absolute physical and political power, ruthlessness, swagger, and elegance" but with the "listless reclining Moor" in *Hassan and Namouna.* This surprising identification complicates any attempt to see in Regnault's art an attempt to define a stable and normative masculine subjectivity during a time of military crisis. Yet Regnault's late resolve in January 1871 to embrace the group ethos of selflessness and unerring commitment to the cause of war creates a shift from the romantic individual to the citizen, from the "self-indulgent and discontent" young man to the "man of action." One consequence of this resolve was the temporary suspension of his art practice. A far more dire

consequence resulted from his insistence on fighting one of the last battles of the war before France surrendered. Regnault did not return from this battle.

One of the crucial ramifications of this analysis is the reexamination of the representation of masculinity. In this respect, Clayson's essay is consonant with recent reassessments of eighteenth-century images of feminized masculinity which claim that the stoic masculinity of the *Oath of the Horatii* or *Brutus,* for example, is neither normative not paradigmatic. Examining the eighteenth-century male nude in the context of homosociality, Abigail Solomon-Godeau argues that "masculinity is a construction (as is femininity), an image, a fiction, a mask variously inflected by the needs, desires, the context and the political unconscious of the moment of its making."[21] Clayson participates in these crucial revisions by examining Regnault's psychic response to the social upheavals during the Franco-Prussian War and arguing that his wartime paintings offer alternatives to the dominant trope of "barbaric Eastern masculinity."

Another important factor of Regnault's wartime watercolors is the reconfiguration of the familiar harem topos. In *Haoua, harem interior,* the conventional representation of harem woman as seductress is replaced by a woman who, Clayson argues, is frail yet confident and self-possessed — thus defying the consuming gaze. And in a striking reversal, the male in *Hassan and Namouna* usurps the passive, languid pose of the female, thereby complicating stereotypes of Western masculinity.

Mary Roberts also analyzes harem representations that are distinct from the more familiar Western stereotype in her essay "Contested Terrains: Women Orientalists and the Colonial Harem." In an intriguing analysis of nineteenth-century British women's diary accounts of harem visits, Roberts focuses on the feminine fantasy of the British traveler and portraits of harem women that revise our understanding of women's role as agents in the discourse of the colonial harem.

Given women's unique access to harems, recent scholarship has focused on the diaries as ethnographic accounts, which, as Reina Lewis has importantly argued, displaces the sexual tropes of masculine fantasy, thereby transforming the harem from a sexual to a social space.[22] What is significant about Roberts's analysis is her claim that the ethnographic quality of the diary accounts does not preclude a feminine fantasy, nor does this feminine fantasy entirely preclude a masculine fantasy. Roberts argues that these diaries articulate a unique feminine fantasy by

redeploying the popular trope of the "Arabian Nights." By viewing their experiences of harem visits through the screen of *Arabian Nights Tales,* women saw themselves as protagonists in harem adventures rather than just ethnographic observers. Thus, by reworking the familiar stereotypes of the harem, these texts inscribe a unique mix of ethnography, domestic narrative, and harem fantasy.

The diaries of British women travelers are valuable also because they disclose the interactions between Ottoman women and British artists-travelers variously registering the agency of these women and the impact of their interactions on the harem representations that were produced. The accounts of harem portrait sittings in the diary of the amateur painter Mary Adelaide Walker disclose the conflicting values of the British painter and her harem patrons. In contrast to the very familiar role of harem women as mute objects of Western fantasy, Roberts argues that these contentious sittings indicate that the harem women intervened to ensure that their portraits reflected their taste for Western dress while also conforming to Islamic cultural values. Rather than being solely an expression of European cultural values and desires, these portraits emerge as the product of a negotiation between sitter and painter, thereby inverting the power relations between painter and harem woman, as the latter actively intervened in the compositional process. Analyzing these harem representations in the context of the Sultan's patronage of European Orientalism, Roberts shifts the frame of reference from the West as the site of consumption to the East as the site of production and reception for harem images.

Roberts's attention to harem portraiture as a focus for contestation between Eastern and Western women is indicative of the complexities of Orientalist visual culture that this book elucidates. Focusing on the visual culture of both East and West, and interfaces between them, these essays question the stability of colonial authority. These authors contribute to the ongoing project of calling into question the truth claims of Western Orientalism by revealing the contradictory imperatives in Western cultures and investigating the ways indigenous responses articulate cultural differences and indigenous identities. And yet, Orientalism's interlocutors take on vastly different forms in the various essays in this volume. A number of assumptions about Orientalist visual culture are revised through the analysis of a range of styles and a diversity of signifying contexts, both Eastern and Western. A major contribution of this book is

that the range of perspectives encompassed in the essays create unfamiliar images of the Orient, thus shifting and redefining the parameters of Orientalist studies in art history.

Notes

We would like to express our sincere thanks to Jocelyn Hackforth-Jones for her incisive comments on an early draft of this introduction.

1 Mary Adelaide Walker, *Eastern Life and Scenery with Excursions in Asia Minor, Mytilene, Crete and Roumania*, 2 vols. (London: Chapman and Hall, 1886), 1.17.

2 Zeynep Çelik, "Colonialism, Orientalism and the Canon," *Art Bulletin* 78, no. 2 (June 1996): 202.

3 Analysis of this shift has most notably taken place around assessments of the legacy of Edward Said's seminal book *Orientalism* (London: Pantheon, 1978). Participants in the *"Orientalism* debate" include Said and others too numerous to mention in full. Homi Bhabha and Lisa Lowe are among those in the interdisciplinary field who have thoughtfully explored the impact of this shift in emphasis. Exploring the complexities of Said's text, Bhabha argues that it simultaneously presupposes a monolithic notion of Orientalist discourse and yet also reads this discourse as constituted ambivalently. See Homi Bhabha, "Difference, Discrimination, and the Discourse of Colonialism," in *The Politics of Theory,* ed. Francis Barker et al. (Colchester, England: University of Essex, 1983), 194–211; Lisa Lowe, *Critical Terrains: French and British Orientalisms* (Ithaca, NY: Cornell University Press, 1991).

4 Lowe, *Critical Terrains,* 29.

5 Linda Nochlin, "The Imaginary Orient," *Art in America* 71, no. 5 (May 1983): 118–31, 187, 189, 191.

6 For instance, John Mackenzie argues for a more historically nuanced analysis of the multifarious connections between imperialism and British Orientalism: John M. Mackenzie, *Orientalism: History, Theory and the Arts* (Manchester, England: Manchester University Press, 1995).

7 Çelik, "Colonialism, Orientalism and the Canon," 205.

8 Julie F. Codell and Dianne Sachko Macleod, eds., *Orientalism Transposed: The Impact of the Colonies on British Culture* (Aldershot, England: Ashgate, 1998).

9 Roger Benjamin, ed., *Orientalism: Delacroix to Klee* (Sydney: Art Gallery of New South Wales, 1997); Holly Edwards, ed., *Noble Dreams, Wicked Pleasures: Orientalism in America, 1870–1930* (Princeton, NJ: Princeton University Press/Sterling and Francine Clark Art Institute, 2000).

10 This is Holly Edwards's aptly coined subtitle in her essay, "A Million and One Nights: Orientalism in America, 1870–1930," in *Noble Dreams, Wicked Pleasures,* 18.

11 Analyzing the period before America took center stage in Middle East politics, Edwards addresses the ways Orientalism in America related to forms of internal colonization (as the frontier hero was merged with the sheik); debates around slavery in the post–Civil War period; Protestantism; immigration; religious diver-

sity at home (including polygamous Mormanism); and the woman question. See ibid., 11–58.

12 Ursula Prunster, "From Empire's End: Australians as Orientalists, 1880–1920," in Benjamin, ed., *Orientalism: Delacroix to Klee,* 41–53.

13 Roger Benjamin, "Post-Colonial Taste: Non-Western Markets for Orientalist Art," in *Orientalism: Delacroix to Klee,* 32–40. The Williamstown exhibition also included indigenous perspectives through Çelik's essay on Turkish participants at the World's Columbian Exhibition at Chicago, 1893. Çelik argues that the very inclusion of the writings of Fatma Aliye in the library of the woman's building at the Chicago Fair is evidence of resistance to Western stereotypes of women's oppression through the harem system. The fact that Aliye's alternative views could be completely overlooked by the majority of the visitors to the Chicago Fair because they would not have been able to read its message in Ottoman points to a more profound and persistent lacuna in the "dialogue" between East and West. Çelik states: "It could be argued that the phenomenon of not listening and not hearing was more profoundly engraved into the consciousness of the observers and that it went beyond the technical impenetrability of a foreign language" ("Speaking Back to Orientalist Discourse at the World's Columbian Exposition," in Edwards, *Noble Dreams, Wicked Pleasures,* 96).

14 Nochlin, "The Imaginary Orient," 122–23.

15 Said, *Orientalism,* 54–55.

16 Reina Lewis, *Gendering Orientalism: Race, Femininity and Representation* (London: Routledge, 1996).

17 Ibid., 43.

18 Nochlin, "The Imaginary Orient"; Olivier Richon, "Representation, the Harem and the Despot," *Block* 10 (1985): 34–41.

19 Ali Behdad, "Orientalism after *Orientalism,*" *Esprit Créateur* 34, no. 2 (summer 1994): 5.

20 Gayatri Chakravorty Spivak, "Three Women's Texts and a Critique of Imperialism," *Critical Inquiry* 12 (autumn 1985): 244.

21 Abigail Solomon-Godeau, "Male Trouble: A Crisis in Representation," *Art History* 16, no. 2 (June 1993): 294. See also Abigail Solomon-Godeau, *Male Trouble: A Crisis in Representation* (London: Thames and Hudson, 1997), especially the preface and chap. 1; Alex Potts, "Images of Ideal Manhood in the French Revolution," *History Workshop Journal,* no. 3 (autumn 1990): 1–20; Thomas Crow, "Revolutionary Activism and the Cult of Male Beauty in the Studio of David," in *Fictions of the French Revolution,* ed. Bernadette Ford (Chicago: Northwestern University Press, 1991), 55–83.

22 Reina Lewis, "'Only Women Should Go to Turkey': Henriette Browne and the Female Orientalist Gaze," in *Gendering Orientalism,* 127.

SPEAKING BACK TO ORIENTALIST DISCOURSE

Zeynep Çelik

"Opium!
Submission!
Kismet!
Lattice-work, caravanserai
 fountains
a sultan dancing on a silver tray!
Maharajah, rajah
a thousand-year-old shah!
Waving from minarets
clogs made of mother-of-pearl;
women with henna-stained noses
working their looms with their feet.
In the wind, green-turbaned imams
 calling people to prayer"
This is the Orient the French poet sees.
This
 is
 the Orient of the books
that come out from the press
at the rate of a million a minute.
But
 yesterday
 today
 or tomorrow
an Orient like this
 never existed
 and never will.[1]

This quotation comes from a much longer poem, titled "Pierre Loti" and written by the great Turkish poet Nazım Hikmet in 1925. Hikmet's target is not so much Loti himself as European imperialism, and his angry response is charged by his Marxist worldview and his proto-Third Worldism. Nevertheless, his speaking back to Orientalist discourse follows a turn-of-the-century Ottoman intellectual tradition. To refer to two earlier literary examples, Halit Ziya's 1908 novel *Nesl-i Ahîr* (The first generation), opens with the protagonist's quarrel with a book written by a European author on the "Orient." Although a great deal more placid than the poet's penetrating voice, the sentiments of this fictional character, a well-educated Ottoman man on a boat returning from Marseille, are also in revolt against Orientalist misconceptions: "Whenever he began reading a book on the East, especially on his own country, he felt inclined to leave it. As he witnessed the Western writers' accounts of a lifestyle they attempted to discover under the brightness of an Eastern sun that blinded their eyes and amidst the ambiguities of a language they did not understand, his nerves would unravel and his heart would ache [rebelling against] their idiotic opinions and their self-righteous courage that produced so many errors." [2]

Ahmed Mithad Efendi, another prominent Ottoman writer, dealt with the same theme in his 1889 *Avrupa'da Bir Cevelan* (A tour in Europe), focusing on (among other things) the European fantasy about the Eastern woman. He captured the Ingresque formula to indicate the epistemological status such representations had achieved:

> [This] lovable person lies negligently on a sofa. One of her slippers, embroidered with pearls, is on the floor, while the other is on the tip of her toes. Since her garments are intended to ornament rather than to conceal [her body], her legs dangling from the sofa are half naked and her belly and breasts are covered by fabrics as thin and transparent as a dream. Her disheveled hair over her nude shoulders falls down in waves. . . . In her mouth is the black end of the pipe of a *narghile,* curving like a snake. . . . A black servant fans her. . . . This is the Eastern woman Europe depicted until now. . . . It is assumed that this body is not the mistress of her house, the wife of her husband, and the mother of her children, but only a servant to the pleasures of the man who owns the house. What a misconception! [3]

Ahmed Mithad's "correction" to the distortions he sarcastically describes has its own problems, of course. It is static; it is also based on a struggle for power; it replaces one "truth" with another; and it reclaims the hierarchy by inverting it.[4] I address these complex issues only tangentially; I limit myself, instead, to the presentation of several artistic and architectural responses to Orientalism in an attempt to contribute to the triangulation of recent critical scholarship in art history that examines the Orientalist discourse from the "Western" perspective. The study of Orientalist art owes a great deal to Edward Said's groundbreaking book, *Orientalism* (1978). Said enhanced the importance of viewing cultural products through a lens that highlights the underlining politics of domination, specifically where the "Orient" is concerned. Art and architectural history responded to Said's challenge and, not surprisingly, followed the model established by *Orientalism*, thus engaging in analyses of artworks that contributed to the construction of an "Orient." They offered innovative and critical readings of Orientalism, but focused solely on the "West." As Said himself stated, *Orientalism* was a study of the "West" alone. It was not intended as a cross-cultural examination of and did not claim to give voice to the "other" side, an issue Said addressed in his later writings.[5]

Triangulation is a technical term borrowed from engineering and adapted by sociology as a research tool. Used in land surveying to determine a position, it offers the possibility of multiple readings in history. In Janet Abu-Lughod's words, triangulation is based on the understanding that "there is no archimedian point *outside* the system from which to view historic reality."[6] My approach to Orientalism from the "other" side, the side of "Orientals," is aimed to bring another perspective to the discourse. Studied from this unconventional corner, Orientalism reveals a hitherto concealed dynamism, one that is about dialogue between cultures and about contesting the dominant norms. When the Oriental artists and intellectuals speak and begin shaping the terms of the debate, the Orient as represented by the West sheds its homogeneity, timelessness, and passivity, and becomes nuanced and complicated. It can no longer fit the frozen categories. CASE STUDY ONE:

My first case study is the late nineteenth–early twentieth-century Ottoman painter Osman Hamdi, whose artistic career centers on speaking back to Orientalism. His response takes place within the very norms and artistic format of the school he addresses his critique to. Osman Hamdi's

pursuit is deliberate and consistent. Nevertheless, there are other "corrective" messages to Orientalism in the Ottoman discourse, although not always explicit. Consider, for example, Prince Abdülmecid's *Beethoven in the Palace* (ca. 1900), which depicts a truly oppositional palace scene to the one we know from Orientalist paintings (Plate 1). A trio, consisting of a male cellist and two women, one playing the violin, the other the piano, performs for an audience of three women and one man, the prince himself. These men and women, dressed according to the latest European fashions, are immersed in the music as performers and listeners. The interaction between genders is established through music and the artistic communication implies mutual respect. The room is lavishly decorated with turn-of-the-century European furniture, including a paysage painting hanging on the wall, an equestrian statue on a pedestal, and a bust of Beethoven. In another example that contradicts European representations of Oriental women, Ömer Adil's *Women Painters' Atelier* (ca. 1920) shows a studio in the School of Fine Arts in Istanbul, where Ottoman women are engaged in a serious study of art—albeit in a segregated setting.[7]

Halil Bey, the flamboyant Ottoman ambassador to Paris in the mid-1860s and well-known at the time for his spectacular painting collection that included Ingres's *Le Bain turc* (1862), seems to have pursued another subtle way to deal with Orientalism.[8] Two years after he purchased *Le Bain turc,* Halil Bey bought Courbet's *Les Dormeuses* (1867), another painting with lesbian undertones, which he hung next to Ingres's bath scene. Admitting that it would be difficult to prove his thesis factually, art historian Francis Haskell feels tempted to speculate that perhaps Halil Bey showed the Ingres canvas to Courbet and suggested that he paint a "modern counterpart" to Ingres's "Oriental fantasy."[9] Courbet's painting is devoid of the paraphernalia that act as "signs" of the Orient and that speckle Ingres's canvas to make his bath unmistakably "Turkish." In this light, one is tempted to push Haskell's speculation a step further and read Halil Bey's intervention as a deliberate gesture to resituate the scene depicted in *Bain turc* to a European setting, thereby evacuating the bath from Ingres's Orientalist implications.

During the years that corresponded to Halil Bey's tenure as ambassador, Osman Hamdi was a student in Paris. There he was drawn to the atelier of Gustave Boulanger and possibly also to that of Jean-Léon Gérôme, and his own work matured under the technical and thematic

influence of the French Orientalist school. Nevertheless, his "scenes from the Orient" provide acute and persistent critiques of mainstream Orientalist paintings. They represent a resistant voice, whose power derives from the painter's position as an Ottoman intellectual, as well as from his intimate acquaintance with the school's mental framework, techniques, and conventions. Osman Hamdi's men and women—dressed in the colorful garments in the Orientalist fashion and placed in "authentic" settings—are thinking, questioning, and acting human beings who display none of the passivity and submissiveness attributed to them by European painters.

Osman Hamdi addressed the major themes of Orientalist painters from his critical stance as an insider on the outside. In contrast to the constructions that convey fanaticism, exoticism, and even violence in Gérôme's series of paintings on Islamic worship, for example, Osman Hamdi presented Islam as a religion that encouraged intellectual curiosity, discussion, debate, even doubt.[10] In painting after painting, his men of religion, reading and discussing books, maintain their upright posture as an expression of their human dignity, against a background of meticulously articulated architectural details. To refer to a few examples, *Discussion in Front of the Mosque* (ca. 1906) depicts three "teachers," one reading aloud (commenting on?) a book, while the others listen with great attention, holding onto their own texts (Fig. 1). The same theme, but now showing only one man in the audience of a savant, is portrayed in *In the Green Mosque in Bursa* (ca. 1900). *The Theologist* (1901) focuses on yet another scholar surrounded by books, reading in a mosque.

Osman Hamdi's repertoire of women, both in public and domestic spaces, makes a statement about their status in the society. Dressed in elegant and fashionable clothes, they are shown moving freely in the city and sometimes interacting with men as they attend to business. The home scenes provide a striking alternative to the myriad familiar and titillating views of harem and bath by French painters. Several of his works, among them *The Coffee Corner* (1879) and *After the Iftar* (1886), depict a couple in a tranquil domestic environment, the seated man being served coffee by the woman. Although the hierarchical family structure is not questioned, the man of the house is not the omnipotent, amoral, sensual tyrant of European representations, enjoying his dominion over scores of women at his mercy and pleasure. Instead, a dialogue is offered that redefines the gender relationships in Orientalist paintings. The scenes that

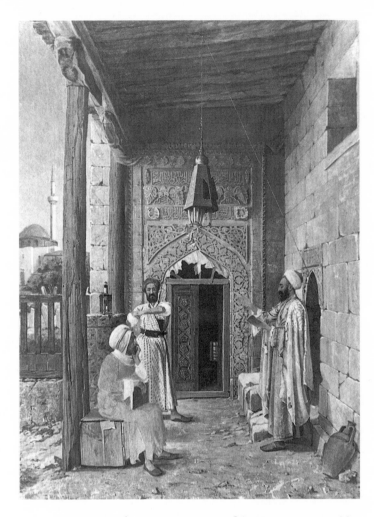

FIG. 1. Osman Hamdi, *Discussion in Front of the Mosque,* ca. 1906. Museum of Painting and Sculpture, Istanbul.

show only women in domestic interiors may belong to the long lineage of *Les femmes dans leur appartement,* but Osman Hamdi's women try to reveal another "truth" about the activities that take place in upper-class Muslim homes than the ones suggested by Delacroix and Gérôme. He hints, for example, at domestic work by showing laundry drying in the background.

Among the themes Osman Hamdi addressed from the checklist of Orientalism is a grooming scene that speaks back to the particular European obsession with the Eastern female body. In *Girl Having Her Hair Combed* (1881), Hamdi Bey recasts both the young woman being tended to and the servant. The Ottoman painter's upper-class demoiselle has control over her own body as she watches herself attentively in the mirror, clearly supervising her coiffure. With this painting, Osman Hamdi counteracts Gérôme's *Le Bain* (1880), whose centerpiece is a young woman in a bath being washed by a black slave. The viewer does not have access to her facial expression, but only to her naked back, her posture and bent neck suggesting her helpless abandonment to her fate in the aftermath of this sensual preparation. Osman Hamdi's servant is a worker, simply doing her job; Gérôme sets a mysterious tone for what is to come by providing a contrast charged with innuendoes.

Osman Hamdi's reaction to the cliché of the "Oriental" woman as sex object becomes even more acute when he focuses on a single woman. His response to Orientalism's innumerable reclining odalisques is *Girl Reading* (ca. 1893; Fig. 2). The painting shows a young woman stretched out on a sofa, totally immersed in a book. Her relaxed and casual tone implies that she is not reading a religious text, but perhaps a work of literature. The composition has the familiar collage of Orientalist details, complete with rugs, tiles, inscriptions, and "Islamic" architectural elements, but the shelves behind her are filled with books, making the statement that reading occupies an important part of her life. The "girl" is hence given back her thinking mind and intellectual life, which had been erased by Orientalist painters.

Corresponding to the time when Osman Hamdi was voicing his individual response to Orientalist representations of his country, an official venture attempted to bring a similar corrective. On the occasion of the 1893 World's Columbian Exposition, the Ottoman Sultan Abdülhamid II presented fifty-one photography albums to the "National Library" of the

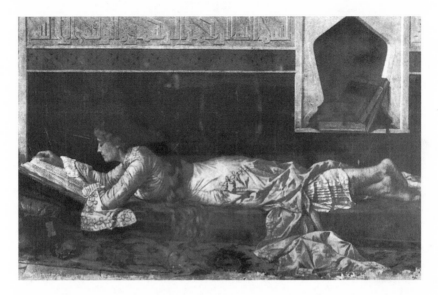

FIG. 2. Osman Hamdi, *Girl Reading,* ca. 1893. Private collection, Izmir. From Mustafa Cezar, *Sanatta Batıya Açılış ve Osman Hamdi,* Istanbul, 1971.

United States.[11] The ornately bound albums, which contained 1,819 photographs by various Istanbul photographers, drew the image of the empire according to the conceptions of its ruling elite. Now at the Library of Congress, the Abdülhamid albums cover the empire in several categories. Although historic grandeur, expressed by photographs of major monuments from the Byzantine and Turkish periods, as well as natural landscapes are given their due respect, the major theme is that of modernization. Modernizing reforms to rejuvenate the empire had been in place since the eighteenth century in response to successive military defeats experienced by the Ottoman army. In search of quick and practical remedies, the Ottoman rulers first imported technological innovations that were seen as proof of European superiority. Nevertheless, the exposure to the West soon embraced other fields and the history of the late Ottoman Empire became a history of Westernization. This significant development that affected all aspects of Ottoman life remained prominently absent from Orientalist accounts.

Modernization covered many areas, extending from military reforms to education to artistic production. It introduced, for example, a new architecture based on European models. One of the most telling state-

ments regarding architectural modernity was made by the construction of Dolmabahçe Palace in 1856. It pointed to the official acceptance of Western models not only as fashionable novelties, but also to bring radical transformation to lifestyles. The overall organization of the palace, based on Beaux-Arts principles of symmetry, axiality, and regularity, was complemented by its ornate classical façades that evoked the contemporary French Empire style. Its main façade turned toward the Bosphorus, the impressive mass of the Dolmabahçe Palace was highly visible from various vistas and defined a new image of monumentality for the capital. The interior spaces corresponded to changing fashions in the everyday life of the palace: European furniture filled the rooms, revealing new customs that ranged from eating at elaborately set tables on high-backed chairs as opposed to the former pattern of sitting on the floor or on low couches around a tray, to substituting built-in couches for armchairs and sofas in living rooms in a redefinition of socializing habits (Fig. 3). The paraphernalia that filled the rooms—including crystal chandeliers, ar-

FIG. 3. Grand Reception Hall, Dolmabahçe Palace, Istanbul. Abdülhamid II Albums, Prints and Photographs Division, Library of Congress, Washington, D.C.

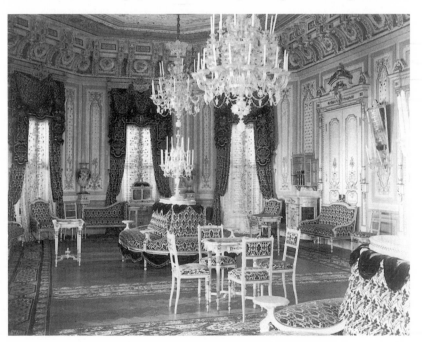

moirs, sideboards, and European paintings—contributed further to the rupture with the former decorative traditions that relied, for example, on an extensive use of tiles on wall surfaces. Dolmabahçe's exterior and the interior photographs in the Abdülhamid albums hence offered a very different palace from the older Ottoman palaces. They also contradicted the palaces of the Orientalist discourse that had constructed imaginary *serails*.

Among other aspects of modernization, industrialization was underlined by photographs of factories, docks, and arsenals. From the 1840s on, a number of state-run industries were founded on the outskirts of Istanbul. They included foundries that produced iron pipes, steel rails, swords, and knives and factories that specialized in textiles, glass, paper, chemicals, and rubber. Boats were made and maintained in modern arsenals. The products were exhibited in all major European universal exhibitions and a considerable sample was sent to the World's Columbian Exposition in Chicago in 1893.[12] The photographs of modern production facilities in the Abdülhamid albums delivered a picture of the industrial environment in the empire.

Educational reforms, conveyed through photographs of new school buildings, occupied the largest component of the exposé. To demonstrate the widespread nature of modern education, photographs of schools included the entire spectrum, from the highest institutions of learning (such as the law school) to middle and elementary levels and offered examples from diverse regions of the imperial territory. Certain institutions of great prestige were given more space. For example, an entire album was dedicated to the Imperial High School of Galatasaray, where instruction was given in Turkish and French. The photographs flaunted the building in its expansive garden, the age range of students from elementary through high school, students with their distinguished teachers, and even gym classes. Another important educational establishment was the school of medicine, shown in one photograph with its entire population. The emphasis on science and scientific research was revealed by a photograph of a group of medical students in front of a cadaver, other relevant artifacts framing the view. Respect for learning and knowledge permeated the albums in various forms, for example, by interior views from the museum of the Imperial Maritime College and the Imperial Library. A scholar of theology, as judged from his attire, reading in a well-equipped modern library in a converted historic building made a state-

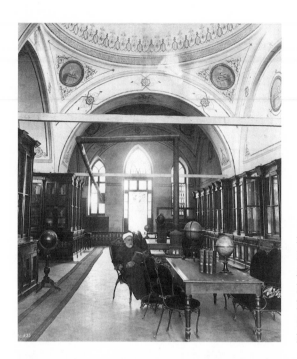

FIG. 4. Imperial
Library, Istanbul.
Abdülhamid II Albums,
Prints and Photographs
Division, Library of
Congress, Washington,
D.C.

ment about the enlightened nature of Islam and its compatibility with
contemporary ideas—just like Osman Hamdi's religious figures (Fig. 4).

To demystify another "misconception," the albums dedicated many
photographs to women's education. Paralleling the photographs on the
education of boys, many girls' schools where modern instruction was
pursued were included. Groups of students carrying their books and di-
plomas—younger counterparts to Osman Hamdi's *Girl Reading*—strove
to give further proof to the status of women in modern Ottoman society
(Fig. 5). Women appeared in the albums in one other classification: health
care. A special hospital for women received extensive coverage, including
the administration building and a group of doctors. Other photos show
the exteriors and interiors of individual pavilions that met high hospi-
tal standards for the turn of the century (Fig. 6). These photographs also
introduced a category of working women: nurses. It is significant, how-
ever, that the distant figures of the nurses and the tuberculosis patients
constituted the only mature women in the albums; the rest were school-
girls.

The Abdülhamid II albums, then, provide an imperial image that is
circumscribed in many aspects but that clearly reflects the official in-

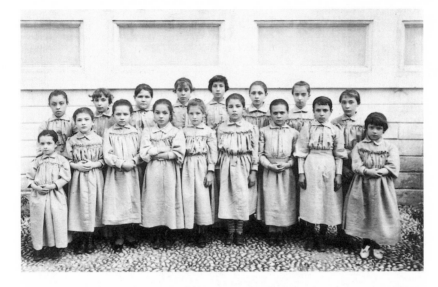

FIG. 5. Students of the Rushdié Girls' School in Emirghan, Istanbul. Abdülhamid II Albums, Prints and Photographs Division, Library of Congress, Washington, D.C.

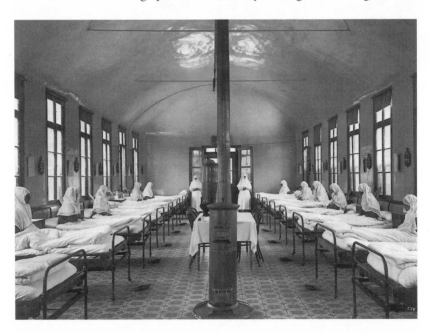

FIG. 6. Tuberculosis Ward of the Women's Hospital in Haseki, Istanbul. Abdül-hamid II Albums, Prints and Photographs Division, Library of Congress, Washington, D.C.

tention to represent the empire in a progressive light. This was a form of answering back to the European discourse that froze Ottoman culture and society in an undefined and imagined past by reductive formulas about fanatic religious practices, irrationality, ignorance, and mindless but sumptuous living. The albums attempted to transform the end-of-the-century image of the empire as the "sick man of Europe" into a rejuvenated, dynamic, and modern one.

The Ottoman Empire may have been on its way to disintegration in the face of the changing global power structure during the late nineteenth and early twentieth centuries, but it was still independent and maintained something from its past prowess. My two other case studies come from colonial contexts, where "speaking back" takes on different forms. Granted that Westernization reigned in all Ottoman social and cultural realms, the relationship between dominating and dominated cultures was far more entangled in a colonial situation. The colonial discourse that punctuated cultural differences also led to the construction of "traditions" for colonized territories. The later adoption, interpretation, and transfiguration of these traditions reveal intriguing questions about issues of authenticity in an age that desperately looks for a sense of national identity while engulfed by globalization.

Research and writing on "non-Western" architecture had already coalesced into a significant body of literature by the end of the nineteenth century in Europe. Nevertheless, in the 1920s and 1930s a major turn from monumental to residential forms occurred in the architectural discourse. North African French colonies present a particularly rich case study as their vernacular architecture was the subject of scrupulous documentation and analysis. The focus originated in part from European modernist sensibilities that saw in the cubical, whitewashed masses and sparse spaces of North African medinas potential sources of inspiration for a modernist vocabulary. It was also connected to the growing housing shortage in colonial cities. French architects in charge of the construction programs undertaken by the colonial administration relied on regional vernacular forms to find appropriate stylistic and spatial models for contemporary housing projects.

Popular books, such as Victor Valensi's *L'Habitation Tunisienne* (Paris, 1923), A. Mairat de la Motte-Capron's *L'Architecture indigène nord africaine* (Algiers, 1923), and Jean Galotti's *Les Jardins et les maisons arabes au Maroc* (Paris, 1926), the last with sketches by Albert Laprade, one of the leading

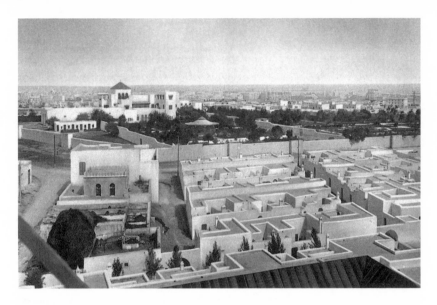

FIG. 7. Albert Laprade, *The Habous Quarter, Casablanca.* From Léandre Vaillat, *Le visage français du Maroc,* Paris, 1931.

architects working in Morocco at the time, presented a wealthy collection of images depicting vernacular buildings, often in their urban or landscape settings. These books played an important role in disseminating the image of North African vernacular architecture in the *métropole* and *outre-mer.* Le Corbusier's own interest in vernacular architecture and his recurrent incorporation of sketches and photographs in his publications to support his arguments for a modern architecture and urbanism enhanced the entry of North African "indigenous" forms into the discourse of modernism.[13] Furthermore, the creation of temporary quarters, deemed "authentic," in the world's fairs from the second half of the nineteenth century on, culminating in the extensive Tunisian section of the 1931 Paris Colonial Exhibition, played a crucial role in the dissemination of North African vernacular imagery.[14]

When French architects built housing schemes for "indigenous" people, they relied on the commentary and documentation developed by the colonial discourse on the North African vernacular. A striking example is the new medina of Casablanca (the Habous Quarter) intended to accommodate the growing Moroccan population of the city (Fig. 7). Designed by Laprade and built in the early 1920s, the scheme combined

the "customs and scruples" of Moroccans with French considerations for "hygiene"[15] and highlighted the contrast between the street and the courtyards of the houses. Reinterpreting local "traditions," Laprade created "sensible, vibrant walls, charged with poetry." These walls defined cubical masses, but their irregularity gave them a "human" touch. However, the project was more than a stylistic exercise; the architect's ambition was to integrate into his design "values of ambiance" as well as a "whole way of life." The spatial and programmatic qualities adhered to these goals: there were narrow streets and courtyard houses, markets, neighborhood ovens, public baths, mosques, and Quranic schools brought together in a stylistic integrity that had "preserved everything respectable in the tradition." Laprade implied that he had improved local architecture by appropriating what was seen as valuable by modernist architectural discourse and by eliminating what was not considered "respectable."[16]

Similar projects were carried out in other North African colonies. About two decades later, the Cité Musulmane el Omrane in Tunis repeated the whitewashed houses with courtyards, but no openings to the exterior, now utilizing vaults on roofs. The architects (G. Glorieux and L. Glorieux-Monfred) organized the site plan according to a relaxed orthogonal street network that allowed for a certain flexibility in the positioning of individual units and their collective massing (Fig. 8). If Cité el Omrane formulized the principles for residential patterns, another Tunisian project dating from the same period, the mosque and market in Bizerte, articulated the essence of community center for the Muslim population (Fig. 9). Rows of vaulted small shops fronted with colonnades framed the public space, significantly named Place de la France; a mosque attached to the market structures stood out with its shifted angle oriented toward Mecca, its multiple domes, and its square minaret. The cumulative image from both projects was that of a dense settlement, composed of small and simple repetitive units woven together with some irregularity, vaults and domes further uniting the scheme on the roof level. The persistence of this pattern in the new residential projects for the indigenous people reinforced the sociocultural duality already existing and already nurtured in the colonial cities. A comparison of Cité el Omrane with its contemporary Quartier Gambetta housing project, again in Tunis but intended for Europeans, acknowledges the policy to maintain, enhance, and express cultural differences between colonizer

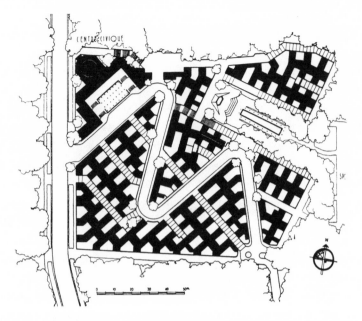

FIG. 8. G. Glorieux and L. Glorieux-Monfred, Cité Musulmane el Omrane, site plan. From *L'Architecture d'aujourd'hui,* no. 20 (October 1984).

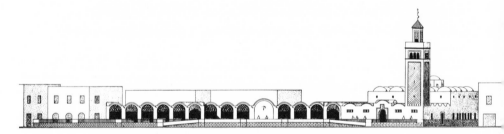

FIG. 9. Jean-Pierre Ventre, Mosque and Market in Bizerte, elevation. From *L'Architecture d'aujourd'hui,* no. 20 (October 1948).

and colonized. Quartier Gambetta was envisioned as a Corbusian grid of longitudinal apartment blocks, separated from each other by spacious gardens.[17]

During the very same years (the mid-1940s), the Egyptian architect Hassan Fathy turned to the vernacular of the Egyptian countryside in his own search for authenticity and proposed an architectural vocabulary for the "poor" that echoed the prototypes offered by French architects in their North African colonies. Fathy's pioneering drive to return to a past of purity, decontaminated from the ills of rapid change, was in reaction to the unquestioning subscription to modernity that had resulted in "cultural confusion" and loss of tradition in Egyptian cities and villages.[18] As such, it was symptomatic of "the passion with which native intellectuals defend the existence of their national culture," analyzed critically by Fanon.[19]

Fathy was a cosmopolitan architect, with strong intellectual ties to Europe and in close touch with recent developments in the profession. His designs for the village of New Gourna, then, should be historically contextualized and not read as isolated experiments of a lone visionary and abstracted from French colonial architectural experiments in North Africa. Fathy's courtyards, private streets, and residential clusters, his aesthetics founded on simple forms (the square domed unit, the rectangular vaulted unit, and the alcove covered with a half dome), his public building types (markets, crafts khan, mosque, bath), and even his socially ambitious program had counterparts in the French projects. In New Gourna, Fathy attempted social reform by revitalizing the traditional way of life both in the built environment and in the patterns of production, which were founded on crafts and construction materials, specifically brick making. This approach echoed Laprade's idea of allowing for "a whole way of life" in the new medina of Casablanca. To return to Fanon's analysis of the "native intellectual," in his attempt to express national identity Fathy relied on techniques and language borrowed from European architects. Like Fanon's "native intellectual," Fathy ended up creating a "hallmark which wishes to be national, but which is strangely reminiscent of exoticism."[20]

Considering the profound impact of the colonial heritage, cultural critic Masao Miyoshi argued recently that "return to 'authenticity' . . . is a closed route" and that there is no such concept as "authenticity."[21] Situating Fathy's architecture and that of the French architects building

in the colonies in relation to each other shows how deeply interlaced were colonial productions and those conscientiously created in opposition to them. However, regardless of the contamination in the concepts of purity and authenticity, the meanings behind formal resemblances shift radically. The similar forms and programs of the French architects and Fathy stemmed from different agendas and carried different future implications. For Fathy, a return to vernacular forms meant endowing contemporary Egypt with a cultural image, a manifest identity in the face of the universalizing power of Western technology; it was an act of resistance. For the French colonist, in contrast, the emphasized difference of North African cultures enhanced the power of France, not only because it displayed the diversity of its possessions, but also because of its expression of tolerance toward the subjugated culture.

The intricate relationship between colonial definitions and adaptations of North African vernacular and Fathy's vocabulary has been overlooked by architectural historians and critics, who abstracted Fathy as a pioneer in a unique search for authenticity — a position that trivializes the complexity in Fathy's thinking and his worldly status among the leading architects of the twentieth century. Nevertheless, the extraordinary popularity Fathy's architecture enjoyed in a wide range of Third World (and some First World) countries makes a statement about the more discreet meanings behind the familiar forms and the significance of the search for expression of cultural identity, albeit still caught up in the exercise of "exoticism" that Fanon criticized in the late 1950s. It also points to the enduring otherness created by the colonial discourse — appropriated, twisted, and turned by the Third World architect to be endowed with an oppositional symbolism that expresses self-identity.

My last case study is Eugène Delacroix's *Les Femmes d'Alger dans leur appartement* (1834), or rather, the authority this painting carries as a reference point, as a *lieu de mémoire* during the colonial and postcolonial periods (Plate 2). As a window into the harem of a Muslim house in the casbah of Algiers, Delacroix's painting alluded to penetrating into the most private, the most sacred part of Algerian society. An official commission charged with political meanings, it represented the conquest of Algeria by entering the Algerian home. A masterpiece, it had always been a popular subject of study, but its importance as a political symbol was highlighted in about 1930, the centennial of Algeria's occupation.[22]

In her renowned book, also titled *Les Femmes d'Alger dans leur apparte-*

FIG. 10. Pablo Picasso, *Les Femmes d'Alger,* 1955. Washington University Gallery of Art, St. Louis.

ment and published in 1979, Algerian writer Assia Djebar reads this painting in reference to Picasso's *Les Femmes d'Alger* (Fig. 10). One marking the beginning of French colonization, the other the end, the paintings evoke divergent interpretations for Djebar, sparked by differences in the visions of the two European artists, but more important, in the sociocultural transformations brought by the French occupation and the Algerian War. It is not Delacroix's "superficial Orient" that Djebar cares to dissect, but the subtler implications of the painting, especially the fact that the scene makes the observer conscious of his unwarranted presence in the intimacy of this room, which is enclosed upon the women frozen in an act of waiting, passive and resigned.[23]

Picasso obsessively reworked Delacroix's theme during the first months of the Algerian War, producing fifteen paintings and two lithographs from December 1954 to February 1955.[24] Djebar argues that in Picasso's work, the universe of the women of Algiers has been completely transformed from Delacroix's "tragedy" into a "new happiness" by means

of a "glorious liberation of space, an awakening of body in dance, energy, free movement." Their previous hermetic situation has been preserved, she tells us, but now reversed into a condition of serenity, at peace with the past and the future. Djebar associates the "liberation" at home with the occupation of the city's public spaces by women resistance fighters taking part in the war. She establishes a metaphorical relationship between fragments of women's bodies and the explosives they carried under their clothes. She also provides a critique of women's conditions in Algeria following independence by arguing that the grenades women hid under their clothes "as if they were their own breasts" exploded against them.[25]

Djebar's reading of Delacroix's and Picasso's works to frame the dramatic change in women's lives during her country's *nuit coloniale* and its aftermath calls for continued debate and possibly disagreement, especially given Picasso's "continual struggle in the *Femmes d'Alger* series to reconcile distance with presence, possession, and watching."[26] What matters, however, is the fact that Djebar reestablishes the connection between domestic spaces and women's lives by relying on the authority of one of the most blatant symbols of French colonialism and the artistic tradition based on the reproductions and reinterpretations of this symbol, thereby accentuating the entanglements of her message. Delacroix's painting becomes a place of memory that can be turned around and recharged with new meanings. Djebar's stand does not imply "giving in" to the colonizer culture, but rather deploying it to broaden her critique.

Djebar is not alone in reloading colonial cultural formations with new meanings and providing complicated linkages between contemporary Algerian questions and the country's recent history. For example, in Kamal Dahane's 1992 documentary film, itself titled once more *Les Femmes d'Alger,* Delacroix's painting reemerges; the famous setting is recreated in the last scene, but now is emptied of women. Following the themes pursued in the film, Dahane suggests that the women have decided to leave Delacroix's symbolic realm in an act of resistance to present-day political and religious movements that attempt to ban them from public life and restrict them to the domestic realm. Novelist Leila Sebbar, whose work has been acknowledged as belonging to the "Maghrebian literature from France," takes another leap and brings Delacroix back to France, to the realities of postcoloniality in the former métropole. When she sees Dela-

croix's famous painting in the Louvre, the protagonist of Sebbar's *Les Carnets de Shérazade* associates Delacroix's women of Algiers with the Maghrebi women imprisoned in dismal, small apartments on the outskirts of French cities.[27]

Hearing "other" voices complicates the meanings and contextual fabrics of the art objects and disrupts inherited historiographic legacies. This, in turn, helps to contest the familiar reductive formulas that explicate sociopolitical relationships and reestablish them in their social density.[28] Furthermore, as Gayatri Chakravorty Spivak observes, when the "hegemonic discourse" repositions itself so that it can "occupy the position of the other," it, too, becomes subject to a major transformation, to its own decolonization.[29]

Notes

1 Nazım Hikmet, "Pierre Loti," in *Selected Poems of Nazım Hikmet,* ed. and trans. Taner Baybars (London: Jonathan Cape, 1967), 19–20.

2 Halid Ziya Uşaklıgil, *Nesl-i Ahîr* (Istanbul: Inkilap Kitapevi, 1990), 21. This is the first printing of *Nesl-i Ahîr* as a book; it was serialized in 1908 in an Istanbul newspaper, *Sabah.* Unless otherwise noted, all translations are mine.

3 Ahmed Mithad, *Avrupa'da Bir Cevelan* (Istanbul, 1890), 164–65.

4 For further discussion on these issues, see Zeynep Çelik and Leila Kinney, "Ethnography and Exhibitionism at the Expositions Universelles," *Assemblage* 13 (December 1990): 34–59.

5 Among Said's writings dealing with this issue, see, e.g., Edward Said, "Intellectuals in the Postcolonial World," *Salmagundi,* nos. 70–71 (spring–summer 1986): 44–64; "Third World Intellectuals and Metropolitan Culture," *Raritan* 9, no. 3 (1990): 27–50; and *Culture and Imperialism* (1993; London: Vintage, 1994). For the first article to explore Said's significance on nineteenth-century art, see Linda Nochlin, "The Imaginary Orient," *Art in America* 71, no. 5 (May 1983): 118–31, 187–91.

6 Janet Abu-Lughod, "On the Remaking of History: How to Reinvent the Past," in *Remaking History,* ed. Barbara Kruger and Phil Mariani (Seattle: Bay Press, 1989), 112.

7 Systematic art education for girls in the Ottoman Empire began with the establishment of *rüştiyes,* secondary girls' schools, in 1858. In these schools, drawing (*resim*) constituted part of the curriculum and, with calligraphy, painting, and dressmaking, complemented the academic core of grammar, arithmetic, and geography. Painting and drawing were also part of the education of upper-class girls, taught by private instructors at home. The School of Fine Arts (Sanayi-i Nefise Mekteb-i Alisi), based on the French model, was established in 1881. It consisted of three departments: architecture, painting, and sculpture. Women's enrollment in the

School of Fine Arts would have to wait until the 1910s. On the education of girls in the late nineteenth-century Ottoman Empire, see Serpil Çakır, *Osmanlı Kadın Hareketi* (Istanbul: Metis Kadın Araştırmaları, 1994), 219–225, and Fanny Davis, *The Ottoman Lady* (New York: Greenwood Press, 1986), 45–60. For the School of Fine Arts, see Mustafa Cezar, *Sanatta Batıya Açılış ve Osman Hamdi* (Istanbul: Iş Bankası Yayınları, 1971).

8 Halil Bey's reputation as an art collector and a bon vivant overshadows his career as a statesman, his commitment to progressive politics, and his involvement in the Young Turk movement. See Zeynep Inankur, "Halil Şerif Paşa," *P* 2 (summer 1996): 72–80.

9 Francis Haskell, "A Turk and His Pictures in Nineteenth-Century Paris," *Oxford Art Journal* 5, no. 1 (1982): 45.

10 For an astute analysis of Osman Hamdi's paintings, see Ipek Aksüğür Duben, "Osman Hamdi ve Orientalism," *Tarih ve Toplum,* no. 41 (May 1987): 283–90.

11 For an informative article on the Abdülhamid II albums, see William Allen, "The Abdul Hamid II Collection," *History of Photography* 8, no. 2 (April–June 1984): 119–45.

12 For a concise discussion of the industrialization efforts in the Ottoman Empire in the nineteenth century, as well as the inherent contradictions, see Zeynep Çelik, *The Remaking of Istanbul* (Seattle: University of California Press, 1986), 33–37.

13 The most widely disseminated of Le Corbusier's publications is *La Ville radieuse* (Paris: Éditions Vincent, Fréal, 1933). Corbusier's interest in non-Western vernacular architecture goes back to the 1910s, to his *Voyage en Orient.*

14 Valensi's design mimicked an "organic" settlement, down to uses of patched building materials and irregular plastering. In the words of a contemporary critic, the architect had "forced himself to reconstitute something badly built, and he succeeded perfectly." See Anthony Goissaud, "A l'exposition coloniale, le pavillon de la Tunisie," *La Construction moderne* 18 (October 1931). For the presentation of colonial architecture in the expositions, see Zeynep Çelik, *Displaying the Orient: Architecture of Islam at Nineteenth Century World's Fairs* (Berkeley: University of California Press), 1992.

15 Léandre Vaillat, *Le Visage français du Maroc* (Paris: Horizons de France, 1931), 12.

16 Albert Laprade, "Une ville créée spécialement pour les indigènes à Casablanca," in *L'Urbanisme aux colonies et dans les pays tropicaux, La Charité-sur-Loire,* ed. Jean Royer (Paris: Delayance, 1932), 1.94–99; Vaillat, *Le Visage français du Maroc,* 15–17.

17 For these projects, see the "Tunisie" issue of *L'Architecture d'aujourd'hui,* no. 20 (October 1948). Cité Musulmane el Omrane and Quartier Gambetta are presented next to each other in the pages of *L'Architecture d'aujourd'hui,* emphasizing the spatial and aesthetic differences between the two schemes.

18 Hassan Fathy, *Architecture for the Poor* (Chicago: University of Chicago Press, 1973), 19–20.

19 Frantz Fanon, *The Wretched of the Earth,* trans. Constance Farrington (New York: Grove Press, 1963), 209.

20 Ibid., 223.

21 Masao Miyoshi, "A Borderless World? From Colonialism to Transnationalism and the Decline of the Nation-State," *Critical Inquiry*, no. 19 (summer 1993): 747.

22 Le Corbusier's *Les Femmes de la Casbah*, painted on a wall in Eileen Gray's house in Cap Martin, known as E. 1027 and built between 1926 and 1929, dates from this period. The authority of Delacroix's painting as a cultural paradigm did not remain restricted to "high" art alone; the scene and the setting were enacted in colonial popular culture, most memorably in postcards.

23 Assia Djebar, *Les Femmes d'Alger dans leur appartement* (Paris: Des Femmes, 1979), 170–78.

24 For a comparative discussion of various versions of Picasso's *Femmes d'Alger*, see Leo Steinberg, "The Algerian Women and Picasso at Large," in *Other Criteria: Confrontations with Twentieth-Century Art* (New York: Oxford University Press, 1972), 125–234.

25 Djebar, *Femmes d'Alger*, 186–89.

26 Steinberg, *Other Criteria*, 130. Picasso's sympathy for the Algerian side in the war is expressed most blatantly in his drawing of Djamila Boupacha, whose accounts of torture had made her a cause célèbre in France and throughout the world. The portrait was published in 1962 on the cover of *Djamila Boupasha*, written by Gisèle Halimi, with an introduction by Simone de Beauvoir.

27 Leila Sebbar, *Les Carnets de Shérazade* (Paris: Stock, 1985), 152. For an analysis of this novel, see Françoise Lionnet, "Narrative Strategies and Postcolonial Identity in Contemporary France: Leila Sebbar's *Les Carnets de Shérazade*," in *Writing New Identities*, ed. Gisela Brinker-Gabler and Sidonie Smith (Minneapolis: University of Minnesota Press, 1997), 62–77.

28 Edward Said, *The World, the Text, the Critic* (Cambridge, MA: Harvard University Press, 1983), 23.

29 Gayatri Chakravorty Spivak, *The Post-Colonial Critic: Interviews, Strategies, Dialogues*, ed. Sara Harasym (New York: Routledge, 1990), 121.

COLONIAL TUTELAGE TO NATIONALIST AFFIRMATION: MAMMERI AND RACIM, PAINTERS OF THE MAGHREB

Roger Benjamin

The assessment of the indigenous arts of the Maghreb[1] in the early twentieth century is shot through with the complexities of the colonial situation. Two visual arts, painting and photography, were colonial imports, the practice of which was central to bringing the colonized into representation, and hence the purview of Europeans. To control such representations was to help form perceptions of colonized peoples, their country, and their traditions. For an indigenous person to stand behind the camera or the easel was clearly an act with potential for redressing, if only for a moment, the superficialities and prejudices that informed the typical Orientalist picture. In the hands of a Maghrebian addressing the French it might be a corrective of considerable possibility — provided the norms of professional competence were satisfied and the picture found a way of being ratified and disseminated by exhibition and publication.

Yet the practice of mimetic painting was slower even than photography in being taken up by indigenous Maghrebians.[2] For religious reasons, there was virtually no local tradition of painting scenes and figures; apart from applied arabesque decoration in architecture and furniture, painting in the familiar Western sense of oils on canvas or mural work was done almost exclusively by Europeans. This essay studies two Algerians who were among the first practitioners of painting to be recognized by the French, from 1920 on. As such, their work has the value of a his-

torical symbol: of Maghrebian self-affirmation in the face of the colonial presence. But more than this, their work raises questions about how a non-European artist might fashion the visual tropes of painting in the modernist era and fray a path between Western aesthetic models and the desiderata of local cultures and traditions.

Two Paths

When, around 1915, two young Algerians from privileged backgrounds chose to take up the art of painting, each followed an option of quite different cultural valence. The first may be called the option of emulation, adopting a manner of painting closely modeled on a dominant mode of European (and indeed Orientalist) painting: the perspectival landscape view. The oil painter Azouaou Mammeri painted the Moroccan cities of Fez and Rabat seen from a distance, the streetscapes and rooftops of their old casbahs, and generally avoided the figure. Displaying a fine compositional competence and an irreproachable grasp of single-point perspective, Mammeri developed a way of summarizing detail in a racy geometric manner that he shared with certain colonial painters of the 1920s. From the outset he was encouraged by the administration of General Lyautey's new Protectorate of Morocco, which promoted his exhibitions in Paris as the fruit of the French "civilizing mission" and a newly respectful association with the Muslim elite. Thus a sense of Mammeri's co-optation by colonial authorities mingles with admiration at his effort to prove that a North African could excel at the colonizer's mode of expression.

In contrast, the pictorial option chosen by the miniaturist Mohammed Racim insists on Islamic roots; it might best be described as an indigenous neotraditionalism. His language of expression was a source of both admiration and uncertainty among the French: the Persian and Mughal miniature, modified in ways that accommodated Western modes of seeing. The frames of his tempera miniatures were painted with great learning in traditional arabesque decoration, yet the pictorial inserts, with their vistas of old Algiers and scenes of precolonial Muslim life, construct a perspectival picture-space. The result is a hybrid, a cross-cultural marriage of manners that spoke, apparently more persuasively than Mammeri's, to quite different constituencies. Founder of a school of miniaturists, Racim was embraced successively by the colonial regime, by Algerian nationalists after the war of independence, and most recently by pan-

Arab institutions such as the Institut du Monde Arabe, which mounted a retrospective of his work in 1992.[3] The "emulator" Mammeri, in contrast, though a frequent exhibitor in the 1920s, has hardly been studied since the demise of the Moroccan and Algerian colonial regimes in the 1950s.

The Path of Emulation: Azouaou Mammeri

When he came to describe the state of contemporary Algerian painting for the 1930 *Guide bleu,* the French North African arts administrator Prosper Ricard privileged just these two Algerian-born Muslims as worthy of attention:

> One, M. Racim of Algiers, preserves in his magnificent illuminations the technique, the patience and the imagination of the Persian school of the 15th and 16th centuries, adapted to Algerine and Andalusian subjects. The other, M. Azouaou Mammeri . . . a child of the Kabyle mountains, is in contrast a strikingly modern artist, concerned with questions of light, color, . . . and construction; he makes a clear break from all the old traditions of Orientalism.[4]

This ringing endorsement shows how far a specialist in Islamic art and architecture could prefer indigenous work to the cultural expressions of French colonial amateurs or the latter-day Orientalists whose work filled the annual salons of the Société des Artistes Algériens et Orientalistes in Algiers. Ricard's comment is expressive of a contempt for the philistinism of many European colonists and a sympathy, if not fascination, for indigenous cultures that, though a minority view, was not limited to scholars. It included political "arabophiles" such as the governor-general of Algeria, Charles Jonnart (1900–1911), and the brilliant soldier he hired in 1903, Colonel Hubert Lyautey, who went on to establish the French Protectorate of Morocco as its resident-general (his regime ran from 1912 until the War of the Rif in 1925).[5]

It is under the sign of Jonnart and Lyautey that Mammeri's career as a teacher and artist took wing. He was born into a privileged family of hereditary Caïds among the Aït-Yenni at Taourirt-Mimoun, in the mountains of Kabylia south of Algiers, the region of Algeria most favored by the penurious government program in francophone education for the indigenous.[6] Mammeri's biographers, the Tharaud brothers, record that he

studied under "an old French school-master, become almost Kabyle him-
self after spending thirty years in the region."[7] This was very likely the
teacher Verdy, who between 1883 and 1906 aggravated many colonists
by training dozens of future Muslim schoolteachers.[8] Qualifying for the
training college for schoolteachers in Algiers, the Ecole normale de Bou-
zaréah, Mammeri's three years there were followed by a series of isolated
school postings from 1910 to 1913.

This highly educated speaker of Kabyle, Arabic, and French was an
évolué, a member of the indigenous elite that Jonnart's Algerian and then
Lyautey's Moroccan administrations wished to foster under their gentler
new colonial policies of "association." Associationism contrasted with
the forced cultural "assimilation" to a French model that had typified
nineteenth-century colonial practice in Algeria.[9] Initially a military
model for arm's-length colonial government inspired by British Indian
practice, the theory of association had first been put into practice by
Lyautey serving as an officer under Gallieni in Indochina in the 1880s.
Rather than suppressing local elites, he extended trust and weapons to
them, using existing power structures to gain support for French rule.[10]

In the cultural correlate of associationist policy, French language was
the "gift" that gave access to European modes of knowledge, to be main-
tained beside the Arabic that provided social cohesion. Mammeri can be
said to have acquired a second cultural good, drawing and painting in the
French manner, a tool of visual communication addressed primarily to
Europeans. Drawing would have been part of the syllabus at the Ecole
normale; learning painting, however, proved more chancy. Initially self-
taught, Mammeri sent a sample painting to the inspector of Artistic Edu-
cation in Algeria, Prosper Ricard (himself a graduate of Bouzaréah), who
commended Mammeri to two French painters then at Taourirt-Mimoun;
one of them, Edouard Herzig, offered fruitful lessons. At his next posting,
to Gouraya in 1913, Mammeri encountered the young French Orientalist
Léon Carré, who gave friendly instruction in painting for eight months.[11]
A kind of latter-day Pissarro as a landscapist, Carré became well-known
in the 1920s as an Orientalist illustrator (Racim worked alongside him on
the *Thousand and One Nights*). The element of European tutelage is promi-
nent in all French accounts of Mammeri's life; its informal nature and the
fact that primary school teaching remained his main employment until
1919 means that Mammeri initially was a kind of gentleman amateur. In
1919, however, his artistic skill was recognized by the Moroccan authori-

ties: he was appointed drawing master at the Collège Franco-Musulman in Rabat.

The teaching profession had enabled Mammeri to quit Algeria in 1916 for the ancient Moroccan capital of Fez, where his cousin Mohammed Mammeri himself taught (becoming tutor to the Sultan's children and eventually an influential vizier after his former student Mohammed ben Yussef ascended the throne in 1927).[12] Mohammed had written extolling the beauties of the city where, in contrast to an Algeria transformed by settler colonialism, Muslim life retained its full splendor.[13] Azouaou Mammeri found in Fez "a city of 100,000 inhabitants where Arabs were not 'wogs' (bicots), but where they possessed money, prestige and power; where everyone went to the mosque; where the purest Arabic was spoken; where one saw elegantly-clad men and women who lived in houses far more luxurious than those he had been able to see in Algiers!"[14] With his Algerian passport and French connections Mammeri prospered; he apparently began a small primary school specializing in teaching the children of the Fassi elite in French.

Mammeri's complex attitudes to the colonial process are indicated in several short articles he wrote for the French government's cultural magazine France-Maroc.[15] They are illustrated by awkward but forceful crayon drawings, his earliest published artwork, which apparently caught the attention of Lyautey himself (Fig. 1).[16] Treating the traditional life of Fez, its architecture and its schools, they give a sense of the sensitive mission of the intercultural broker in a city where, just five years before, much of the small European population had been massacred.

The first article, recounting a typical day in the kind of bicultural primary school that had proven so contentious in Algeria, gives a sense of Mammeri's obeisance to a modern French culture judged superior. The Moroccan boys' morning begins with two hours of Koranic lessons from a "severe master" or faïh, who teaches on the traditional mats with handheld chalkboards (Fig. 2). The afternoon French class is run by a "gentle Frenchman," a culturally sensitive soul who "speaks Arabic and eats . . . without asking for a chair," in a schoolroom replete with benches and maps of France. Mammeri implies that the boys prefer to the Koranic class the tales of La Fontaine and their lessons in arithmetic, concluding, "Thus the image of . . . noble France floats above these little heads being guided on the path of civilization and progress."[17]

Yet Mammeri's drawings contradict this conclusion, in that all of them

FIG. 1. Azouaou Mammeri, *Bridge on the Oued-Fez (Pont sur l'Oued-Fez)*, ca. 1917. Pen drawing. From *France-Maroc*, 1917. Photo BNF.

picture traditional elements of the school: boys with the faïh, boys playing in the courtyard in Moroccan garb and scholar's pigtails. To that extent Mammeri follows the strategy of most Orientalist art addressing a European audience: he pretends to the absence of the invader and focuses on construing indigenous traditions. Note, however, that his subject position is quite different: he writes and draws from a participatory rather than ethnographic vantage point, and for proselytizing and didactic more than picturesque reasons.

The artist-teacher's second article sympathetically explains a traditional Koranic school (rather than a bicultural one) for the French readership. Not uncritically, Mammeri details a pedagogical system that he now argues provides the fundamental moral and religious education of all Muslim men, as well as ensuring universal literacy.[18] His drawing of the *Koranic Class* turns out to record an important early oil that I have located at the Cleveland Museum of Art (Fig. 3). These illustrated articles thus form essential background to additional paintings such as *Class in Algeria* and *The Call to Prayer,* featured in Mammeri's first one-man exhibition held in Paris in 1921 at the Galerie Feuillets d'art "under the high patronage of Marshal Lyautey."[19] It was the second of Mammeri's Parisian exhibitions; the first had been in a large exhibit of Moroccan decorative arts

and painting organized by the Union des Arts Décoratifs and the Société des Peintres Orientalistes Français in 1917 to support Moroccan soldiers injured on the Western Front.[20] On that occasion, the artist-teacher's two small landscapes of Fez were so admired by Léonce Bénédite, curator of the Musée du Luxembourg (and president of the Société des Peintres Orientalistes), that he showed them to the Minister of the Colonies and the pro-indigenous French President Georges Clémenceau, who agreed to their purchase for the state collections.[21]

Although more contentious in subject than such landscapes, Mammeri's scenes of Muslim religious life, while charged with a certain "artificiality" by critics like the Tharauds and Bénédite, did attract appreciative comments: "These compositions, which have the grace of things born to a fresh mind . . . appear to me like dreams made true. . . . All these young boys assembled around a Muslim master . . . have the gestures and thoughts of the most veridical Islam."[22] Such comments suggest a sympathy for *la France musulmane* in metropolitan France, at a high point in

FIG. 2. Azouaou Mammeri, *Koranic School (Intérieur d'une école coranique)*, 1917–1918. Pen drawing. From *France-Maroc*, 1917. Photo BNF.

FIG. 3. Azouaou Mammeri, *Interior of a Koranic School (Intérieur d'une école coranique),* 1917–1918. Oil on canvas, 77.5 × 92 cm. Copyright The Cleveland Museum of Art. Gift of Jacques Cartier, 1923.223.

the aftermath of the recent war in which Maghrebian and other colonial soldiers had served with great distinction on the Western Front. The contradiction is that among emergent indigenous political movements of the interwar years (be it the reformist theological movement of the *oulémas* or Messali Hadj's radical *Etoile nord-africaine*), the Koranic school was considered a precious social institution in organizing resistance to colonial rule.[23] Thus, in 1921 Mammeri quietly promoted to a tolerant and receptive French elite an aspect of traditional society that later political conditions (intensified by Abd-el-Krim's anticolonial war of the Rif in 1925–1926) would have made more controversial.

The way Mammeri's work is now being rediscovered by art experts from the Arab world encourages a reading of his work as containing grains of resistance. The Institut du monde Arabe in Paris recently purchased *Interior of the Karouiine Mosque, Fez.* For curator Brahim Alaoui, himself a Moroccan, the interest of this image is its presentation of Islamic

piety from the perspective of a practicing Muslim.[24] It is possible to rec-
ognize precise signs of Islamic observance, such as the colors of the devo-
tional flags and the way the imam occupies the niche of the Mihrab with
his back to, rather than facing, the viewer. This is hardly a "picturesque"
device in terms of the Orientalist tradition; its severity contrasts with
Gérôme's and Leighton's views of Turkish and Egyptian mosque interi-
ors which, despite their architectural detail, stress gaudy costume and
the frontality of the worshipers. Visiting mosques was and is forbidden
to nonbelievers in Morocco; yet Alaoui believes Mammeri could have
painted this scene because of his high standing as a member of an "impor-
tant maraboutic family" whose own piety was unimpeachable. Paintings
such as this and the *Koranic School* suggest that Mammeri positioned him-
self before his French audience as a man of faith, who was both fascinated
by the European pictorial language and used it to improve the compre-
hension of Maghrebian culture.

Alert French critics were flattered by Mammeri's strategy of emulation
and also aware of its contentiousness. "This is the first time that a Muslim
artist offers us an exhibition of painting, and of painting fully conceived
with our Western vision and methods," wrote Bénédite (erroneously, as
to the first claim). He actually recalled his "stupefaction" on learning, in
1917, that Mammeri's Fez landscapes had been signed by an Arab artist.
Aware that painting hardly existed in the artist's culture of origin, Bé-
nédite offered the following explanation of how Mammeri, a practicing
Muslim, had obtained a virtual theological dispensation to paint in the
vicinity of Fez:

> His scruples led him to consult the most learned *tolbas* concerning
> the liberties he might have been accused of taking, and they agreed
> with him on the interpretation to give to the famous passage of the
> Koran concerning the ban on the reproduction of images.
>
> What is forbidden is reproducing images which "cast a shadow,"
> that is to say sculpted figures which, in a word, could become idols.
> In any case, the ban that was in force in the ancient days of idolatry
> would, according to Islam's open minds, no longer apply to the art
> of sculpture as it is generally conceived in modern times.

For Bénédite, the advent of Mammeri marks a significant stage in the "as-
cent . . . of Muslim minds toward European culture," being comparable
to certain Algerians and Tunisians recently distinguished in medicine and

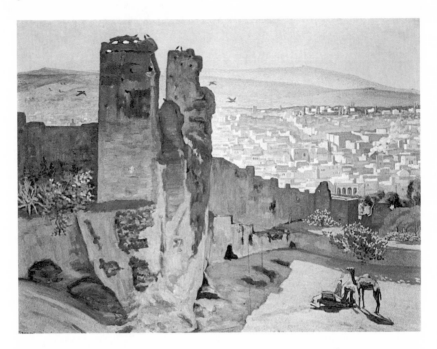

FIG. 4. Azouaou Mammeri, *View of Fez (Vue de Fez)*, ca. 1920. Oil on canvas, 70 × 92 cm., Musée d'Orsay, Paris. Photo RMN.

the sciences. Giving the lie to the supposition that religious belief had closed the domain of art to Arabs, for Bénédite Mammeri had "the courage to leave familiar pathways, and to show his coreligionists the pathway to the future."[25]

There is evidence that cultural sensitivities may have fueled Mammeri's reluctance to paint the human image, at least in his earlier career.[26] Essentially a landscapist, certain of his surviving views conform to the typical images of tourist photography on the one hand, and share elements with contemporary French colonial painting on the other. *View of Fez (Morocco)* (Fig. 4) was one of the early canvases by Mammeri to achieve the accolade of purchase by the French government.[27] The forbidding image was in fact one of the notable picturesque sites in Fez; a photographer from the French Service of Historical Monuments (founded by Lyautey in 1912 and run by the artist Tranchant de Lunel) used the same crumbling ramparts to frame the panorama of the city, which subsequently illustrated Ricard's 1924 book *Les Merveilles de l'autre France* (Fig. 5). Ricard evoked the "northern panorama of Fez, seen from the top of the

FIG. 5. Fez from the tombs of the Merinids. From *L'Illustration*, 1922. Photo Baillieu Library, Melbourne.

Hill of the Merinids," with its "cascade of terraces . . . from which the green Koubbas of the sanctuaries and the tall minarets of the mosques emerge." The leitmotif of both the Mammeri and the photo was the "salient of the old Almohad defensive wall, mutilated but still standing, and as such, a powerful symbol of the thousand-year-old city." [28]

This passage, written by a man charged by colonial authorities with overseeing Moroccan indigenous art and its traditions, betrays a passion for Moroccan antiquity and history that Mammeri shared, albeit for different reasons, as mentioned above — a congruence that also links Racim with his French supporters. Already in 1921 the Tharauds and Bénédite, no doubt learning from conversations with the artist himself, suggested that a desire to experience Maghrebian culture in all of its richness formed Mammeri's decision to emigrate to Morocco. It was (and still is) a common view that Morocco, far more than Algeria, had managed to preserve a large part of its traditional culture as well as its ancient architectural fabric.[29] Lyautey's progressive urbanism, with its system of *nouvelles villes* built adjacent to, rather than replacing, existing towns, assured this result.

Yet the visual conformity of Mammeri's exact and technically conser-

vative *View of Fez* to demonstrated European criteria of the picturesque raises hesitations in interpretation. To what extent could Mammeri be seen as a creature of the French presence — educated in the French system, taught painting by Carré, supported as both teacher and artist by the Lyautey regime? His actual painting had no engagement with indigenous traditions of image making, as did that of Mohammed Racim. Mammeri risks being seen as a kind of cultural apostate, a mere Francophilic imitator with powerful patrons.

Certainly one progressive French critic, writing of Mammeri's inclusion in the wide-ranging 1922 exhibition "Morocco Seen by Contemporary Artists" at the Galerie Georges Petit, viewed his Occidentalism with suspicion. Contrasting an earlier display of more modernist Fauve-like landscapes by the Tunisian painters Terzi ben Hasnaoui and Mohamed ben Macri Roached at the Galerie Bernheim-Jeune, Gustave Kahn wrote:

> There is an indigenous participant in this exhibition, M. Mammeri. Certainly the administration is happy to present him to us. This is not the first time we have been shown new Arab art inspired by our methods. At Bernheim-Jeune, the fine painter Antoine Villard . . . showed us entertaining decorative pages by his indigenous students. . . . But those youthful productions clearly derived from Oriental art. M. Mammeri paints in a completely Occidental manner, armed with precepts nourished by the [conservative] Salon des Artistes Français. And that's a shame.[30]

The "Occidental manner" of Mammeri here appears as a kind of denial of roots, a wholehearted embrace of European visuality. The way out of this interpretative impasse, however, lies in recognizing the differences that can be masked by an apparent visual equivalency. Extravisual questions of the context of production and of reception are crucial in establishing such a play of possible differences.[31]

To paint in a realist mode — especially in 1921, when many French painters associated with the *Rappel à l'ordre* were eschewing avant-gardism anyway — was, in an important sense, for a colonial subject to demonstrate his cultural accomplishment in terms recognized by the new authority. And Mammeri received accolades from the French, some patronizing, some not. In addition, it is quite likely that for Mammeri and his presumably small indigenous audience, the language of mimesis was

a satisfactory and respectful way of documenting observable truth. I have argued elsewhere that a preference for realist painting is marked among today's Islamic collectors of Orientalist art, and such an attitude may have been emerging in Mammeri's day.[32]

During the 1920s Mammeri's abilities as a painter developed away from the harshly detailed description of landscape in the *View of Fez* to a more measured ability to summarize that connects with modernist practice. In transferring in 1919 from Fez to Rabat, Mammeri moved from the center of traditional culture to the new seat of French government, being transformed with the addition of a *nouvelle ville* near the medina. It was the streets and terraces of the latter that Mammeri again elected to paint, but with a new planarity reflective, I would argue, of contemporary French artists active in the city. From 1921 Mammeri began exhibiting such work in his old home of Algiers, to the approval of local critics such as the prominent arabophile Victor Barrucand:

> The prodigious feeling for values and oppositions, the austerity of the impression, the weighty value of the planes commend his views of Rabat, which possess primitive purity and a monastic intensity. This is the real Morocco, and a good deal better than in Benjamin Constant. . . . The Salon des Orientalistes offers . . . nothing more interesting nor better suited to its brief than the work of this indigenous painter, who wants no more than to copy what he sees, but who does so in such a way that you couldn't mistake his manner for anyone else's.[33]

The process of describing Mammeri's paintings by employing a standard language of art criticism — Barrucand's "values," "planes," and "primitive purity," or the "feeling for linear and aerial perspective," the "envelope" and the "atmospheric phenomena" admired by Bénédite in Paris[34] — have a crucial role in inducting Mammeri's work into the art world, giving it a fully ratified status that supervenes over the apparent negative of the artist's indigeneity. Approving his "pagan joy in seeing," one critic likened the Mammeris to the French landscapist Corot's early impressions of Italy. Virtually no one, however, likened Mammeri to one of the more progressive Orientalists whose work apparently conditioned his own: Bernard Boutet de Monvel (1881–1949).

This racy exponent of *art colonial,* a regular of Parisian salons who began visiting Morocco during World War I, first exhibited together with

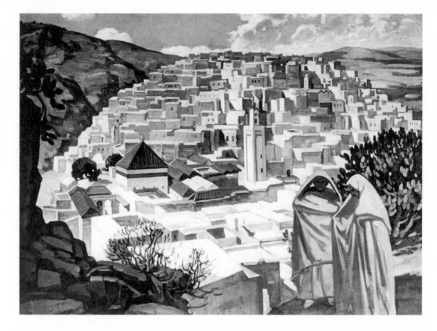

FIG. 6. Azouaou Mammeri, *View of Moulay-Idris (Vue de Moulay-Idris)*, ca. 1929. Oil on canvas, 100 × 130 cm. Private collection, Paris. Photo courtesy Lynne Thornton.

Mammeri in 1918 at the Hotel Excelsior in Casablanca. In the early 1920s de Monvel purchased a number of Mammeri's landscapes of Rabat.[35] A painter of heavily robed Moroccan figures arrayed symmetrically in market scenes and of the severe architecture of Moroccan fortified towns also studied by Jacques Majorelle, de Monvel had a style that can be described in phrases Barrucand used for Mammeri's own work in 1923: "In a precise, well-outlined manner, M. Mammeri's is an Orientalism that is not concerned with the romance of the sun, but which takes effect by geometric lines and the contrast of flat tints."[36]

An excellent example of Mammeri's work in this later manner is the hypnotic *View of Moulay-Idris* (Fig. 6). The view of the city and its dramatic emplacement in a gorge reminds one of El Greco's famous image of the city of Toledo (where Mammeri had traveled to paint on a *bourse Hispano-Mauresque* in 1924). Then again, this physical vantage point overlooking Moulay-Idris was one favored by photographers of the kind who worked for Ricard. Mammeri framed the view with a dark *repoussoir* of angular rocks and silhouetted cactus plants, while in the shadows, two

heavily draped figures stand immobile, as if mysterious guardians of the holy city, which was (and is) off-limits to nonbelievers.

A little history of the site helps establish a range of resonances for the painting. Moulay-Idris is dedicated to the memory of Moulay Idris El Akbar, who in the eighth century escaped his Abassid rivals on the Arab peninsula and founded the first Arab realm in the Maghreb. His son Moulay Idris El Azhar established the city of Fez. In the foreground of the painting, rendered with great precision and giving every sign of its careful upkeep, is the *zaouïa* of the patron saint Moulay Idris, "a *horm* or sacred place, forbidden to infidels, in which the saint's tomb, a mosque, and Koranic schools are located, and whose priests are Idrissid Sherifs, descendants of the illustrious ancestor."[37]

The perspectival orientation of the picture focuses precisely on the sacred precinct's greenish copper roofs. Moulay-Idris was not only a religious center famous well beyond Morocco, but was situated in the Zerhoun, a region where the Berber presence continued to be strong. For such reasons the view may have had added ethnic and religious resonance for the Berber Kabyle, Azouaou Mammeri. Painting emerges as a celebration, a commemoration of a place and a way of life presented not with a gaze that is touristic in a territorial, predatory sense (as one might say of much Orientalist art by Europeans), but rather as *participatory,* awash with specific associations and cultural memories.

A measure of the extent to which Mammeri was able to integrate the fact of his realist painting with his broader life is evident in his returning to serve his traditional community, acting as caïd or administrator to the *douar* of the Benni-Yenni in Kabylia from 1922 to 1927. These are years when French interest in his art was at its height, when he was showing in group exhibits at the Algiers salon and the 1922 Colonial Exhibition in Marseille, and in a solo show at the Galerie Georges Petit in Paris. According to Mammeri's son, at Taourirt-Mimoun his portraits "excited interest and admiration amongst local people," a memory confirmed by the report of Bénédite in 1925, who pictured Mammeri receiving his constituents "palette in hand, on the doorstep of his studio, to hear their reports or their complaints," or would find them "saluting him deferentially when they encounter him set up *en plein air* before his portable easel."[38]

This is the skilled cultural broker who had himself photographed for the mass-circulation French weekly *L'Illustration,* which devoted a two-

FIG. 7. *Si Azouaou Mammeri, Muslim artist and drawing teacher at the Franco-Arab School, Rabat (Si Azouaou Mammeri, artiste musulman, professeur de dessin à l'Ecole franco-arabe de Rabat).* From *L'Illustration,* 1921. Photo Baillieu Library, Melbourne.

page article to him in 1921 (Fig. 7).[39] Mammeri appears in Arab costume, seated with palette and paintbrush in hand before his easel and canvas. A chaplet of prayer beads at his chest connotes religiosity, and an ornamented Moroccan tablecloth and the fine metalwork globe of an incense burner exemplify traditional Maghrebian artistry. There is nothing of the grimy bohemia standard in many French artists' portraits, but an impeccable toilette and discreet signs of wealth. Oriental identity and Occidental activity combine in the person of one man, viewed in impassive profile and dubbed for the occasion "First Muslim Painter." It is as if Mammeri wished to forestall any impression of cultural apostasy that might arise from the sight of his Occidentalist paintings. The very step of seeking expression in this system, the effort of mastering the language, can be considered an empowering move, an accession to arenas of status usually proscribed the "native."

And we have seen that Mammeri did accede rapidly to a level of success and recognition: at least three one-man shows between 1921 and 1931, extensive critical coverage, biographical articles. It proved impossible, however, to extricate such plaudits from the certainty of Mammeri's being promoted by the Moroccan administration.

The Path of the Hybrid: Mohammed Racim

Mohammed Racim never had that particular problem. The language of expression he chose was a source of both admiration and uncertainty: the traditional Islamic miniature, modified in ways that accommodated Western modes of seeing. The road to success in European terms was harder for Racim than for Mammeri, but his reputation has proved to be more long-lasting. Unlike Mammeri, who has virtually dissappeared from the history of art, Mohammed Racim became a major figure in Algerian culture from the late 1930s until his death in 1975.[40]

In contrast to his countryman Mammeri, Mohammed Racim did what an "indigenous" man was supposed to do when it came to art: practice the Islamic decorative arts, and with distinction. He was born into an Algiers family of artisans of Turkish origin, whose precolonial prosperity had been undermined by the French regime's confiscation of property.[41] By 1880 Racim's father had been able to reestablish a wood-carving and copper-working workshop in the Casbah of Algiers, where his brother engraved decorated tombstones. The Racims won commissions for deco-

rating public buildings and the pavilions of French colonial exhibitions; indeed, the "calligraphies of the Racim brothers" were mentioned in Arsène Alexandre's 1907 report on the indigenous arts in Algeria.[42]

Mohammed Racim was born in 1896 and raised "in an art milieu frequented by erudite people and indigenous notables."[43] Like his older brother, Omar, he was schooled to enter the family workshop, being sent, as Mustapha Orif explains, to "a school designated 'for the indigenous' where he followed studies strongly oriented towards manual work, developing his drawing above all."[44] He completed this schooling in 1910, when his evidently exceptional work was noticed by Prosper Ricard, director of the new Service des arts indigènes founded in 1908 by Governor Jonnart following the Alexandre report. Ricard offered Racim a position as draftsman in the Service's Cabinet de dessin, a visual resource center for the recovery and documenting of Algerian traditional arts and a studio in which neotraditional models could be designed for the colony's workshops. Racim recalled: "From the age of fourteen years, I spent a part of my days doing copies and compositions of carpets, Arab embroideries, ornaments on copper, and sculpted wood destined to furnish models for schools, the workshops of Algeria."[45]

Racim's interpellation into such a state-sponsored program of cultural revival gives an element of subalternity to his identity early on. His visual research into Maghrebian decorative art was fostered by French colonial interests, albeit of an associationist, even arabophile cast. This condition of tutelage was nevertheless matched by Racim's personal artisinal heritage, stretching back into the era of the Ottoman Regency of Algiers. His hybrid position as a historical actor bespeaks a confluence of interests.

The European concept of the artist seemed to draw Racim as a way of escaping the routine work that racialist ideas about ability left to the indigenous; the creative roles at the Cabinet were reserved for Frenchmen trained at Ecoles des Beaux-Arts. His first attempts at painting were criticized for "having the principal fault of a love of detail, pushed almost to a mania," whereas the high art of painting was conceived by the French to require breadth of scale.[46]

According to Racim, Persian miniatures appeared to him at this time, an art remote in time and place from contemporary Algeria, which was virtually without a local tradition of painting. Following Ricard's departure for Morocco in 1914, Racim discovered them in a volume held at the Cabinet de dessin: "I observed that they contained a large quantity of de-

tails . . . and asked myself if what constituted a defect in painting might not be a positive quality in the art of illumination." Racim's first essays in miniature painting were guided by technical advice from his uncle and encouragement by the eminent Orientalist Etienne Dinet, a realist painter who had "gone native" to an unprecedented degree, speaking Arabic, living in Bou-Saâda, and converting to Islam (in 1913).

With Dinet a second plank of European tutelage was put in place: an Orientalist painting devoted to narrating the lives of Algerians, using the language of realist mimesis. According to Racim, the intervention of Dinet was decisive for his career. But before turning to the figural miniatures that best express Racim's aesthetic hybridity, an account of his illumination work must be given. It was Dinet who offered Racim his first commission in this sense: designing fifteen full-page decorative medallions containing Koranic incriptions in Arabic. These were to ornament an illustrated *Vie de Mohammed* being prepared by Dinet and his M'Zabite collaborator Sliman Ben Ibrahim. This was a substantial work of scholarship and deliberate proselytizing, written in French and drawing on authorized Arabic sources. Published in 1918 as a deluxe folio, the book also contains thirty color plates reproducing Dinet's purpose-painted oils, "scenes from the daily life of Muslims plus the holy places of Islam." [47]

Racim's illuminations, reproduced in color, follow tradition in being ornamented frames for specific suras or verses of the Koran (Fig. 8). Stemming from the artistry of the Arabic calligraphers, such illumination is the oldest of the Islamic arts and always carried with it the religious prestige of the transcribed holy word. In considering Racim's abiding interest in such illuminations (which he continued to produce into the 1940s), one must mention his older brother Omar, who himself not only practiced such calligraphy, but early on devoted himself to a life of religion and politics, becoming a *hezzah* or reciter of the Koran at the mosque. In 1903 Omar Racim was one of those who welcomed the politically contentious Egyptian reformer Cheik Abdou to Algiers; in 1912, he made a trip to Egypt and Syria, bringing back with him various Korans and specimens of Arabic illumination.[48] By 1913 he was publishing political tracts, and during World War I was arrested by the French security services for his political activities, initially banished, and then condemned to prison.[49]

Racim's involvement in the *Vie de Mohammed* and continuing illumination work can thus be seen, in both family and Algerian contexts, as

FIG. 8. Mohammed Racim, *Illumination with Koranic verse*, 1916–1917, gouache and gold leaf, 24.5 × 19 cm. For Dinet and Ibrahim, *La vie de Mohammed*, Paris, 1918. Photo courtesy Gros & Delettrez, Paris.

constituting an affirmation of Islamic religiosity as well as a revival of an art very little practiced. From the outset Racim was sensitive to the traditions of illumination from different parts of the Islamic world and sought to differentiate them in his titles; thus, his second exhibition in 1918 contained an *Illumination in Egyptian Style* and an *Illumination in Persian Style*.[50] This practice indicates Racim's awareness of his status as a latecomer, the practitioner of an art that had no real indigenous tradition, but rather was the subject of revival based on the study of classical sources.

Illumination was Racim's bread and butter for a period of eight years spent in Paris (1924–1932) working on the decoration of Henri Piazza's massive edition in twelve volumes of the *Thousand and One Nights* in the Joseph Mardrus translation. Léon Carré (Mammeri's old teacher) did the figurative illustrations, and Racim the countless page decorations, a task, he later recalled with bitterness, that precluded creative work on miniatures.

The transition from works of pure textual illumination to the art of

miniatures was certainly facilitated by Dinet. According to Racim, in 1916 "Dinet's presence was important to me: in this painter's work the documentary side and the sense of colour delighted me—these were the two qualities I most wanted to acquire. I hoped to use the image to fix the memory of Algerian costumes on the point of vanishing, as well as scenes of an Arab life in the process of transformation." Dinet's subject matter was contemporary: scenes of Arab life in the semidesert surroundings of his home at Bou-Saâda, key moments from the religious calendar, occasional sites of religious significance, and illustrations of desert folklore. The foundation of Dinet's style was academically correct figure drawing and a heightened oil color that owed something to Impressionism. Rejecting the tenets of Parisian avant-gardism, he worked in a realist, documentary, and perspectively correct manner not uncommon among French colonial artists.

Racim, while learning from such images, declared that he had "decided to take inspiration from the *mise en page* of the Persians and to apply their technique"—a stylistic preference that definitively privileges the Oriental over the Occidental. The first time Racim's work garnered critical comment was at the 1919 Salon of the Société des Artistes Algériens et Orientalistes (where Mammeri exhibited from 1922). There a pair of Koranic illuminations and miniatures like the *Persian Hunt* were deliberately structured in the Persian manner (Fig. 9). Raoul d'Artenac of the *Dépêche Algérienne* welcomed Racim's "elegant arabesques" and "prodigious prolixity," praising him for reviving the traditions of Persian and Egyptian illumination and predicting (accurately, it turned out), "Here is a young master who could form a school and give life to an art that is soon likely to disappear." For Edmond Gojon, Racim "brilliantly discredits those who pretend that art dies out in Muslim countries."[51]

This repudiation of conservative theories of cultural decline meshes with Jonnart's official policy of encouragement of the indigenous arts. As with Mammeri, Racim must have seemed to some a living justification of their hopes for a productive culture of "association." Mustapha Orif argues persuasively that, in his program of nostalgic recovery of a precolonial past, Racim was guided by the thinking of the *Comité du vieil Alger,* of which Georges Marçais, professor of Islamic art and architecture at the University of Algiers, was a key member. Since 1904–1905, this surprising lobby group of academics, public servants, and enlightened businessmen had been revaluing the indigenous heritage by attempt-

FIG. 9. Mohammed Racim, *Persian Hunt (Chasse persane)*, ca. 1920. Gouache heightened with gold. Musée National des Beaux-Arts d'Alger.

ing to safeguard the surviving precolonial buildings and monuments of Algiers.[52] As Zeynep Çelik has shown, after 1900 French architects were actively reconstituting indigenous architectural traditions and designing new buildings on that basis. This tendency of the colonizer to offer pre-packaged notions of national heritage back to the colonized[53] is one that Racim both imbibed and had to contend with. His personal strategic historical consciousness is illuminated in his comment: "I hoped to use the image to fix the memory of Algerian costumes on the point of vanishing, as well as scenes of an Arab life in the process of transformation."

Connoisseurs in Paris helped Racim enrich his knowledge of the Oriental miniatures. His publisher Piazza was instrumental in introducing Racim, during the 1920s, to a group of collectors and scholars of Persian and Mughal miniatures. Known already to Orientalists like Delacroix and Ingres, Persian miniatures had been shown at intervals in the great exhibitions, and by the 1893 Exposition d'Art Musulman collections were held by connoisseurs such as Louis Gonse and Hakky Bey. After 1900 the rhythm of Oriental miniatures' display increased, with exhibitions in Paris in 1903, 1907, and 1912. Racim's identification with the Persian miniature might even be seen as an implantation of Western connoisseurship. But one must guard against arguments that overly reduce Racim to a subaltern position: one could say equally that Racim instrumentalized the Parisian collectors.

In his 1960 book on Racim, which reworks an early article for the prestigious *Gazette des Beaux-Arts,* Marçais stresses the artist's profound sense of what he had lost to the colonial era. In Algiers, he wrote, the public memory of the "historic days of the Corsairs . . . [was] not completely lost." In Racim's images of women such as *Casbah Terraces* (Fig. 10) and *The Day after the Wedding* there is more than an homage to Delacroix's *Women of Algiers* and the iconography of Orientalism. Marçais affirms: "These are the marriage feasts at which he was present with his father, or those intimate gatherings of women which he witnessed as a small boy."[54]

In their chasteness Racim's images of women, like his coreligionist and countryman Mammeri's, rewrite the degrading protocols of Orientalist painting. When out in the street women of high standing are shown with the full veil; when pictured in their own interiors or on rooftop terraces, their faces are revealed, albeit on a miniature scale. A precise grasp of manners and gesture pervades these scenes of gently smiling figures. Clearly Racim had never studied the live model, as did most Orientalists;

FIG. 10. Mohammed Racim, *Casbah Terraces (Les Terrasses du casbah),* date unknown. Gouache heightened with gold, 26 × 32 cm. Musée National des Beaux-Arts d'Alger.

this produces a stiffly decorous image of the female body closer, indeed, to the seventeenth-century Mughal models he admired.

Perspective is a great marker of hybridity in Racim's work. As Marçais notes, "Living in the twentieth century, Mohammed Racim could not pretend to the complete absence of . . . laws of perspective that the Persian miniaturists did not possess. He had to find . . . artifices which rendered perspective implicit without imposing it on our attention. This he achieved by placing the horizon very high . . . by recalling the convergence of lines . . . by the paving of a courtyard or the carpets in a room.[55] Yet Racim seldom employs a perspective that reads as correct to the point of transparency. In some of his early compositions, such as his miniature of the *Persian Hunt* from the Algiers museum, the viewpoint is so high that the figures of horsemen are laid out up the space with little diminution of scale—an appropriation of classical Persian compositions.

More generally, Racim employs a bird's-eye perspective to contain a panoramic view. In such works, subtle distortions of perspective are evident. In *Casbah Terraces* the foreground of four women is tipped sharply up toward the viewer. Yet beyond them, in the vista of casbah rooftops descending to the old Algiers port, the view slips down and out, curving back up to a horizon of hills and sunset that seems the only perspectivally solid element in the picture. Racim's lavish foreground evokes aperspectival Mughal miniatures, and his panorama refers to European topographical tradition. Racim's is a rich example of the use of "perspective as symbolic form" (to use Panofsky's phrase); his refusal to draw in irreproachable perspective richly asserts his Maghrebian painterly identity. The worthy emulator Mammeri took pleasure in reiterating his mastery of perspective; the skilled hybrid Racim enjoyed teasing its codes.

Despite Racim's working in a medium that was marginal in the hierarchy of European visual arts, a public in Algiers began to form for this artist who simultaneously exemplified a preservationist mentality and, more clearly than Mammeri, the possibility of exalting the indigenous. The breakthrough year was 1923: exhibiting at the Salon des Artistes Algériens et Orientalistes, Racim was awarded a bursary from the Municipality of Algiers and the medal of the Société des Peintres Orientalistes Français of Paris (linked with the colony through Dinet and others). The jury for Racim's awards included local Orientalists and figures from the Algiers arts establishment.[56] Press coverage was extensive, with warm appreciations in *L'Afrique du nord illustrée* and *La Dépêche algérienne,* whose

critic, Victor Barrucand, previously a supporter of Mammeri, claimed, "Nobody today, not even in Teheran, composes the faithful rhythms of a Persian miniature better than he."[57]

Barrucand's perspective is worth singling out. This former symbolist dramatist from Paris, well-known as editor of the left-leaning newspaper *L'Akhbar,* was the literary executor of the transcultural adventuress Isabelle Eberhardt and, like her, was considered a "militant indigenophile" by some colonists.[58] Barrucand was receptive to the miniature as an art form as well as the historicist material that Racim specialized in. In 1924, in front of miniatures on the themes of Moorish Grenada and old Algiers, Barrucand penned the following appreciation:

> The Oriental miniature, which . . . constitutes the pinnacle of achievement in the illustration and illumination of manuscripts, has found in our North Africa a representative who will make his mark. M. Mohammed Racim exhibits, at the Orientalists, two admirable compositions that are distinguished by their sense of spectacle, their luxury and their tradition. The *Splendor of the Grenada Caliphate,* with its surround of Andalusian verses, is at once visionary and nostalgic, while the *Moorish Idyll* of old Algiers is equally a page of precious visual poetry. The ornamented presentation of the first sura of the Koran is a marvel of coloration and ritual exactitude. For this vitrine alone, the exhibition of Algerian artists deserves to be called Orientalist.[59]

For such a critic, the work of Racim better exemplifies an "Orientalist" art than the hackneyed perspectives of many a European artist-traveler.

Notwithstanding praise from such a quarter, one must suppose that the Algerian colonial authorities found nothing subversive in Racim's work; like Mammeri and the Moroccan administration (but less energetically), they used Racim's art as an exemplar of government aims at the next great Parisian exposition, the Exposition des arts décoratifs et industriels modernes of 1925. Racims of the previous generation had showed at Expositions, but when Mohammed and Omar Racim were included in the Algerian hall of the Pavillon de l'Afrique du nord, it was not as decorators or traditional arts manufacturers, but as exponents of the newly licensed art of the miniature.[60]

Barrucand made the trip to Paris for *L'Akhbar* and mentioned the Algerian contingent with some pride: "The beautiful ornamented inscrip-

tions of Omar Racim leave those of the other sections far behind. In them the artist is able to enclose the mystery of thought in the elegance of the arabesque."[61] (One must assume that the former political activist Omar had been released from prison and rehabilitated by the regime of the newly appointed progressive governor-general Maurice Violette.) Edmond Gojon, while praising the work of Mohammed Racim, expressed a desire to see "more durable monuments" come from his brush.[62] In its ambivalence about the small scale of the miniature as a kind of image making, this comment exemplifies the equivocation that dogged Racim before being recognized by the award of the Grand prix artistique de l'Algérie (1933) in the category "enlumineur-miniaturiste"—the first time this award had gone to an "indigène." Soon after, Racim was named professor at the Ecole nationale des Beaux-Arts in Algiers, from which position he was able to form an entire generation of Algerian artists in miniature painting.[63]

François Pouillon has written, "The heart of the Orientalist artifice . . . always consists . . . in presenting a society as virgin—as if at the moment of its unveiling—and from which the corruptions of history and of contact with the foreigner are systematically erased."[64] Racim's work redefines this convention. The subjects for his miniature "history" paintings are all situated specifically, in the time before the French invasion of North Africa, in the heroic days of the Corsairs of the Barbary Coast and the earlier Moorish Caliphate of Andalusia (Plate 3). In his reconstruction of these far-off times, everything was new: neither time nor the European invaders had yet struck at the pristine polychrome buildings and their exquisite details.

A little history of precolonial Algeria is needed here.[65] Racim's particular love is the splendor of the Corsairs, the state-sanctioned privateers of Algiers whose profession was the systematic pillage of European and thus Christian shipping in the Mediterranean. The most famous of the Corsairs were the brothers Barbarossa ("Red-Beard"), of Levantine origin. Around 1516 they were called by the people of Algiers to fight against the Spanish, who since 1492 had been the dominant force along the North African littoral. Algiers city was threatened by a Spanish fortress called the Peñon, built on the largest of the port islets that gave the city its name. The elder Barbarossa failed to take the Peñon but consolidated his strength by a series of muderous alliances along the Barbary Coast. It was his brother, Khaïr Ed Dine, who succeeded in reducing the

FIG. 11. *Algiers, 1700.* Engraved French map. Photo Baillieu Library, Melbourne.

Peñon in 1529, with the aid of the Sultan of Constantinople, who placed Algiers under Ottoman protection.

Barbarossa fortified the port and made Algiers a sort of military republic, led after his death by a series of oustanding Corsair Beys. Increasingly placed under direct Ottoman control, the Barbary state of Algiers went on to flourish for almost three centuries on the proceeds of its maritime activity, whether described as brigandage or *jihad*. In its heyday during the seventeenth century Algiers held up to thirty thousand European captives (the Spaniard Cervantes was one), used to man its galleys, provide household slaves, and fuel ransom payments.[66]

Duplicating Orientalist convention (and even stereotypy) from the other side, Racim's work avoids such unsavory topics and abounds instead with brisk martial feeling and positive images of the Corsair capital, the famous triangle of its white cubes rising up from the blue sea. This specific topography seems to be inspired by the many old views and maps of Algiers published in Europe (Fig. 11). Racim made a close study of Turkish and Barbary galleys, which he details minutely in works such as *Galleys Fleeing the Storm* (Plate 3).[67]

Racim's erudition is evident in the remarkable *Naval Battle,* where a sixteenth-century Spanish galleon struggles broadside with a Barbary galleass flying the distinctive Turkish colors. Racim has depicted the most intense rivals in the Mediterranean: the sailors of the Catholic kings of Spain who, having expelled the Moors from Andalusia, were now losing control of the Barbary Coast to their Turkish-led allies.[68] In such a scene Racim went far beyond the Islamic miniature and reworked models probably studied in the museums of Europe, in particular Dutch masters of marine painting who occasionally depicted such combats.[69] A visual sophisticate, he had a pragmatic approach to the use of sources.

Racim's early interest in Barbarossa had been cemented by a failed commission to illustrate the "Bey of Bey's" life.[70] The artist went on to paint Barbarossa in a variety of miniatures: commanding from the forward castle of a gilded galliot;[71] as protector of the city in his double-page *History of Islam;* and as the subject of a posthumous portrait inscribed "Barbarossa, Founder of the Algerian State."

This is unequivocal heroization, with all the schematic character of political icon making. A figure who for many was the "Scourge of Christendom" is, from the Maghrebian perspective, the founding father of a state that began to take on the lineaments of nationhood as a result of Khaïr Ed Dine's rule. It is easy to see how such imagery came to be prized by Algerian nationalists prior to and after the ousting of the French around 1960.

Similar in inspiration is the portrait of the late eighteenth-century Rais Hamidou (Fig. 12). Georges Marçais explained of such works:

> The Rais . . . is a master of a Corsair ship, a member of the powerful corporation . . . on which the fortune of Algiers rests. Traditional rivals of the Turks who comprise the militia . . . among [the Raises] one finds native-born Berbers [like Hamidou] and Levantines like Barbarossa . . . also people from European countries who . . . thanks to a more or less sincere conversion, have embraced the adventurous but lucrative career of Barbary pirate.[72]

Standing before an exact reconstruction of Algiers Harbor, Hamidou is presented as a figure of great dignity, a dynamic leader acting with the legal imprimatur of the sovereign Algerian nation. The exaltatory character of Racim's portraits of the Rais is all the more evident given the fear these captains inspired in Europe. Racim betrays a fondness for images

FIG. 12. Mohammed Racim, *The Rais (Le Rais)*, ca. 1931. Gouache heightened with gold, 18.5 × 13.5. Collection Tayeb Zahzah, Paris.

of strong patriarchal leadership in these and other images. Even as he reveals a nationalist aspiration, Racim employs a Western iconography to express it: the full-length portrait for military leaders that originated with Renaissance masters such as Titian. This is the double bind detected by Benedict Anderson at the heart of ideologies of nation in colonial situations: Western technologies normalize and intensify ideas of nation around certain key concepts and historiographical figures.[73]

It is intriguing that in reviews of Racim's exhibitions in Algiers and Paris, French critics broadly applauded his work, as has been seen. They seemed not to detect the element of political resistance that is apparent from a postcolonial perspective (although, for the celebrations of the Algerian Centenary, Racim's work, including the miniatures acquired by the newly inaugurated Musée National des Beaux-Arts, was placed to one side).[74] After all, Racim repudiated colonial modernity by using documents to reconstruct Moorish buildings demolished by the French and to people them with figures of a respectful ethnic exactitude. This

was the fabric of Racim's imaginary counternation. And his heroizations of Barbarossa, the Raises, and the Andalusian Caliphs suggest national polities.

But "nation" must be understood broadly here, be it the smallish Regency of Algiers, ultimately under imperial protection, or the much grander Maghrebian cultural and political unity, which once stretched all the way from Tripoli to the palaces of Granada and Toledo. The nationalists of the Etoile nord-africaine movement (initially banned because of its close association with the anticolonial French Communist Party) called for complete independence from colonial rule for all the nations of the Maghreb—not only Algeria, Morocco, and Tunisia, but Tripolitania (Libya), recently annexed by the Italians. The leading polemicist Ferhat Abbas used the nom de plume "Abencerage," after a great Moorish family expelled from Granada by the Catholic kings, to sign his 1931 *Le Jeune Algérien,* a text that codified the position of his modernizing, probilingual, yet Islamic movement (modeled on the Young Turks). Even the famous slogan coined by the popular Algerian reformist theologian Ben Badis in 1931—"Arabic is my language, Algeria my country, Islam my religion"[75]—gives a sense of how far transnational cultural and religious considerations motivated the consciousness of Algerian colonial subjects in Racim's era.

Although Racim was a cosmopolitan moderate close to the French culturati and married to a Swede, his art suggests that he shared something with the nascent Algerian nationalism of the day. In 1932 an indigenous journal associated with the Islamic reformist movement characterized him in politicized terms as an "Algerian Muslim painter who has raised the head of Muslim and Arab Algeria with pride, thanks to the inspiring beauty of his art and by means of his original paintings, in which he sets out the most brilliant and most beautiful pages of Islamic civilization, pages of glory and pride in this world."[76]

With the revolution of 1962 and the ousting of the French, nationalist appreciations of Racim proliferated, as Pouillon has shown. Thus Bachir Hadj Ali, drawing lessons from Racim's *Casbah Terraces* as reproduced in *La Nouvelle Critique,* wrote, "This painting constitutes an act of accusation against colonialism, at the same time as it proves . . . that all national art produced under the occupation is politically engaged art."[77] Dreaming away the modern colonial reality of twentieth-century Algiers, Racim issued an aesthetic call to arms, an invitation to recapture, via images of

the past, a cultural focus that might outlast the reality of colonial occupation.

Notes

I wish to thank Lynne Thornton and Brahim Alaoui for kindly providing me with copies of rare materials on Mammeri, and Maître Si Ali Tiar for letting me examine his photodocumentation on the artist. All translations are mine.

1 The Arabic word for the Western Islamic bloc of Morocco, Algeria, Tunisia, and Libya.

2 On Orientalist photography, see Mounira Khemir, "The Orient in the Photographer's Mirror: From Constantinople to Mecca," in *Orientalism: Delcroix to Klee,* ed. Roger Benjamin (Sydney: Art Gallery of New South Wales, 1997), 189–95.

3 François Pouillon, "Tableaux d'Occident et d'Orient: La synthèse Racim," in Brahim Alaoui, ed., *Mohammed Racim, miniaturiste algérien* (Paris: Institut du Monde Arabe, 3–29 March 1992), 14–20; most of the Racim works discussed are illustrated in this catalogue.

4 Prosper Ricard, "Aperçu réligieux, artistique et littéraire," in *Algérie, Tunisie, Tripolitaine, Malte* (Paris: Les Guides Bleus, Hachette, 1930), lviii.

5 On Lyautey and his policies in Morocco, see Paul Rabinow, *French Modern: Norms and Forms of the Social Environment* (Cambridge, MA: MIT Press, 1989), esp. 275–319.

6 This biographical sketch draws on the following: Jérôme Tharaud and Jean Tharaud, "Si Azouaou Mammeri, Peintre de Rabat," *Art et Décoration* 39, no. 235 (July 1921): 21–24; Léonce Bénédite, "Avant-propos," in *Exposition sous le haut patronage de M. le Maréchal Lyautey des dessins et peintures de Si Azouaou Mammeri* (Paris: Galerie Feuillets d'Art, 2–21 May 1921), [1–8]; and Louis-Eugène Angéli, "Les Maîtres de la peinture algérienne: Azouaou Mammeri," *Algéria* 42 (May–June 1955): 40–44.

7 Tharaud and Tharaud, "Si Azouaou," 21.

8 Charles-Robert Ageron, *Histoire de l'Algérie contemporaine* (Paris: Presses Universitaires de France, 1979), 2.166, where he notes that many Europeans feared that formal education for the Arabs would reverse the power structure; on Algerian educational policy, see 152–68.

9 See Raymond F. Betts, *Assimilation and Association in French Colonial Theory, 1890–1914* (New York: AMS Press, 1970).

10 Rabinow, *French Modern,* 50–51.

11 Angéli, "Azouaou Mammeri," 41–43; Carré was an early scholarship holder at the Villa Abd-el-Tif, the government art studio at Hamma in Algiers.

12 See Charles-André Julien, *Le Maroc face aux impérialismes, 1415–1956* (Paris: Editions J.A., 1978), 141.

13 Jérôme Tharaud and Jean Tharaud, *Fez, ou, les bourgeois de l'Islam* (Paris: Plon, 1930).

14 Tharaud, *Fez,* 236–37. The chapter entitled "Histoire d'Azouaou" (234–92) draws on the biography of Mammeri as corroborated by other sources, including their 1921

article, which it reuses; at some points, however, the Tharauds seem to collapse together the careers of the two Mammeris.

15 Simply signed "Mammeri, instituteur à Fez-Djédid," it is possible they were written by Mohammed Mammeri but illustrated by Azouaou (whose style and signature in the drawings correspond to his later paintings).

16 See Lyautey's preface in *Exposition du peintre musulman Azouaou Mammeri, sous le patronage de M. le Maréchal Lyautey* (Paris: Galerie Jean Charpentier, 4–19 May 1931): "I think it was in *France-Maroc* that I saw your first drawings, sketches of children and views of terraces. The line was already firm, exact, expressive."

17 Mammeri, "L'Enseignement: Une classe Marocaine," *France-Maroc* 3 (15 March 1917): 34–35.

18 Mammeri, "Une classe coranique," *France-Maroc* (December 1918): 351–54.

19 Bénédite, *Exposition sous le haut patronage*, 1921, catalogue numbers 2 (*Classe en Algérie*), 41 (*Ecole coranique*), and 42 (*Appel à la prière*).

20 *Exposition des arts marocains* (Paris: Pavillon de Marsan, May–September 1917); Mammeri showed *Campagne de Fez* and *Coin de Fez* (p. 5).

21 Bénédite, "Avant-propos," 5–6.

22 Tharaud and Tharaud, "Si Azouaou," 24.

23 See Benjamin Stora, *Histoire de l'Algérie coloniale (1830–1954)* (Paris: La Découverte, 1991), 41–42, 70–73.

24 See Roger Benjamin, ed., *Orientalism: Delacroix to Klee* (Sydney: The Art Gallery of New South Wales, distributed by Thames and Hudson, 1997), catalogue number 108.

25 Bénédite, "Avant-propos," 1, 6, 2–3, 4, 8.

26 According to Bénédite ("Avant-propos," 4), at Rabat Mammeri refrained from teaching the figure "to avoid any contestation" and focused on traditional vegetative motifs and nature study, a point repeated in the anonymous article "Le Premier peintre musulman" in *L'Illustration* 4094 (20 August 1921): 162–64; from the 1920s, however, Mammeri painted the figure (especially his family and portraits of French and Moroccan notables) with increasing frequency.

27 See Benjamin, *Orientalism: Delacroix to Klee*, cat. no. 107.

28 Prosper Ricard, *Les Merveilles de l'autre France: Maroc, Algérie, Tunisie* (Paris: Hachette, 1924), 292; see 288 for Communal's oil painting of the same site.

29 Conversations with Djaffar Boulharouf, Algiers, 1992, and Brahim Alaoui, Paris, 1996.

30 Gustave Kahn, "Art," in *Mercure de France* 160 (December 1922): 762–63; on the exhibitions he refers to, see Gustave Rouger, "Nos Artistes au Maroc," *L'Art et les Artistes*, n.s. 6, no. 30 (October 1922): 34; and *Printemps dans l'oasis de Gafsa* (Paris: Galerie Bernheim-Jeune, 18 February–2 March 1918).

31 The Homi Bhabha–inspired reading of Australian Aboriginal landscapist Albert Namatjira provides useful parallels to Mammeri; see Ian Burn and Ann Stephen, "Namatjira's White Mask: A Partial Reinterpretation," in *The Heritage of Namatjira: The Watercolourists of Central Australia*, ed. Jane Hardy et al. (Melbourne: Heine-

mann, 1992), 264–82. Also relevant is Sylvia Kleinert, "Aboriginal Landscapes," in *Lying about the Landscape,* ed. Geoff Levitus (Sydney: Craftsman House, 1997), 82–99.

32 See Roger Benjamin, "Post-colonial taste? Non-Western Markets for Orientalist Painting," in *Orientalism: Delacroix to Klee,* 32–40.

33 [Victor Barrucand], "Salon des Orientalistes," *L'Akhbar* (5 March 1921).

34 Bénédite, "Avant-propos."

35 Illustrated in Rouger, "Nos Artistes au Maroc," 5; see also *Exposition Si Azouaou Mammeri — Tableaux et Dessins: Afrique du Nord et Andalousie* (Paris: Galeries Georges Petit, 16–31 March 1925), cat. nos. 67–69.

36 Victor Barrucand, "Peinture au Salon des Orientalistes," *La Dépêche Algérienne* (16 February 1923).

37 See Ricard, *Merveilles de l'autre France,* 322, and photo p. 326.

38 Notes provided by Professor Driss Mammeri to Lynne Thornton; Bénédite, "Avant-propos," in ed. Mammeri 1925, p. 4.

39 Illustrated in "Le premier peintre musulman," 162.

40 See Pouillon, "La synthèse Racim," 14–15, 18.

41 For biographical information and broader thematic issues, this section is heavily indebted to Mustapha Orif, "Mohammed Racim, inventeur de la miniature algérienne," in Brahim Alaoui, ed., *Mohammed Racim,* 22–34; reprinted from *Actes de la Recherche en sciences sociales,* 75 (November 1988).

42 Arsène Alexandre, *Réflections sur les Arts et les Industries d'Art en Algérie* (Algiers: L'Akhbar, 1907), 23–24.

43 Robert Randau, "Un maître algérien de la miniature: Mohammed Racim," *L'Afrique du Nord illustrée* 817 (10 January 1937); reprinted in Brahim Alaoui, ed., *Mohammed Racim,* 38.

44 Orif, "Racim," 24.

45 This and the following quotes from Racim are translated from Randau, "Un maître algérien," 38–40.

46 On this point, see Orif, "Racim," 25.

47 The English edition is Etienne Dinet and Sliman Ben Ibrahim, *The Life of Mohammed, The Prophet of Allah,* illustrated by E. Dinet, ornamental pages by Mohammed Racim (Paris: Paris Book Club, 1918); for an excellent discussion of this much reprinted book, see François Pouillon, *Les Deux vies d'Etienne Dinet, peintre en Islam* (Paris: Baland, 1997), 120–24.

48 Orif, "Racim," 24–25; there is an example of Omar Racim's work in the Musée de l'Institut du Monde Arabe, Paris.

49 Ageron (*Histoire de l'Algérie,* 241) notes that in 1913 Omar Racim, "in a little journal lithographed in Arabic, *Dhou-l-Fiquar* . . . worked to spread the reformist [Islamic] doctrine of the *Salfiyya.*" On his imprisonment, see Orif, "Racim," 26. Mohammed agitated for his brother's release, making gifts of miniatures to people in influential posts.

50 See listings in Brahim Alaoui, ed. *Mohammed Racim,* 44; Georges Marçais's *La vie musulman d'hier vue par Mohammed Racim* (Paris: Arts et Métiers graphiques, 1960),

shows no fewer than five such varieties of style: "Oriental," "Algerian," "Persian," "Turco-Persian," and "Maghrebian."

51 Orif, "Racim," 26 (sources not given).

52 Ibid. "This association intervened in various ways: it indicated to the authorities those residences which it felt ought to be classed as historic monuments; it organized lecture tours in the Casbah; it published a review, *Les Feuillets d'El Djezaïr,* in which the stories of a Rais . . . a Dey . . . a saint or a building were told."

53 See Zeynep Çelik, *Urban Forms and Colonial Confrontation: Algiers under French Rule* (Berkeley: University of California Press, 1997), and her essay in the present volume.

54 Marçais, *La vie musulman d'hier,* 10; see also Georges Marçais, "Mohammed Racim, miniaturiste algérien," *Gazette des Beaux-Arts* 141 (1939): 52–53.

55 Marçais, *La vie musulmane d'hier,* 9; Marçais, "Miniaturiste algérien," 53.

56 See J[ean] B[évia], "Les Récompenses: Au Salon des Orientalistes," *La Dépêche Algérienne* (17 February 1923); Bévia congratulates Racim, "whose fine talent as an illuminator and miniaturist have earned everyone's admiration."

57 Victor Barrucand, "Peinture: Au Salon des Orientalistes," *La Dépêche Algérienne* (17 February 1923).

58 Orif, "Racim," 27. Barrucand stood at the Algiers municipal elections among primarily autocthonous Muslim candidates.

59 Victor Barrucand, "Salon d'Hiver," *La Dépêche Algérienne* (21 February 1924).

60 *Catalogue officiel, Exposition internationale des arts décoratifs* (Paris, 1925), "Section d'Algérie," 507: "Racim, Omar, miniaturiste, Alger (miniatures)." (Although Mohammed is not listed, critics' accounts indicate he did exhibit.)

61 [Victor Barrucand], "Aux Arts Décoratifs," *L'Akhbar* (21 August 1925).

62 Edmond Gojon, "L'Algérie," in *Album de l'exposition internationale des arts décoratifs de 1925* (Paris: L'Art Vivant, 1925), 132.

63 For details, see Orif, "Racim," 28–34.

64 Pouillon, "La synthèse Racim," 18.

65 My principal sources here are Ricard, *Aperçu,* 6–7; Charles Delvert, *Le Port d'Alger* (Paris: Dunod, 1923), 8–16; and Jamil M. Abun-Nasr, *A History of the Maghrib in the Islamic Period* (Cambridge, England: Cambridge University Press, 1987), 151–68.

66 See Miguel de Cervantes Saavedra, *The Captive's Tale,* ed. and trans. Donald P. McRory (Oxford: Oxford University Press, 1992).

67 Illustrated in Benjamin, ed., *Orientalism: Delacroix to Klee,* 175.

68 Richard Pennell has kindly translated Racim's Arabic inscription as "A sea battle between the Muslim fleet and the fleet of the Christians" (emphasizing the element of religious struggle); yet French titles for the exhibited work were the anodyne *Combat navale devant Alger* (in 1934) and *Bataille navale (Algérie contre l'Espagne)* (in 1947; a title that constitutes "Algeria" as a nation-state *avant la lettre*); see Brahim Alaoui, ed., *Mohammed Racim,* 45, and illustrated, 39.

69 See, e.g., Andries van Eertvelt, *A Spanish Engagement with the Barbary Corsairs,* illustrated in David Cordingly, *Pirates: Terror of the High Seas* (Atlanta, GA: Turner Publications, 1996), 76.

70 Racim lists his projects for book illustrations in Randau, "Un maître algérien," 40.

71 Barbary Corsairs preferred the highly maneuverable galliot (with just sixteen to twenty oars) over the large galleys with battering rams and multiple oar banks used by both Europeans and Turks in the Mediterranean; see Saavedra, *The Captive's Tale,* 167.

72 Marçais, *La vie musulmane d'hier,* 29.

73 See Benedict Anderson, *Imagined Communities: Reflections on the Origins and Spread of Nationalism,* rev. and extended ed. (London: Verso, 1991).

74 See Orif, "Racim," 28, where he notes that the acquisitions were probably intended to mollify an indigenous elite aggravated by the centenary. On the centenary, see chapter 10, Roger Benjamin, *Orientalist Aesthetics: Art, Colonialism, and French North Africa, 1880–1930* (Berkeley: University of California Press, forthcoming 2003).

75 See Stora, *Histoire de l'Algérie coloniale,* 74.

76 Article in *Ech Chibab,* quoted in Orif, "Racim," 29–30.

77 Bachir Hadj Ali, "Culture nationale et révolution algérienne," *La Nouvelle critique* 147 (1963): 35, quoted in Pouillon, "La synthèse Racim," 18.

THE MOSQUE AND THE METROPOLIS

Mark Crinson

With physical and cultural displacement there often emerges a struggle for new architectures and for renewed or at least newly inflected symbols of identity. The visual tropes of colonial architecture—the gothic church among the palm trees, the emplacement beside the *maidan*—become uncannily inverted in postcolonialism as the minarets rise above the bungalows and the Bengali restaurant faces the Mecca bingo hall. Such spatial articulations have been among the most powerful visual aspects of the emerging public formation of the Muslim diaspora. They challenge ideas of the nation-space, refusing to sit easily either within some model of transplanted traditionalism or within linear histories of absorption and development. An architectural history whose protocols are premised on the unfolding unities of aesthetic, geographic, or technological interests has been little concerned and little able to deal with the cross-cultural nature of the metropolitan mosque. Likewise, that mosque's ambivalent relation to concepts of cultural temporality has been of little interest to a closely related form of architectural history based on the continuities and variations within some religious or cultural unity. In short, histories and analyses of British architecture, Islamic architecture, modernism, or revivalism are all equally unlikely to provide adequate accounts of a mosque in London.[1]

The notion of "Muslim space" or the "Islamization of space" has been recently developed in sociology and may appear to address this problem. In one argument, for example, certain characteristics are essential to Islamic spatial practices: the presence of written Arabic words; the

"normatively enjoined practices" of prayer, education, and meditation; certain sounds and smells; and finally, the "utter 'portability' of Islamic ritual."[2] These enduring themes, it is suggested, are recreated and re-imagined in the varying sites of the diaspora, where the condition of marginality tends to give them greater relief as social practices and perhaps also as actual spatial articulations. The new environment induces an acute sense of contrast, both with the past and with the host society. Yet the tendency in such an argument is still to use a group of practices central to religious observance as the determining code for the decipherment of a physical space that "belongs" to a minority community: religion is the most irreducible practice through which the diaspora must be figured and registered. Content becomes reduced to its formal container, or the formal container becomes reduced to a prescribed list of contents;[3] the inescapable condition of semiosis is exchanged for a limited circuit of correspondences, a foreclosure providing a comforting sense of prescribed and describable boundaries. The notion of "Muslim space" conflates an empty geometric space, the ineffable space of modernism now become ubiquitous, with what Henri Lefebvre called "the space of a practice embracing morphologically privileged and hierarchically ordered places where actions are performed and objects are located." To the common-sensical idea of "an inert spatial medium where people and things, actions and situations, merely take up their abode," one would want to apply Lefebvre's corrective that space is not in any simple way produced by ideology but is, in fact, "the seat of a practice consisting in more than the application of concepts, a practice that also involves misapprehension, blindness, and the test of lived experience."[4] Among such experiences one might indicate at this stage the appropriation of other codes of spatiality, the conflict with existing practices, and the involvement in more global patterns of change and relations of production. These also indicate that diasporic cultures have many other defining contexts than their culture of origination.

The argument in favor of the notion of Muslim space also has troubling echoes of older arguments that were propounded about the "Islamic city." The Orientalist tropes that came to coalesce around the notion of the Islamic city in the twentieth century were based on a static, unchanging ur-type of city.[5] This derived neither from some originating city form or representation, nor from some established set of rules or ordinances to be found in the culture. Instead, the Islamic city was a negative con-

struct, born of the projection of otherness: what was *not* the Western, the modern, the capitalist; what was presumed to be essential as opposed to what was all too clearly changing. Muslim space has similar dangers. It suggests a singular diasporic response to the postcolonial situation. At last, it seems, architectural form can be closely bound up with social practices unified around some core cultural content. Space is thus seen as the compound product of a mentality and a geography.

I want to move beyond this particular essentialist sociological interpretation of Muslim space, as well as beyond the various diachronic accounts of Islamic architecture. Work in this direction might attempt to reconnect the factors dissociated by such approaches and to speculate instead about the possibility of an analysis that recognizes how the particular spatial forms taken by diasporic architecture have arisen out of negotiations between local and global concerns, modern and traditional interests, dominant and subaltern loyalties. To do this it seems most challenging to focus on the mosque, both as the most overt sign of Muslim presence and also because at first sight it seems least tractable to the readings offered by critical and spatial theory. The more radically disjunctive notion of space, the emphasis on the multivalent use, appropriation, and cooptation of space that Lefebvre alerts us to, is consonant with the emphasis in postcolonial theory on culture as an active process of translation and interpretation. The spaces of the diaspora represent a *partial* culture, "culture's 'in-between,' bafflingly both alike and different," as Homi Bhabha puts it, "a complex act that generates borderline affects and identifications."[6]

The Shah Jahan Mosque at Woking, just outside London, announces itself to trains passing into Woking from London not just via the ornate and colorful façade of the mosque clearly visible from the railway line but also by a large banner bearing its name. The mosque dignifies its small scale and suburban location by appropriating forms from the Mughal architecture of India: among them, an onion dome, ogee-shaped niches, and a number of decorative motifs (Fig. 1). The sources that authorize these forms are the Badshahi Mosque in Lahore and the Taj Mahal, after whose joint founder the Woking mosque was named. To these sources the Victorian architect, William Isaac Chambers, seems also to have added a number of details from Egyptian Mamluk architecture, probably taken

FIG. 1. The Shah Jahan Mosque, Woking, 1889.

from such works as Jules Bourgoin's *Les Arts arabes* (1873) and these details offer another kind of authority, that of the Western architect who sifts through the archive and recombines his findings to new effect. The mosque is thus the product of classic Orientalist views and gambits. Its miniaturized synthesis typifies the way that, by the late nineteenth century but initiated arguably as early as the 1840s,[7] British Orientalism had reached such a confidence in the analysis and reuse of Islamic forms that the combination of historical detail and aesthetic elision signified both scholarly knowledge *and* mastery over space and time. Indeed, the mosque as image, as object of representation, might be seen as the very product of this discourse.

The Shah Jahan Mosque presents a studied synopsis or distillate of knowledge about some object imagined as utterly other and, it will be contended, its appearance of respect or sympathy for this cultural otherness is part of the management of consent essential to the dynamics of hegemonic power. It was the creation of the Hungarian-born Orientalist Gottlieb Leitner, professor of Arabic and Islamic law, fluent from an early age in Turkish, Arabic, and Modern Greek, from 1866 principal of Government College in Lahore, and employee at various times of the British, Austrian, and Prussian governments. Leitner seems to have seen

his own cultural nomadism as a kind of model for the transparency and peaceful interchange of cultures on a global scale. His project was to promote mutual intellectual enlightenment and a mutual exchange of cultural products, while preserving essential cultural differences. Leitner can be seen, therefore, as typical of that "modern Orientalist [who] was, in his view, a hero rescuing the Orient from the obscurity, alienation and strangeness which he himself had properly distinguished." In common with the great Orientalists discussed by Edward Said—among them Edward Lane, Silvestre de Sacy, Ernest Renan, and William Jones—Leitner's project "bore the traces of *power*—power to have resurrected, indeed created the Orient, power that dwelt in the new, scientifically advanced techniques of philology and anthropological generalisation." Continues Said, "In short, having transported the Orient into modernity, the Orientalist could celebrate his method, and his position, as that of a secular creator, a man who made new worlds as God had once made the old."[8] The imaginative geography of Leitner's work is also, of course, one that manifests benevolent powers of improvement and close empathy for its objects.

In 1883, not long after he had settled himself in England, Leitner established the Oriental Institute just outside London in Woking. The institute was intended to be the preeminent European center for the study of Oriental cultures and included an Oriental Museum largely made up of the objects that Leitner himself had collected in his travels. Leitner intended to foreground certain cultural connections, while reinforcing the distinctions between others. He attempted to promulgate the idea that Indian art was closely attached to the Greco-Roman tradition and also to promote the direct commercial importation of contemporary Indian goods into Britain.[9] The institute's main job was to teach Asians living in Europe and Europeans who wanted to study or travel in the East. But while the former, for instance, could "study all the great scientific appliances which England can produce," they would do so "without coming into any sort of contamination . . . with European manners and customs."[10] It was also for the former constituency as well as visiting dignitaries that Leitner built his mosque on the grounds of the institute in 1889, largely funded by Begum Shah Jahan, wife of the ruler of Bhopal State.[11] This mosque therefore offered a further insulation through staging a confirmation of absolute cultural difference in the matter of manners and customs.

The meanings of architecture shift as it is reused or enters into a dif-

ferent relation to its various contexts. Gradual though its transformation might have been, and certainly not rejecting the legacy left by Leitner, the Shah Jahan Mosque was reappropriated in the later twentieth century by a Muslim community in Woking. The institute itself was closed down when Leitner died in 1899, the contents of the library and museum were dispersed, and the mosque was left in virtual disuse until 1912, when Khwaja Kamaluddin, a Muslim missionary, reopened it. Woking's symbolic importance as a center for Muslims in Britain was reinforced when a Muslim burial ground was established nearby for Indian soldiers killed in the First World War. Although this position of centrality has since been lost, due partly to differences between the trust responsible for the building and the local Muslim population, and partly to the emergence since the 1970s of other, more richly endowed mosques, particularly in London, Woking itself has an unusually large Muslim population for a small Surrey commuter town. This has much to do with the well-established mosque there.

What has happened to the hegemonic management of consent that underpins the project of Orientalism? The "new world" that Leitner created at Woking, the celebration of Orientalist techniques, has been quietly but effectively appropriated by the needs of a community that Leitner would probably have found hard to imagine. This might be compared with what is currently happening to another product of Orientalism, the chain of bingo halls mentioned at the opening of this essay. First founded as a London smoking café in 1884, five years before the Woking mosque, Mecca in the 1990s was the object of several attacks and protests by Muslims in Luton who wanted to reclaim its name. Mecca's parent company, the Rank Group, was briefly forced to consider a change of name for this particular outlet.[12] Both of these instances of reclamation, of the name Mecca and of the Orientalist architectural trope, the mosque-as-image, might be seen to exist in what Michel de Certeau calls the form of "tactics."[13] They are both fundamentally local manipulations of the sign, enabling the less powerful to assert their interests as subjects of discourse. The appropriation at Woking was of a quieter yet more direct kind because here the forms of power/knowledge have been reclaimed by the ostensible objects of discourse even if a dualism still persists. Is this "Muslim space"? If so, and despite the fact that the mosque is too small effectively to house a fraction of its local worshippers, then it is a space that has come into being neither by physical alteration to

FIG. 2. The Central London Mosque, Regent's Park, London, 1969–1977.

the environment nor by changes in its function but instead by a kind of localized reinvention: a shift in the character of the signified without change to the nature of the sign; or to put it differently, the assertion of a socially constructed space or practice, to use Lefebvre's terms, rather than merely a representation of space. The mosque-as-image has become the mosque as testimony to the reclamation of colonial history for the diasporic Muslim.

Since its completion in 1977, the Central London Mosque in Regent's Park, London, has often been described as the most important mosque in Britain (Fig. 2). This is probably due to its declared intention of symbolizing accord between nations,[14] to its visibility in a prestigious location near the commercial and cultural center of London, the old heart of empire, and to the relatively high sums lavished on its building, including an international competition for its design and the employment of a prominent British architect. Yet its rhetorical use of a combination of the signs of modernity and traditionalism proved to be as unattractive to the professional architectural press as to certain sectors of the Muslim population.

Although the idea of a mosque had been mooted in the 1920s it was not seriously promoted until Nashat Pasha, Egyptian ambassador to London, and Lord Lloyd, former High Commissioner to Egypt, began to campaign for it during the Second World War. Lloyd argued that the project would help cement Muslim support for the Allied war effort. A site was purchased from British government funds in 1944 on the edge of Regent's Park, using an existing building for an Islamic Cultural Centre. In 1947 a trust was constituted from the ambassadors of thirteen Muslim governments, but various delays ensued including the withdrawal of Egyptian funds due to the Suez Crisis in 1956. When a design was eventually produced in 1959, the work of the Egyptian architect General Ramzy Omar, it was rejected by the London County Council and the Fine Arts Commission because it was deemed inappropriate to its context.

The tensions in this first design for the mosque continued when the project was relaunched in 1969. One site for expression of these tensions was the professional architectural journals in Britain, which reviewed the various designs, engaging and subsuming them into an unquestioned historicist view of architectural development. An international competition was launched in 1969 and attracted over fifty entries, the majority from Islamic countries.[15] No reviewer could find a worthy design among these entries, mainly, it seems, because none could be deemed to have fully reinterpreted the mosque tradition according to Western modernist principles. Even the most modernist design, the second-placed entry with a billowing shell dome and a soaring minaret by the Istanbul-based Yasar Marulyali and Levent Aksut, appeared to be legitimate only from the outside. In fact, so the *Architects' Journal* opined, "the most meaningful modern religious buildings are those which are rethought from the outside image inwards."[16] The measure here was not just the modernist notion of form being generated out of function but also a more recent radical and interdenominational movement that aimed to reappraise Christian church design in the light of modernist principles and that had received great support in the architectural press in the 1960s. This "new reformation" was critical of what it understood as the formal vestiges of merely conventional liturgy and symbolism in church design.[17] It aspired to make function and symbolism indissoluble; to place, as Reyner Banham explained it, "the conceptual stages of church design on the same intellectual and imaginative footing as applies in the most forward areas of secular architecture at present."[18] The mosque competition entries

FIG. 3. Competition design for the Central London Mosque, 1969. Architect, Sir Frederick Gibberd. *Architects' Journal,* 22 October 1969.

were also judged on these rationalist criteria, with reviewers discarding the many "exercises in intricate historical detail"[19] and vainly seeking a new design analysis of the functions of a mosque.

In this mode of interpretation, the winning design by Sir Frederick Gibberd was clearly a compromise between modernist and traditionalist approaches (Fig. 3). On the one hand, Gibberd had achieved a scenographic staging of Islam that matched the picturesque eclecticism of John Nash's stucco-faced terraces nearby: "The shade of Prinny . . . must delight in the prospect of a stately Indo-Saracenic dome floating over a cool white colonnade of Persian pointed arches among the planes of his royal park."[20] Implicit in this attitude was the common belief that Nash's architecture embodied a quintessential "Englishness," a native eclecticism summoning forth the genius loci safely distant from the more recent challenges of imperial decline. On the other hand, there were certain elements in Gibberd's design that, if not proclaiming a hard-edged modernism, were definitely modern. The large, initially clear glazing of the windows around the mosque and the precast concrete, standardly framed and fully glazed treatment of the elevations, even despite their four pointed arches, both give the clue to Gibberd's approach and certainly the way it was understood by these commentators. Here, not dissimilar to the new churches, was modular, extendable, and relatively open planning.

Gibberd provided auxiliary prayer spaces on three sides of the main hall as well as below it. He used modern construction and modern materials, and the mosque's exterior was claimed to be the direct expression of the plan. But here also was: decor. "Of course, you cannot put the decor to one side," bewailed the editorial in the *Architectural Review*. "It is not the fact that it is decorated that upsets us, or even that it is recognisably traditional in appearance, but the fact that there is no internal logic which ties the decor to the structure behind it. This makes it (at least for architects) a frivolous building."[21]

It was this very indeterminate position, neither wholly modern nor wholly respectful of tradition, that came up again and again in reviews of the Central London Mosque. Gibberd was accused of "pasticherie" and said to have "lost his nerve."[22] He had produced "a literal rendition of Islamic features . . . executed in a cardboard model style, [in which] structural elements are used to provide nonstructural symbolism, [with] arbitrarily selected patterns and forms from a variety of styles."[23] But it was also pointed out that the horseshoe-shaped gallery that, in Gibberd's winning design, originally projected over the prayer hall was a religious solecism, because in Islamic religious space women usually are not permitted to stand above or in front of men (Fig. 4).[24]

Behind all of these comments lie issues that are bound up with a more historically particular and a more political understanding of the production of space than the search for essentialism that underlies both Muslim space and a Saidian-derived critique of Orientalism. The mosque's design and construction period covers important changes in the political and economic relationships between oil-rich Middle Eastern states and oil-dependent Western countries. It could thus be seen, and indeed was seen at the time, as a building that represented the "gold rush" of British and other Western architects and construction companies working for Middle Eastern clients.[25] Indeed, it was regarded by some not just as a *product* of this gold rush but as representing the kinds of compromise that were bound to result from it. Furthermore, although its construction might be understood as a symbolization of religious tolerance and even political alliance, this was brokered over a set of more particular geographic interests. The clients, for instance, consisted of the various and changing ambassadors representing Muslim nations in Britain. The site, on Crown Property and zealously watched over by various conservation bodies, required that certain proprieties be observed. One result,

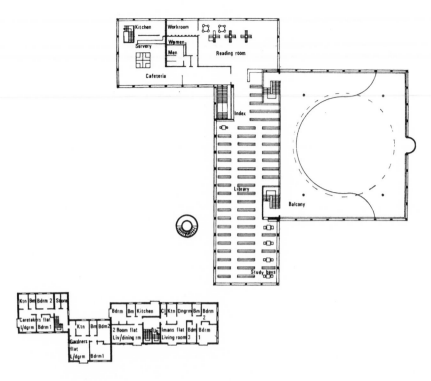

FIG. 4. Competition design for the Central London Mosque, 1969. Architect, Sir Frederick Gibberd. *Building,* 17 October 1969.

for instance, was the fact that although a minaret was built, no prayer would ever be called from it. Similarly, following the historical and architectural importance of Nash's nearby terraces, it was also argued that the mosque should be in character with Nash's work, that it should be disciplined within, or "mimic," this form of picturesque eclecticism and not challenge its boundaries.

One particularly interesting incident occurred around the issue of the orientation to Mecca required of any mosque. In the original brief Mecca was mislocated, and so Gibberd's design, following this misorientation, was placed right up against the building line. When the mistake was realized Gibberd had to rotate his complex on the narrow triangular site and win permission to break the building line (Fig. 5). At about the same time, the building committee—made up of the various Muslim ambassadors—decided that the mihrab or directional niche should not further impinge on the building line and therefore should not project outside the

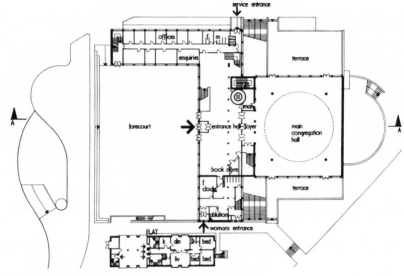

Ground floor plan.

FIG. 5. Revised design for the Central London Mosque, ground floor plan. Architect, Sir Frederick Gibberd. *Architects' Journal,* 10 August 1977.

main cube of Gibberd's prayer hall.[26] It was this decision, resulting in the design of a wooden mihrab that is not integrated into the building's structure, that has also led to unfair criticisms that the architect did not understand the role of the mihrab.[27]

This abandonment of the built-in mihrab indicates the most interesting of all the components that went into the making of the Central London Mosque. The decisive factor in the final appearance of the mosque was probably neither Gibberd's understanding of Islamic architecture, nor the influence of local property owners and conservation groups and their pressure to conform with the "genius of the place." Instead, the most influential of the interested communities was the extranational one represented and envisaged by the Muslim ambassadors. To focus on this influence is to move away from the binary oppositions that have dictated appreciation of the building and that present its designs as the result of several stark options: principles *or* pastiche; modernism *or* traditionalism; the West *or* the East. In a sense, the building is "ecumenical" in form and ageographical in its spatiality. Part of the brief required that "the Muslim community of London . . . be inspired by the visual effect of

the mosque as being reflective of traditional mosques in which they had worshipped in their own countries."[28] It also followed from this that, to satisfy disparate groups, Gibberd's winning design reduced its elements of cultural specificity, and these were further refined away by the building committee's recommendations. Among these, it was urged that the dome should be made more prominent and the minaret should not rise out of a pool but be joined more closely with the main structure (it also lost its specifically Turkish form in the first design), as well as the changes to the mihrab and balcony already mentioned.[29] Without such specifics, and with no desire to factionalize by embodying a fundamentalist view of Islamic practice, the Central London Mosque aimed for pan-Islamic symbolization through salient but generalized images of Islam. Thus the minaret had a signal function, but it was not that of the call to prayer but the *idea* of the call to prayer in Muslim tradition. In other words, a romantic, colonial-era Orientalism—the gilded dome, the rows of arches, and the minaret—had returned but for different reasons and these were also the cause of its uncanny effect. Arguably the mosque design was less about forging a dialogue between cultures, divergent traditions, or different religious practices, and more about proposing that there were no good grounds for *not* having such a dialogue; a temperate architecture, culturally and climatically. Either this or pretending that there was no need to have a dialogue because oppositions and differences had been erased.

An entirely different program, both in an architectural and an ideological sense, is manifested in the Mohammedi Park Masjid Complex, at present nearing completion in Northolt, a suburb of west London. The complex is located on an industrial estate backing onto the old Great West Road, one of the major routes out of London, and facing a park that separates it from much of the rest of Northolt's garden suburb (Fig. 6). At first sight, and from the road, its twin red sandstone minarets and domes add no markedly incongruous note to a scene already notable for its collection of 1930s factories and offices decked out in a variety of Art Deco mannerisms. Yet the complex is designed for and created out of a set of principles that are markedly distinct from this context of architectural pluralism, as well as implicitly critical of the Orientalist features that characterize both the Shah Jahan Mosque and the Central London Mosque.

The new complex in Northolt has been built by the Dawoodi Bohras,

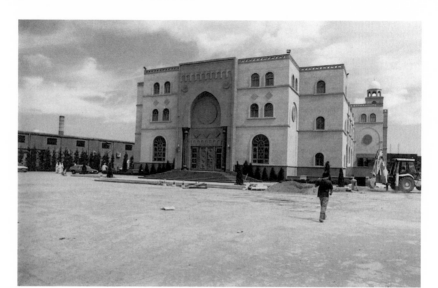

FIG. 6. Mohammedi Park Masjid, Northolt, London, 1989–1998.

an Islamic sect originating in Gujarat and living as dispersed communities and international traders. In their words "it stands testimony to the resilience of their faith regardless of environment, and it demonstrates their attachment to their new land of abode."[30] The architecture is to negotiate between a pre-modern transnational tradition and the spatial politics of the postimperial nation state, a negotiation that simply excises the formations of imperialism as an irrelevance and that sees the commitment to architecture as itself the sign of allegiance to the locality, while it reserves to architectural representation the role of re-evoking the physically mobile but ahistorical resilience of its faith. Unlike the other two mosques, then, the Northolt masjid simply disregards a modern (Western) dynamic as a necessary referent.

The masjid (or neighborhood mosque) at the center of the complex reiterates the continuity of tradition and the "global sacred geography" that is fundamental to the Dawoodi Bohras' view of religious architecture.[31] Although a relatively small population in Britain, where they number some four thousand, they are closely linked with similar communities in East Africa, North America, and, of course, India. Their architecture, however, derives from the medieval Fatimid architecture of Egypt, from which dynasty they also date the lineage of their sect. Many of the features

of the masjid, especially its twin minarets, its floorplan, its main portal, and such details as the medallions and columns, are inspired by tenth- to twelfth-century mosques in Cairo, and all are carried out by London builders and craftsmen. In this tradition, authorship, in the sense of an individual architect being the source or having responsibility for design, is not an issue—certainly not to the Dawoodi Bohras—and the generation of design concepts and the transformation of models are both rejected in favor of an image of organic evolution. Mixed with features from Tunisia and Mamluk Egypt, the original Fatimid type is passed down, with the architects and builders acting as a medium for its passage to the present and the leader of the sect approving any changes to the inherited typology. The "heresy of modernism" is rejected, and this includes its architectural forms among its other social and religious effects.[32] The architecture of the Central London Mosque, with its attempt to modernize the ties of empire, is distrusted by the Dawoodi Bohras in contrast to their own postmodern vision of tradition. In many ways, then, the architecture of the Northolt masjid exemplifies a restorative project where imperial and postimperial ties and formations, as well as any logic of multiculturalism, are all set aside in favor of longer historical and cultural frameworks.

The masjid at Northolt is the centerpiece of a complex of buildings that carve out a small Islamic enclave in this part of London. Around the mosque are twenty-two houses in two terraces arranged so that they create a gateway into a square dominated by the masjid. The houses themselves provide a perimeter wall around the two exposed sides of the complex, turning their backs on the industrial estate and nearby park. Apart from this they are unexceptional designs, typical of the bricky neovernacular and nuclear family image that became a widespread developer's idiom in the 1980s, but adapted internally to the extended families of the Dawoodi Bohras.

A glance at the history of the complex may provide an explanation for this image of an embattled community turning in on itself.[33] In 1983 the Dawoodi Bohras acquired a youth center in Boston Manor, a few miles from Northolt. Applications to erect a masjid on this site were rejected by the local council, following pressure from white neighbors. In 1986 the new Labour-controlled administration agreed to buy this site in exchange for another, hopefully less contentious one. It was then that the community found the disused site on the industrial estate at Northolt, and two years later planning permission was granted for the construc-

tion of the new complex. However, in the following year and after the foundation stone had been laid, local residents led by active British National Party members in the area protested against the use of industrial land for building a masjid. The protestors—a coalition of residents, businesses, and their employees using the industrial estate, and even local estate agents concerned about property values—attacked the intended complex for its "alien" character and the threat it posed of extending the nearby "Islamic ghetto" of Southall into Northolt's garden suburb.[34] Construction was stalled for two years until the injunction was rejected by the High Court in 1991. The incident exposes, even more than the Central London Mosque, the transgressive character of the translation of culture through architecture but also the constantly negotiated position of mosques, both newly built and adapted from existing buildings, in relation to the planning system. The claims for an architecturally inscribed identity may conflict with "the cultural codes and preferences of the dominant social group" as they are inscribed in the hegemonic functioning of normative values and bureaucratic forms within the planning system.[35]

The inward-looking nature of the Dawoodi Bohras' complex can be seen, then, as a focusing of its identity on its communal buildings but also as a defensive reaction against the kinds of protest that dogged its attempts both to find a site and to establish a masjid on that site. Those white residents who protested against the sites in Boston Manor and Northolt clearly perceived an unfamiliar and threatening reorientation of space, an "alienation" of British land in the metropolitan "center" following the same process abroad in the colonial "periphery." For them a concept like Muslim space would actually serve to encapsulate their fears. An entity is thus brought into existence by being given a quasi-academic status that has no status in legal, bureaucratic, religious, or even cultural terms. The rights of any individual or community to work through the legal system and local planning laws to establish their architecture—which the Dawoodi Bohras have successfully done at Northolt—may not be helped by such a concept. Equally, perhaps, an approach to diasporic architecture that overvalues its transnational aspects can take attention away from its subjection to the local inequalities of race and class.

The three mosques discussed here are not typical of mosques in Britain; indeed, the very idea of a typical British mosque or a typology of Muslim space in the diaspora is exactly what this essay has demonstrated does not and cannot exist.[36] To pursue this complex situation further, and to gain insight into how both the urban landscape of Britain and the imaginary nation-space have been affected by it, would call for an analysis that is open to the readings offered by postcolonial theory. By such means we might explore the grounds on which the production of space is riven by "conflicting 'territories of meaning,'" precisely because the signifying functions of these localities are bound up with imperial and postimperial histories.[37] There is no easy transition, however, into theorizing this architecture as postcolonial space. Apart from the fact that the major postcolonial theorists, such as Edward Said, Gayatri Chakravorty Spivak, and Homi Bhabha, have not written on architecture, and only obliquely and with suspicion on spatiality, there is also the problem that their interest has largely been in the discursive formations of colonialism and the cultures of resistance to these formations. How can we position British mosques in relation to these two areas of interest? How can we see them as of cultural rather than just sociological importance? What insights can be gained from theorists whose writing, premised on a radical secularism, has yet to show interest in the ways that the architectures of religion themselves offer radical difference and implicit critique?

Perhaps the most relevant essays on postcolonialism, though they operate obliquely to the concerns of this essay, are those written by Bhabha since 1988. In this second phase of his work Bhabha has moved from colonial discourse analysis as a questioning of the binary of colonizer and colonized found in Said's *Orientalism* and toward the ramifications of neo-colonialism and the inherited effects of racial discourses in contemporary culture.[38] In particular, though Bhabha is more likely to read *The Satanic Verses* than look at mosques, these recent writings have been concerned with how the regimes of modernity are intersected by the temporalities of minority discourses.

Bhabha's 1992 essay "The Postcolonial and the Postmodern: The Question of Agency" helps us to locate several problems. One thing we learn from the mosques of the diaspora, perhaps most especially in the old imperial homeland of Britain, is how, in Bhabha's words, "contingency as the signifying time of counter-hegemonic strategies is not a celebration of 'lack' or 'excess' or a self-perpetuating series of negative ontologies."

To cite Bhabha again, there is "not simply a change of cultural contents and symbols; a replacement within the same time-frame of representation is never adequate." To challenge and remake dominant cultural discourses, Bhabha argues, "requires a radical revision of the social temporality in which emergent histories may be written, the rearticulation of the 'sign' in which cultural identities may be inscribed." The time of the national imaginary is questioned by the newer discrepant temporalities of the diaspora. It follows, then, that several established modes of analysis need to be set aside: first, the diaspora mosque as index of a temporally discrete cultural identity; second, the mosque as an outside or "exotic" contribution to some fundamentally unchanged host culture with its "ordered *musée imaginaire*"; third and fourth, following from the first two, both a temporal, "historical" analysis that lacks a spatial dimension *and* an analysis of spatial and global forces that neglects culture's dialectical relation to history. In other words, the formulation of culture that is most relevant here is that of "an uneven, incomplete production of meaning and value, often composed of incommensurable demands and practices, produced in the act of social survival."[39]

It is not enough to say, as have some recent writers on the subject, that the diaspora mosque is "a repository of identity and authenticity for those who have found themselves distanced from their home countries." Not enough, in part because it still presumes a split East-West world, but in part too because of its presumption of identity as something whole and already achieved, locatable and easily acquired. Nor is it enough to claim, perhaps in relation to the Central London Mosque, that "identity has come to be increasingly represented in hybridized, 'creolised' forms in today's post-modern climate."[40] This glosses over the deep ambivalence of hybridity: its dependence on an older colonial production of knowledge and its inescapable tethering to the inverse presumption of purity.[41] By contrast, Bhabha's work forces a critical shift, a dissolution of the binary in favor of a reemphasis on the *constructing* of culture and the *inventing* of tradition in the very articulation of the sign. Culture can then be seen as an "enactive, emancipatory site" rather than an "epistemological object."[42] Architecture, one might add, as one of the most important sites for the contestation of identity, is crucial to these processes of reimagining.

What is glimpsed in Bhabha's 1992 essay can be explored further through his essay of 1994: "How Newness Enters the World: Postmodern

Space, Postcolonial Times and the Trials of Cultural Translation." Here the "'transitional' reality" and the "'translational' phenomenon" of post-colonial migration and settlement become the twin signs under which a new poetics of the interstitial might be realized.[43] For this sense of the interstitial, or a newly conceptualized *inter*national culture, we need to return to Bhabha's conception of the "Third Space" discussed in his earlier work. It is this conception that articulates his critique of the synchronous and evolutionary frameworks that establish a normative subject of culture. Instead, Third Space "challenges our sense of the historical identity of culture as a homogenising, unifying force, authenticated by the originary Past, kept alive in the national tradition of the People."[44] Third Space is, then, both a claim to describe society more clearly and a project of social change. Because it stands for ambivalence in the act of interpretation and intransitivity in the utterance, Third Space emphasizes the way cultural symbols and meaning can be "appropriated, translated, rehistoricised and read anew."[45] It enables us to understand cultures of the diaspora outside both the grid of liberal relativist multiculturalism and the production of knowledge about the surveyed essentialized colonial object that is the disciplinary force in Orientalism. Instead, Third Space is a culture that constantly rehearses the impossibility of its own containment as culture, its status at the borderline between cultures.

The transitional and translational aspects of the interstitial as elaborated in "How Newness Enters the World" indicate how the postcolonial colludes and collides with globalization: from Lahore via Gatwick to Woking, or perhaps from Northolt to Bombay via Riyadh. Bhabha points to the anxiety that must be figured into the attenuation of local space by the transnational, most notably as communities are reimagined in the light of migration and settlement. To paraphrase, living between atavism and metropolitan assimilation, the very problem of translation in the subject of postcolonialism also offers an "element of resistance" to transformation within either "the assimilationist's dream, or the racist's nightmare."[46] What is counterhegemonic is thus seen to be as much a matter of acts of interpretation and the potential of mobile interpretative positions as of fixed cultural forms.

The diaspora mosque is one of the most visible but also one of the most disjunctive and inassimilable manifestations of the colonial, the other,

within the metropolis. If, as James Clifford suggests, "the nation-state, as common territory and time, is traversed and, to varying degrees, sub-verted by diasporic attachments,"[47] then the mosque embodies one of the most visible articulations of diaspora identity in built form. The con-tingencies described in these three mosques—the appropriation of the representation of otherness, the re-invigoration and re-direction of old Orientalist tropes, and the contestation over land between rival groups and different notions of community and continuity—demonstrate how an older set of Western conceptions of the mosque can be shifted and displaced while issues of power remain central. There is no claim here that diaspora mosques are created as, in some way, critical of the soci-eties where they are placed, though just such a claim could be made from a fundamentalist position. Nor would I want to claim that they embody a critique of Western representations of the East.[48] While religious space should not be privileged as beyond considerations of power and repre-sentation, there are limits that need to be recognized in the relevance of the secularist ideal within postcolonialism. Rather than any engagement with forms of contestation, diaspora mosques may offer anything from conciliation to an apparent disregard of the majority culture. Almost un-avoidably, then, diaspora mosques are overdetermined cultural forms. At once both stereotypical and symptomatic, they represent "the locus and locution of cultures caught in the transitional and disjunctive temporali-ties of modernity."[49] The presentness of these mosques, however, and the very diversity of issues and resolutions they represent, help us to see how the colonial moment and its postcolonial effects can be written back into and across the time and space of modernity.

Notes

1 I would especially like to thank my editors and Helen Hills for their close reading of earlier versions of this essay and many suggestions. Thanks also to Michael Heb-bert, Peter Kohane, Robert Home, Nazar-e-Mustafa, and Ali Asghar Zainuddin. Three recent accounts of the mosque are relevant here: Martin Frishman and Hasan-Uddin Khan, eds., *The Mosque: History, Architectural Development and Regional Diversity* (London: Thames and Hudson, 1994); Ismaïl Serageldin and James Steele, eds., *Architecture of the Contemporary Mosque* (London: Academy Editions, 1996); Renata Holod and Hasan-Uddin Khan, *The Mosque and the Modern World: Architects, Patrons, and Designers since the 1950s* (London: Thames and Hudson, 1997).

2 Barbara Metcalf, ed., *Making Muslim Space in North America and Europe* (Berkeley: University of California Press, 1996), 6.

3 Henri Lefebvre, *The Production of Space,* trans. D. Nicholson-Smith (Oxford: Blackwell, 1991), 296.

4 Ibid., 296–97.

5 See J. Abu-Lughod, "The Islamic City: Historic Myth, Islamic Essence and Contemporary Relevance," *International Journal of Middle East Studies* 19 (1987): 155–76; and Aziz Al-Azmeh, "What is the Islamic City?" *Review of Middle East Studies* 2 (1977): 1–12.

6 Homi Bhabha, "Culture's In-Between," in *Questions of Cultural Identity,* ed. Stuart Hall and Paul du Gay (London: Sage, 1996), 54.

7 See Mark Crinson, *Empire Building: Orientalism and Victorian Architecture* (London: Routledge, 1996), chap. 4.

8 Edward Said, *Orientalism* (New York: Pantheon, 1978), 121.

9 *Times* (London), 27 August 1884.

10 Ibid.

11 For a contemporary illustration, see *The Building News* 57 (2 August 1889): 144.

12 *The Guardian,* 7 January 1998; information from Debbie Catt.

13 Michel de Certeau, *The Practice of Everyday Life,* trans. Steven Rendall (Berkeley: University of California Press, 1984), 15–44.

14 The land was given by the British government in 1940 to reciprocate the gift of a site by the Egyptian government for an Anglican cathedral (Holod and Khan, *The Mosque,* 230; Serageldin and Steele, *Architecture,* 165–66).

15 See *Architects' Journal* 150 (22 October 1969): 988–90.

16 Ibid., 990.

17 Peter Hammond, ed., *Towards a Church Architecture* (London: Architectural Press, 1962), 11. See also Peter Hammond, *Liturgy and Architecture* (London: Barrie and Rockliff, 1960). In the Anglican Church this was simply known as the Liturgical Movement.

18 Reyner Banham, "A Modern Church on Liturgical Principles," *Architectural Review* 128 (December 1960): 400.

19 *Architects' Journal* 150 (22 October 1969): 990.

20 Ibid., 989.

21 *Architectural Review* 162 (September 1977): 145.

22 *Home and Garden* 32 (September 1977): 70; *Building* 233 (15 July 1977): 48.

23 *Architects' Journal* 166 (10 August 1977): 269.

24 *Building* 233 (15 July 1977): 48.

25 See *Architects' Journal* 162 (13 August 1975): 326–30; *Royal Institute of British Architects' Journal* 83 (June 1976): 14–17; *Building Design* 354 (8 July 1977): 8–9. It was even reviewed in *Middle East Construction* 2 (May 1977): 55–59.

26 *Architects' Journal* 166 (10 August 1977): 266.

27 *Times Higher Education Supplement* (London), 9 January 1998.

28 *Architects' Journal* 166 (10 August 1977): 259.

29 Ibid., 266.

30 Mohammedi Park brochure, July 1996.

31 Metcalf, *Making Muslim Space,* 18.

32 T. A. Davoodbhoy, *Faith of the Dawoodi Bohras* (Bombay: Department of Statistics and Information, 1992), 4.

33 The following discussion is partly based on John Eade, "Nationalism, Community and the Islamization of Space in London," in Metcalf, *Making Muslim Space.*

34 Ibid., 228.

35 Robert Home, "Building a Mosque in Stepney: Ethnic Minorities and the Planning System," *Rising East* 1 (1997): 59; see also Huw Thomas, "'Race,' Public Policy and Planning in Britain," *Planning Perspectives* 10 (1995): 123–48.

36 The best-known example of a mosque reusing older religious space in Britain is in Brick Lane, East London. This mosque took over a building that was originally erected in the late seventeenth century as a Huguenot church, used as a Methodist chapel in the nineteenth century, then converted into a Jewish synagogue in 1898, and from 1976 taken over by the local Bangladeshi community; see Jane M. Jacobs, *Edge of Empire: Postcolonialism and the City* (London: Routledge, 1996), 70–102; Eade, "Nationalism," 218–23. Of the six hundred or so mosques serving some 1.5 million Muslims in Britain, only about 150 are purpose-built. Of the rest, many have adapted residences for religious purposes, and others have taken over church buildings, cinemas, or factories (*The Guardian,* 20 March 1996). The numbers are difficult to estimate accurately; see Home, "Building a Mosque," 66.

37 Ibid., 60. See Jacobs, *Edge of Empire,* 34–35.

38 For discussion of these two phases in Bhabha's work, see Bart Moore-Gilbert, *Postcolonial Theory: Contexts, Practices, Politics* (London: Verso, 1997), 114–51.

39 Homi Bhabha, *The Location of Culture* (London: Routledge, 1994), 171–72.

40 Holod and Khan, *The Mosque,* 12.

41 Although he is aware of this ambivalence, Bhabha uses hybridity as a term of value — something that reverses the terms of colonial power. For an analysis of the problems in this formulation, see Robert Young, *Colonial Desire: Hybridity in Theory, Culture and Race* (London: Routledge, 1995), especially 22–28. It is these problems with the term hybridity that have led me to prefer the concept of the interstitial or Third Space in my use of Bhabha.

42 Bhabha, *Location,* 172, 178.

43 Ibid., 224.

44 Ibid., 37. See also Edward Soja, *Thirdspace: Journeys to Los Angeles and Other Real and Imagined Spaces* (Oxford: Blackwell, 1996), 139–44.

45 Bhabha, *Location,* 37.

46 Ibid., 216, 224.

47 James Clifford, "Diasporas," *Cultural Anthropology* 9 (1994), 307. In adopting the term 'diaspora' of the Muslim population in Britain I recognize that the term now extends beyond the sense of national dispersal to encompass the experiences of immigration and displacement among communities of refugees, exiles and expatriates, even the waxing and waning of diasporism as allegiances change. In using this term one is

indicating shared experiences of separation and transnationalism (what James Clifford calls "multi-locale attachments") *across* the highly differentiated elements of the Muslim population in Britain. On this and other issues, Clifford insists on the "routing of diaspora discourses in specific maps/histories" rather than the use of the diaspora as a master trope for the displacement of modern identities. See also A. Brah, *Cartographies of Diaspora: Contesting Identities* (London: Routledge, 1996).

48 See John Biln, "(De)forming Self and Other: Toward an Ethics of Distance," in *Postcolonial Space(s)*, ed. G. B. Nalbantoglu and C. T. Wong (New York: Princeton Architectural Press, 1997).

49 Bhabha, *Location*, 251.

EARTH INTO WORLD, LAND INTO

LANDSCAPE: THE "WORLDING" OF ALGERIA IN

NINETEENTH-CENTURY BRITISH FEMINISM

Deborah Cherry

The climate is delicious[,] the sea & distant mountains more beautiful than words & pencil can express & then the new vegetation & the new animals[,] the wonderfully picturesque town & people give one so much to do with one's 6? senses . . . I did not expect anything half so wonderfully beautiful as I find. I never saw such a place! . . . I can't draw it in the least. . . . The place intoxicates one.[1]

Visiting Algeria for the first time in the winter of 1856, Barbara Leigh Smith (later Bodichon, 1827–1891) put her first impression on paper for her women friends. At the outset of her career as an artist, she illustrated her letters copiously. To Marian Evans (the novelist George Eliot) she wrote of a country that was at once "ravishingly beautiful" and almost impossible to draw or paint.[2] Her correspondence narrated a desiring subject who confessed to a heady intoxication by sensations outside feminine and artistic respectability.[3] Desire oscillates with denial, seduction with repudiation. Although Algeria is picturesque and pictorial, it is impossible to draw or paint. Captivated by its mystery and exoticism, the writer struggles with Algeria's intractability, its resistance to visual representation. Algeria was perceived not so much as different from the West as beyond its frames of reference, despite, or perhaps because of, the visual spectacle and artistic compositions it offered.

The twin themes of this letter — the formation of subjectivity and the

project of representation—set the ground for this essay on the "worlding" of Algeria in the writings and images of a group of nineteenth-century British women. They holidayed and over-wintered in Algiers, traveled extensively, wrote tourist literature, and sent their paintings and watercolors to London galleries. In Britain they campaigned for the equal opportunities and political and civil rights of Western women. Their views on Algeria were published in the feminist paper *The English Woman's Journal,* the title of which proclaimed a distinctly insular identity. Advocating paid work for middle-class women, these activists embarked on careers in art and sold their pictures of Algerian scenes to fund feminist causes in Britain.

Not so much an oppositional "other," Algeria was everywhere in mid-nineteenth-century feminist discourse. Polarized divisions between (Near) East and West, here/there, colonizer/colonized are of little assistance in coming to terms with the connections between British feminism and what was then a French colony. These often oblique and tangential relations may be more usefully approached through the "logic of the supplement." Alluding to its double meanings of addition and replacement, Jacques Derrida has proposed that the supplement is dangerous, its movement one of violence, fracture, and interruption.[4] To bring Algeria into conjunction with Western feminism is to destabilize its isolationist histories and preoccupations. To locate British feminism in Algeria is to take account of its supplementarity, imported with French colonialism yet not part of it, while acknowledging its complicity with what Gayatri Chakravorty Spivak has identified as "the planned epistemic violence of the imperialist project."[5]

In picturing Algeria as a far-distant and inaccessible place of secrecy, opacity, and illegibility and as a colorful and strange location under the sway of Islam (Fig. 1), the scattering of images and texts discussed here[6] contributed to the staple themes of European Orientalism.[7] Less concerned with grand narratives, the focus here is a microhistory of localized dis/articulations among feminism, imperialism, and visual culture.[8] Moving away from art historical discussions that cede priority to representations of the body and sexuality[9] allows an address to the politics of landscape. My discussions of the (re)inscription of colonial space and the location of visual culture in the violence of imperialism draw on Spivak's concept of the imperial project as "worlding," Derrida's concepts of framing, and Homi Bhabha's analysis of the ambivalence of colonial authority.

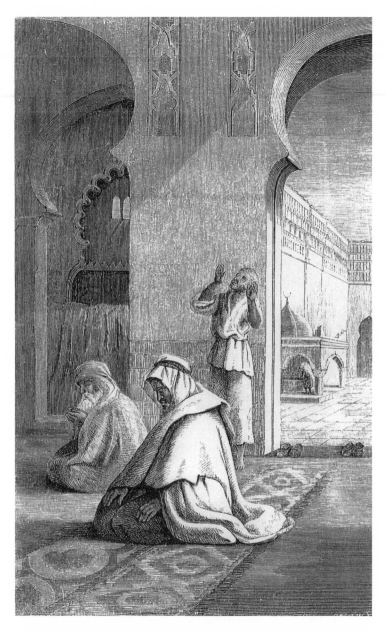

FIG. 1. Eliza Bridell Fox, *Arabs at Prayer,* frontispiece to Matilda Betham-Edwards, *A Winter with the Swallows,* London, 1867. The British Library, London.

Like so many other British and French representations of North Africa, the cultural productions of these women artists and writers disavowed the devastation and genocide of the 1830s and 1840s and the massive environmental transformations of the midcentury. Yet, fashioned from diverse European and Maghrebi elements, these uneasy, hybridized views signal something of the resistance of a land that remained in excess of its Western representation, and they register a precariousness and instability at the heart of the imperial project.

Worlding

In conversation with Elizabeth Grosz in 1984, Gayatri Chakravorty Spivak spoke of "the notion of the worlding of a world on a supposedly uninscribed territory." She continued, "When I say this, I am thinking basically about the imperialist project which had to assume that the earth that it territorialised was in fact previously uninscribed. So then a world, on a simple level of cartography, inscribed what was presumed to be uninscribed. Now this worlding actually is also a texting, textualising, a making into art, a making into an object to be understood."[10] An extended account in "The Rani of Sirmur: An Essay in Reading the Archives" (published in 1985) elaborated on worlding as central to and formative of "the planned epistemic violence of the imperialist project." Spivak drew on an essay by Martin Heidegger which suggested that the work of art emerges in the conflict between earth and the world. Taking up the philosopher's assertion that this conflict is more than "a mere cleft . . . ripped open" and his emphasis on "the intimacy with which opponents belong together," Spivak explained the German word *Riss* not as a neutral interval or empty space, but in terms of "the violent implication of a fracture." She thus proposes that the work of art is produced within the chasm generated by imperialism between the already existing society and culture and the new order.[11] In the imperial context, the work of art is not so much a product of ideology as a product of violence, born of a collision between two epistemes. Spivak's analysis thus breaks new ground in theorizing cultural violence, the relations between culture and imperialism, pushing beyond Linda Nochlin's compelling argument that the barbarity of colonial conquest, imaged in numerous battle paintings in the 1840s, was transferred in subsequent decades to images of native

cruelty and destruction and W. J. T. Mitchell's provocative contentions that landscape is intimately connected to imperialism.[12] Spivak's theory of worlding suggests that violence was not so much the precondition or pre-text to visual culture as integral to its making, for it was in the "planned epistemic violence of the imperialist project" that earth was transformed into world, land into landscape.

Spivak's concept of worlding engages a double inscription: that which physically changes the land and the inscription of a visual culture that erupts from traumatic conflict. Landscape, that category of visual representation concerned with the transformation of earth into world, land into art, may thus be perceived as central to the Western imperial project along with the seizure, settlement, and alteration of land. For Edward Said imperialism means "at some very basic level . . . thinking about, set-tling on, controlling land that you do not possess, that is distant, that is lived on and owned by others."[13] And many postindependence historians of Algeria have confirmed that it was on land that the violences of im-perialism and colonization were enacted. The Algerian environment, its physical and geographic appearance, was dramatically changed. Land as-sets were stripped through cantonment, mining, deforestation, and the introduction of intensive agriculture for colonial markets. The ecology of the region was drastically altered by the introduction of European plants, animals, and diseases as well as by new transport infrastructures. Existing species were seriously depleted and soil structures fundamen-tally changed by European systems of farming and cropping. Colonial land policies devastated the existing and highly complex forms of land ownership and property relations, disposing of the belief that land was not a commodity for purchase or sale and assigning it to private owner-ship by individuals and corporations, most of whom were European.[14]

Visual (re)inscriptions and framings of space and time were necessary to imperialism's projected control over land. With environmental trans-formation came an extensive range of cultural activities and products, for in Algeria as elsewhere, invading armies were quickly followed by surveyors, archaeologists, geographers, and artists.[15] In the processes of colonization, Algeria became the mise-en-scène of a flood of paintings, watercolors, souvenir prints, and, by the 1850s, photographs. Tutored amateurs as well as holidaymakers with no known propensity for sketch-ing turned Algeria's sites into sights. Guidebooks in French and English

were profusely illustrated and utilized a markedly pictorial language. Illustrated publications on Algeria and French North Africa with titles such as *L'Algérie pittoresque* dramatically increased, as did maps and charts, archaeological reports, and pictorial histories like *L'Afrique française (illustré)* of 1846, replete with full-page reproductions of fine art prints and paintings.[16] This commodification, which turned Algeria into a seemingly endless visual spectacle, generated an extensive range of consumer products that could be bought and sold on a world market along with the goods of the newly introduced industrial and agricultural processes: fine art provided not only cultural capital, but objects for trading and investment, things that had a social life.[17] As Spivak emphasizes in her discussions of worlding, the new imperial cartographies were not simply two-dimensional surfaces; they had, she insists, material form and substance. What emerges from the violence of the rift is "the multifarious thingliness [*Dinglichkeit*] of a represented world on a map."[18] This emphasis on the materiality of the object recalls her earlier words to Elizabeth Grosz, that "this worlding is actually a texting, textualising, a making into art, a making into an object to be understood." To extend her analysis, worlding equally involved the production of things, such as works of art, and the production of "understanding," which included the global circuits of distribution and exchange of the nineteenth-century art markets as well as the mediating work of critics, dealers, and exhibitions.

"a texting, textualising"

From the French invasion of 1830 Algeria was promoted as a new holiday destination and a winter health resort; according to Timothy Mitchell, "From its opening act of violence European colonization of the Middle East began to involve the new tourist industry."[19] By the 1850s British artists and writers were visiting and settling in Algiers, joining an expatriate community well-established by the end of the century and promoting it as a tourist destination and artistic resource. Holidaying there with her family in the winter of 1856–1857, Barbara Leigh Smith met and soon married a French *colon,* Eugène Bodichon, whose writings contributed to the development of French imperial policy. Friends came to stay: the artists Eliza Fox and Sophia Lady Dunbar, the feminist activist and coeditor of *The English Woman's Journal* Bessie Rayner Parkes, the travel writer Matilda Betham-Edwards, and the artist and gardener Gertrude

FIG. 2. Annie Leigh Smith, *BRP at the Campagne du Pavillon,* ca. 1860, ink on paper, 170 × 115 mm. The George Eliot and George Henry Lewes Collection, The Beinecke Rare Book and Manuscript Library, Yale University, New Haven.

Jekyll, whose planting schemes owed much to her visits. New members of the women's movement, including Emily Davies (to become first Mistress of Girton College Cambridge), were recruited here. Letters, publications, artwork, and travelers shuttled north and south. A drawing of Bessie Rayner Parkes at the Bodichons' house on the outskirts of Algiers shows her surrounded by European books and papers, including the *Journal* (Fig. 2). Shared interests in Algeria helped to cement a diverse community. Correspondence reported on campaigns in Britain and told of discussions in Algeria for feminist journalism, premises for women's organizations, and the founding of a Ladies Reading Room in central London.[20] Turning travel into text with remarkable alacrity, writings were quickly placed in general interest magazines, the art press, and *The English Woman's Journal.* A guidebook compiled by Barbara Bodichon, *Algeria Considered as a Winter Residence for the English,* was published at the offices of the *Journal* in 1858.[21] Betham-Edwards recounted her excursions

to and in Algeria, illustrating them with reproductions of artworks by her companions (Fig. 1).

In the 1850s fine art was one of the few occupations open to middle-class women; several combined professional practice of oil painting or watercolors with an active support for the campaigns for women's rights. Bodichon specialized in landscape, and despite her claim to Evans, quoted at the opening of this essay, she made hundreds of Algerian studies. Comprising probably over one third of her artistic production,[22] these subjects were worked up for exhibition and sale in public and dealer galleries in London as well as at the Ladies's Reading Room. Trading on the cachet of her married name, she exhibited at the French Gallery run by the dealer Ernest Gambart.[23] Her work seems to have sold well: a solo show at this venue in 1861 was sold out at the opening.[24] Eliza (Bridell) Fox (?1824–1903) took up Algerian subjects on a protracted visit to Bodichon in the mid-1860s. The two friends shared much in these decades: joint exhibitions of their Algerian works and an active commitment to women's rights, legal reform, and enfranchisement. Their reputations as artists, like that of another friend, painter, and feminist supporter, Emily Mary Osborn (1834–after 1909), were, in varying ways, indebted to their North African subjects. Sales generated funds which enabled individual independence as well as the funding of feminist campaigning and projects such as the *Journal* and Girton College Cambridge, the first British institution of higher education for women.[25] Their work visualized a recently colonized land, less for its colonizers than for an educated middle-class market in London, well-informed on events taking place. The British press provided detailed coverage and comment on Algeria as well as regular features on the pleasures of travel and tourism. Debates on French colonization and denunciations of French brutality stirred up an intense nationalism as well as a sense of imperial superiority.

Feminist Subjects in the Landscape

In the pages of *The English Woman's Journal,* Algeria was advocated as "a new field of exploration" to that novel tourist, the traveling feminist: "English ladies, as we ourselves have tested, may ride, walk, or sketch alone, with as much impunity as they might in the heart of old England."[26] Feminist pleasures of walking and riding, viewing and sketching landscape were, along with artists' materials, carried from Europe to North

FIG. 3. Barbara Leigh Smith Bodichon, Drawings included in a letter to Marian Evans (George Eliot), 21 November and 8 December 1856, ink on paper. The George Eliot and George Henry Lewes Collection, The Beinecke Rare Book and Manuscript Library, Yale University, New Haven.

Africa. Barbara Bodichon, her sisters Annie and Bella, and Bessie Rayner Parkes went out on walks and sketching expeditions. *Algeria Considered* and articles in the *Journal* related their adventures. Sketchbooks and letters were filled with drawings of Western women whose outdoor activities as much as their costume of loose jackets or capes, unsupported skirts, broad-brimmed hats, and sturdy boots or shoes identified them as feminists whose attire was to be differentiated from the tight bodices and full crinolines of aristocratic ladies (Fig. 3). In Annie Leigh Smith's drawing Parkes wears a short jacket with a hood, the distinctive dress of men in Kabylia. This little sketch, laid down on letter paper and sent to Marian Evans,[27] indicates the matrix of pleasures discovered in Algeria: cultural and gendered cross-dressing, contemplative reading, and the ocular delights of a panoramic vista (beyond lies the bay of Algiers) of the kind routinely celebrated in tourist literature.

In letters as well as published writings colonial space offered Western women an unchaperoned freedom of movement. In Algeria a feminist bid for independent mobility, a key concern in the 1850s, coincided with the Western voyager's fantasies of solitude. Yet "alone" was a slippery word and may not have meant unaccompanied. Nineteenth-century travel writings sustained a hallucination of aloneness by overlooking the native or Western guides employed to furnish itineraries, accompany visits, point out the sites, and translate to and from Arabic and/or French.[28] As Spivak affirmed in her analysis of worlding, the experience of landscape, of riding through, looking at, and reporting on land was structural to the European concept of the sovereign self. In Algeria it was similarly formative of the "female militant subject."[29] Romantic notions of an immersion in nature facilitated a saturation in sensation, scenery, and self. Drawings depicted a single figure striding alone across the countryside, gazing over promontories, sketching, or racing on horseback over a beach (Fig. 3). Letters and essays described solitary wanderings in "wild hills" and "scented glens." In Parkes's essay of 1861 on working women, closely argued prose suddenly gives way to an account of a ramble through "a ravine of the most beautiful and romantic description" on the outskirts of Algiers: "It winds about among the steep hills, its sides clothed with the pine, the ilex, the olive, and with an underwood of infinite variety and loveliness. Wild flowers grow there in rich profusion, and under the bright blue sky of that almost tropical climate it seems as if anything so artificial and unnatural as our systems of industry could hardly exist for shame; yet in that very valley young female children are at this very moment, while I speak and you listen, winding silk for twelve clear hours a day!" The vision of "untrammelled nature" is abruptly displaced by the sight of a French-owned silk-winding enterprise. Confronted with "what perhaps in Europe might never strike the heart with equal vividness," the narrator abandons lyrical description for dry irony. She concludes that "our modern civilisation is in some respects a very singular thing when the kind hearts of a great nation best show their kindness to orphan girls by shutting them up to spin silk at a machine for twelve hours a day from the age of thirteen to that of twenty-one."[30] The colliding forces of the text—intense visual, corporeal, and sensory pleasures, pity for the native women and concern for their working conditions, measured criticism of imperial exploitation—are held together by a narrating subject who recounts her sensations and who reflects that, "whenever in after spring

days I walked over the wild hills and scented glens of Algiers," she would recall what she had seen.

The "female militant subject" was thus doubly formed, in relation to landscape and, as Spivak has argued, in "shifting relationship" to the "native female."[31] The responses to native women by British feminists were certainly changeful, over time and within the group. Both Parkes and Bodichon took an interest in a school for Algerian girls and young women run by Mme Eugènie Luce which received intermittent funding from the French government. Discussed at length by Parkes in the *Journal,* Luce was hailed as a pioneer of women's education in Bodichon's *Women and Work,* a long essay advocating paid employment for middle-class women. Written in Algeria in the winter of 1856–1857 it incorporated a first-person account of the school which asserted that Algerian women were illiterate, indolent, and fat, characterized by "utter debased ignorance," suffering from "religious and social tyranny," and wasting their days in an "idle slovenly existence." Such claims fueled assertions that they were in need of an education that would turn them into "rational and responsible beings" and productive laborers. For a short period the pupils at Mme Luce's were employed as needlewomen in a workroom attached to the school, and there was a proposal for the handkerchiefs they made to be sold at the feminist premises in central London.[32]

British activists affirmed their own independence by representing women of the Arab world as surrounded by "a multitude of restrictions" and "allowed . . . no freedom."[33] As far as can be discerned, these campaigners had little direct contact with Algerian women; their approach was oblique, made through Mme Luce, Eugène Bodichon, and the wife of the French governor-general, who "rendered Mrs Bridell [Fox] much assistance in obtaining insight into the native Arab life."[34] None of them spoke Arabic, although Bodichon learned French. Although Parkes regretted arranged marriages and female illiteracy, she respected the proprieties of the veil, which was, by contrast, deemed immodest, impure, and deceitful in *Women and Work.*[35] And whereas Parkes considered Algerian women to be "intelligent," Bodichon publicized her husband's views of their "barbarous state." Increasingly allied with French colonial society, she supported French Catholic philanthropy, collected cultural artifacts, and, as the owner of substantial property in a smart suburb of Algiers, dabbled in environmental transformation, with her husband planting eucalyptus. Bodichon's initial sense of wonder and intoxication evaporated;

a later unease was prompted less by sensory excitement than by regret at the lack of interest in fine art taken by French colonials and English travelers.

In published and unpublished accounts, the female militant subject often acted as a textual borderline, slipping between Algeria and Britain. The narrative subject of Parkes's essay, quoted above, was the solitary walker in the Algerian countryside, the author of a paper given to the National Association for the Promotion of Social Science in August 1861, and the contributor to *The English Woman's Journal*. A lengthy article in the *Journal* by Bodichon described the expeditions of a group of "English ladies [who] have spared ten days of their valuable time to *see* this African colony," and whose metropolitan modernity was juxtaposed to the historic queens, archaic sights, and picturesque ruins that are Algeria. Not only will the travelers "hurry back as fast as steam can carry them to 'the native coal-hole,' their glorious England; to their district visiting, their parish schools, their societies, associations and what not," but two of them "will often recall that beautiful picture, the blue sea seen through the ruined arches of Selena Cleopatra's aqueduct, as they walk together along the bald, blank, streets of London."[36] Such memorable views might be charged with pleasurable recollections of proximity, a productive exchange of ideas, a relative autonomy, or the novelty of tourism; equally, they might be shot through with troubling sensations of difference or uneven responses to French colonialism. But most of all they were memorable as views, for what differentiated Algeria from the "bald, blank, streets of London" was its pictorial disposition. The colony was perceived by British and French visitors alike in terms of artistically composed views: quick sketches of the scenery, glimpses out of windows, formal panoramas from high vantage points, and extensive vistas of supposedly empty space — "worlding" involved the "pictorializing" of Algeria.[37]

Disavowing the violent dislocation of colonization, this pictorializing fostered a twofold European disposition of land: into the artistically arranged landscape views of visual culture and into the new physical geographies demanded by colonization. Bhabha's attention to the multiple significations of "disposal" and "the strategies that articulate the range of meanings from 'dispose to disposition'" in colonial contexts in his essay "Signs Taken for Wonders" is particularly helpful in analyzing the pictorializing of Algeria. "Disposal," according to the *Oxford English*

Dictionary, conveys several meanings in which power and regulation co-
incide, including "the action of arranging, ordering or regulating by right
of power or possession"; the action of disposing of, settling or definitely
dealing with"; and "power or right to dispose of," where dispose may
signify both making arrangements for and getting rid of. "Disposition"
may signify setting in order and arranging; to have at one's disposal; in-
clination or physical aptitude or constitution. Taking up these multiple
meanings in a discussion of the forms, modes of address, positionings, and
ambivalence of colonial authority, Bhabha writes of "the reality effect":
"Transparency is the action of the distribution and arrangement of dif-
ferential spaces, positions, knowledges in relation to each other, relative
to a discriminatory, not inherent, sense of order. This effects a regulation
of spaces and places that is authoritatively assigned; it puts the addressee
into the proper frame or condition for some action or result. Such a mode
of governance addresses itself to a form of conduct that equivocates be-
tween the sense of disposal, as the bestowal of a frame of reference and
disposition as mental inclination, a frame of mind." The seizure, canton-
ment, urban development, agribusiness, European industries and their
infrastructures all disposed of earlier forms of land use and ownership
and disposed Algerian land into new arrangements. Ordered by a raft of
laws and decrees, this "regulation of spaces and places," which was, as
Bhabha suggests, "authoritatively assigned," profoundly changed the ap-
pearance of Algeria and the disposition of countryside, settlements, and
populations. At the same time, spatial regulation rendered the colony
more accessible to view: roads and railways underpinned a flourishing
tourist industry. Tourist literatures emphasized Algeria's pictorial dis-
position, its plenitude of scenes and views; travelers and readers were
positioned as viewers, suggesting, if not advocating, a particular form
of conduct—spectatorship—and visitors readily turned the colony into
pictorial views.[38]

This metamorphosis of land into landscape, into a category of West-
ern art, was enabled by repeated use of well-established artistic proto-
cols. These are among the "rules of recognition," identified by Bhabha as
the procedures, forms, and modes of address of colonial discourse that
worked by common consent. In landscape art these "rules" regulated the
disposition of the scenery, provided points of view, and offered authori-
tative frames of reference that allowed the strange to be presented within
the familiar. Indeed, they are what enabled Algerian scenes to be recog-

nized as "landscape." In the colonial context of the mid–nineteenth century, perceptions of land were thus caught between, in Bhabha's words, a "sense of disposal, as the bestowal of a frame of reference," and "disposition as mental inclination, a frame of mind." And yet, neither Western landscape nor colonial authority could remain untouched in this encounter. If Algeria was turned into pictorial text, the authority of Western vision and Western landscape were equally disturbed.

"a making into art, making into an object to be understood"

Bodichon's watercolors provided an uneven map of contemporary Algeria. Nevertheless, for British audiences her exhibitions provided a pictorial gazetteer of the French colony. The *Illustrated London News* wrote of a selection of her work exhibited at the French Gallery in London in 1864: "The drawings, like other series which have preceded them[,] represent scenes in Algeria, and comprise views of the towns and district about Algiers; of that angry sea, as it were, of hills and mountains, the homes of the hardy Kabyles; and of various points along the coast, with its azure Mediterranean and glowing golden shore; together with representations of forts, chateaux, villages and tombs; of the luxuriant growths of flowers, palms, aloes, prickly pears and giant plants of all kinds; and of the climatic phenomena and strange aspects of the sky from wind, rain etc."[39] But her repertory was by no means as extensive or comprehensive as here suggested. Although some titles hinted at a particularity of place — the views of Algiers, the Hydra Valley, the Plain of the Metijda, Point Pescade, and the old walls of Mansoura — others were decidedly imprecise and could work synecdochically: *Arab Tomb near Algiers* (Society of Female Artists, London, 1859), *Cactus Grove* (Girton College Cambridge, French Gallery, London, 1859), *Interior Court of an Old Moorish House* (French Gallery, 1861), *The Province of Oran, Algiers* (Society of Female Artists, 1866).[40] Bodichon shared a Western predilection for locations already well-known from guidebooks, tourist itineraries, antecedent imagery, and the new French histories and archaeological reports. Like many other painters, she dismissed the *colonies agricoles* from the fine art map, although these settlements, extensively mapped in the histories of French colonization, were discussed in an article for the *Journal*.[41] Neglecting the mining settlements whose industrial interest generated occasional engravings, like most artists she preferred to contribute to the

FIG. 4. Barbara Leigh Smith Bodichon, *Near Algiers,* 1858–1867, watercolor on paper, 170 × 360 mm. Hastings Museum and Art Gallery.

prolific imagery of the bay, town, and new harbor of Algiers and to offer novel views of Telegraph Hill and the water tower.[42] In portraying native farmers following their flocks of goats or sheep over scrubland (Fig. 4), through cactus groves, and on forest hillsides, her landscapes registered the impact of land policies that expropriated the most fertile farming land to Europeans. The calculated emptiness of these scenes, almost entirely vacated of habitation or vegetation, played into Western fantasies of Algeria as "uninscribed" and "unsettled" in all senses of the word.

Herdsmen wandering with their flocks through vast swathes of vacant landscape (Fig. 4) or buyers and sellers in animated exchange (Fig. 5) offer exceptions to a common depiction in Orientalist painting of native figures as arrested in time and space. In *A Sketch in the Hydra Valley Near Algiers* and *Roman Aqueduct, Algeria* (both Girton College Cambridge) they are as immobile as the architecture they accompany. Portraying a woman seated at the edge of a pool, deep in the shadows of a garden, contemplating her likeness in its mirrored surface, Osborn's *An Algerian Mirror* of 1883 (Fig. 6) conveys the simplicity of a culture in which the still surface of water provides a reflection. The inertia of these corporeal forms played into an imperialist discourse on idleness that was, as Anne McClintock has indicated, a discourse on work, and it was one in which productive labor and responsibility for it were allocated to Europeans.[43] In diametric contrast and gendered opposition, movement is assigned to Western women. Bodichon's sketches depict the artist and her sisters walking and

FIG. 5. Gertrude Jekyll, *Fruit Shops, Blida,* 1873–1874, watercolor and body color with pencil on paper, 343 × 273 mm. Surrey History Centre, Woking.

riding (Fig. 3). In *Near Algiers* two Sisters of Charity of the Order of St. Vincent de Paul take an evening promenade, strolling leisurely through a valley in a mountainous landscape (Fig. 7). The only figures who are portrayed actively working the land are two members of the same order, depicted in *Sisters Working in Our Field* (private collection). High on a hill above the bay of Algiers and its new harbor, the title and location suggest that their activity takes place on the Bodichons' twelve-acre estate. As Reina Lewis has indicated, paintings of nuns would have been viewed by British, but not French, audiences within the midcentury controversies surrounding Catholicism and the Anglo-Catholic revival, as well as within the discourses of Orientalism that positioned a heathen Islamic Orient against a mythically united Christian Europe.[44] Feminist interests also would have been engaged by these images: the extensive charitable concerns of the Sisters of Charity, from nursing to rehabilitation, were praised in *The English Woman's Journal.* Like other Catholic and Protestant female orders, this sisterhood was hailed as exemplary of women's work and its special qualities: moral superintendence and social guidance.[45] If the figural forms more generally suggest an imperialist inquiry into native

FIG. 6. Emily Mary Osborn, *An Algerian Mirror,* oil on canvas, 710 × 914 mm. Location unknown, Grosvenor Notes, 1883.

work, the portrayal of the Sisters hints at a feminist preoccupation with women's employment. Both interests seem to have displaced the Orientalist imagery of the harem, the bath, and the slave market (portrayed by male and female artists alike) as well as Orientalist landscapes filled with dramatic confrontations and spectacular journeys.[46]

Pictures such as Fox's *An Arab Marriage* (Royal Academy, London, 1871), Bodichon's *Talking to the Dead* (French Gallery, 1861), and *An Algerian Burial Ground,* a joint production by Bodichon and her sister Annie Leigh Smith (British Institution, London, 1863), participated in an interest in "manners and customs" that was central to imperial classifications of race. A repertory of images of Algerians at prayer, conversing, dancing, playing games, or reposing participated in that relentless specification of difference that Sara Suleri has described as "a hysterical overabundance of the documentation of a racial vision."[47] The subject of Bodichon's *Negro Woman Sacrificing at St Eugène, Algiers* may well have been lifted directly out of the guidebooks, such as J. R. Morrell's *Algeria* of 1854 describing "Moorish women, with their attendant negresses . . . performing ceremonies savouring of sorcery and fetichism."[48] Islam is often represented

FIG. 7. Barbara Leigh Smith Bodichon, *Near Algiers*, 1858–1867, watercolor on paper, 250 × 690 mm. Hastings Museum and Art Gallery.

by *marabouts* (the tombs of the holy men of Islam). For British and French audiences alike, imagery of Algeria's historic architecture in ruins evoked sensations of desolation and decay.

Bodichon's *Roman Aqueduct Near Cherchel, Ancient Julia Caesarea* portrays the great bridge of a massive aqueduct built in the second century CE, now in ruins (Fig. 8). When shown at the French Gallery in 1861, a contemporary reviewer's remark that "the solitary stork, and the tall rushes blowing gently in the evening breeze, heighten the desolation of the scene"[49] prompted an emotive response to the depiction of a crumbling ruin dramatically highlighted against the declining rays of a sunset. Linda Nochlin in her now classic study of French Orientalism indicates that ruins and disrepair suggested both the dereliction, idleness, and corruption of North African regimes and the corresponding need for firm Western intervention.[50] Yet there was more at stake. In Bodichon's watercolor the past is doubled upon itself: Roman history is overwritten with a pictorial structure echoing seventeenth-century and eighteenth-century European painting. The picture of the decaying aqueduct evokes paintings by Claude Lorrain and his followers, imagery of the monuments of Rome and the majestic depiction by Hubert Robert of Le Pont du Gard (Louvre, Paris, 1787), which Bodichon may well have seen. These visual precedents, like the fragment of architecture itself, summon not the Ottoman Empire, whose three hundred years of dominion over Algeria ended in 1830. Rather, they (re)inscribe Algeria into a European history and artistic legacy. To portray Algeria's Roman ruins was also to locate the colony's far distant past, a move that not only disclaimed the

FIG. 8 Barbara Leigh Smith Bodichon, *Roman Aqueduct Near Cherchel, Ancient Julia Caesarea,* exhibited at the French Gallery in London, 1861, watercolor with scraping out on paper, 260 × 730 mm. The Mistress and Fellows, Girton College, Cambridge.

more recent present but that demarked this land from the modernity of the West. Osman Benchérif has suggested that support for French invasion and colonization could be justified as the repossession by Christian Europe of the ancient Roman Empire in North Africa. He notes a long tradition of writing about the sacred mission of Christian Europe to restore the light of civilization to the provinces of ancient Rome, in which Islam represents the forces of desecration, destruction, and fanaticism.[51] Roman ruins could evoke meditations on long-standing conflicts between Christianity and Islam, reflections on past and present. The past supplements the present, for worlding is neither a once and for all achieved state nor a complete break with what has gone before but a continual process of reinscription. Supplementarity entails a double inscription that occurs, Derrida suggests, "whenever any writing both marks and goes back over its mark with an undecidable stroke."[52] This "double mark" undoes any securities of meaning; it "escapes the pertinence or authority of truth." A textual movement of "dislocation," it signals a disruption in these seemingly placid views.

In this and other views Bodichon, like artists before and after her, drew on Western pictorial conventions, making an eclectic and diverse use of the art of the past as well as contemporary British and French landscape painting. Algeria was framed and reinscribed within the already known. So characteristic of nineteenth-century Orientalism, this process of citation enabled "the reinscription of a cartography which must (re)present itself as impeccable."[53] The pictorial structures and arrangement of Euro-

pean landscape may be included among the "rules of recognition," defined by Bhabha as "those social texts of epistemic, ethnocentric, nationalist intelligibility which cohere in an address to authority." Bhabha argues that "the acknowledgment of authority depends on the immediate—unmediated—visibility of its rules of recognition."[54] In visual terms, these rules of recognition offered to make the strange familiar, to make sense of and to unify what Spivak in another context has called "a discontinuous and alien landscape."[55]

Several tried and tested formulas for the composition of landscape recur in Bodichon's *opera*. Some watercolors use a pictorial format very loosely derived from the art of Claude Lorrain and later painters in which the landscape is formally organized into contrasting bands of light and shade and in which trees or architectural elements punctuate the scene and lead the gaze across the pictorial field to a distant horizon. Lorrain's landscapes had been reworked for more than a century to shape an allegory of the fluctuating fortunes of empire and a vision in which order was imposed on the mutability of the natural world. In *Roman Aqueduct, Algeria* a tall tree bordering the composition to the left is complemented by the aqueduct set in the middle ground, acting both as a point of interest and as a border device between distinct pictorial areas differentiated by color and light. Organized horizontally, a version of this format could be pressed into service for the rendition of desert scenes and interior plains (Fig. 4). As Timothy Mitchell has indicated, enframing proposes "a place from which the individual can observe."[56] More a point of reference than a point of view, such enframing offers both a place from which the strange may be perceived within the frame of the already known, and a point of vantage from which to scrutinize an extended panorama of plains and mountains or a sweeping vista of seashore and hinterland.[57] While this projection of a distinct viewing position outside and above the landscape assisted imperialist fantasies of boundless possession, other compositional frames extended accessibility: a path through a cactus grove mimics a winding trail through a woodland copse. On occasion, the romantic sublime is conjured to represent mountain ranges and passes as if they were the Alps. Titles of lost works by Eliza Fox such as *The Return of the Caravan* (Royal Academy, London, 1867) suggest a production well within the parameters of the exotic picturesque.

To represent North Africa in the Western conventions of landscape was not only to (re)inscribe it, but to frame it within a preexisting pic-

torial order. In *The Truth in Painting* Derrida indicated that the placing of a frame entails much more than the making of a container, an edge, or a border. Framing, he contends, is a field of force, a violent enclosing that subjects both the inner field and the boundary to the pressures of restraint, demarcation, and definition. Taking up Derrida's insights, it can be argued that landscape painting attempted a violent enclosing of land. Not only was landscape painting the product of violence, one of the forms of art generated by colonial conflict, but it was a form of aesthetic violence in which the enjoyment of pictorial views denied the trauma of colonization. The aesthetic was of paramount importance in the worlding of Algeria, for it was one of the mechanisms that produced the work of art as art, that made it "into an object to be understood" as art. Derrida proposes that "a discourse on the frame" defines and regulates what is judged to be intrinsic or extrinsic to the work of art as well as producing and delimiting the domain of the aesthetic. In commenting on Kant's theories of aesthetic judgment, he contends that "the value oppositions which dominate the philosophy of art (before and since Kant) depend . . . in their pertinence, their rigor, their purity, their propriety" on the *parergon*. From the Greek, meaning "around" (*par*) "the work" (*ergon*), the parergon is "a hybrid of outside and inside"; akin to a frame or framing device, it is both part of the work and yet separate from it. A mobile and regulatory borderline, it moves according to the laws of supplementarity to mark "the limit between the work and absence of work," so designating what is within (and without). Yet Derrida goes further to suggest the parergon as a "formal and general predicative structure which one can transport *intact* or deformed or reformed, *according to certain rules,* into other fields, to submit new contents to it."[58] These suggestions assist the proposition here that landscape painting in the colonial context entailed a double framing: the formal presentation that made the image into art, and the visual framings of land within the Western visual systems and artistic protocols.

Yet, framing for Derrida is a process that is not always or necessarily achieved; disjunctions occur when "the frame fits badly." Moreover, framing could be destroyed by the very forces that imposed it. Derrida writes of a "gesture of framing, which, by introducing the *bord,* does violence to the inside of the system and twists its proper articulations out of shape." At the same time, this field of force pushes the devices of restraint along (with) the borderlines to breaking point, so much so that the frames split:

"A certain repeated dislocation, a regulated, irrepressible dislocation . . . makes the frame in general crack, undoes it at the corners in its quoins and joints, turns its internal limit into an external limit."[59] The setting of a boundary, a bord, not only marks a limit, but also precipitates the overflowing of the boundary and of the meanings for the field delimited by the frame, thus débordement, a textual movement of overspillage, dispersal, and deferral.

In an encounter with Algeria, neither the aesthetic enclosings nor the components of Western landscape remained stable; they changed and mutated. If the ordering of space in Bodichon's watercolors is Occidental, the elements within are based on those seen in Algeria. Architectural motifs, such as tombs, add to and displace the architectural fragments of ancient Rome. Although pine trees and precipitous mountains are familiar elements in Western landscape painting, the specific ranges and their disposition to the plains are geographically distinct. The aloes and cacti, palms, rushes, and bamboo signal a Maghrebi location, as do the architectural fragments (Figs. 4, 7, 8). The protagonists are native shepherds and goatherds in local dress, or modern Western women. These are hybridized views, neither North African nor European, but patched together from disparate, dissonant elements that, working according to the logic of the supplement, jostle against, add to, replace, and break into one another.

To identify these views as hybridized is to invoke Bhabha's powerful analysis of hybridity as "the sign of the productivity of colonial power, its shifting forces and fixities," and as a register of its uncertainty. Bhabha's compelling retheorization of colonial authority accounts for its agility, its indirectness, its dispersals into adjacent cultural forms such as the imagery produced by British women in the French colony of Algeria. The hybridized forms of Bodichon's landscapes are by no means unique to the artist. Rather, they are produced within a consensual pictorial language of topography. Their contradictions are those of the genre in the colonial context: at once a portrayal of a specific location so as to be recognizable to its audience; at once an object of art, the view selected, framed, and inscribed within Western pictorial conventions, those "rules of recognition" that lent authority to the representation. Yet the mutation of Western artistic forms and framings may also indicate a disruptive force *within* colonial representation that calls its authority into question. For Bhabha hybridity breeds uncertainty—there are no guarantees that au-

thority will transfer in the colonial context—and it proliferates difference to an excess beyond representation.[60] And it is that uncertainty of the representation of Algeria with which this essay began.

The concern in this essay has been less with interlocution as speaking back, to, or against Orientalist discourse, and more with interlocution as speaking within, which destabilizes and decenters colonial authority. It has focused attention on "small unimportant folk"[61] at the margins of art historical interest to discover, at a founding moment of Western egalitarian feminism, disjunctions and complicities between the campaigning for women's rights and imperialist specifications of difference. Although feminist audiences for their art can be identified and feminist interests in its female figures can be discerned, this textualizing of Algeria is not "feminist" in content or style. Rather, it was produced within a worlding of Algeria that wrought earth into world and land into landscape. If the hybridity of these images signals something of an instability in colonial authority, nevertheless, the pictorializing of Algeria in feminist writings and images was intimately part of the cultural violence of imperialism and the imperialist violence of culture.

Notes

1 Barbara Bodichon to Marian Evans, 21 November and 8 December 1856, George Eliot and George Henry Lewes Collection, Beinecke Rare Book and Manuscript Library, Yale University, New Haven.

2 Marian Evans wrote to Sara Sophia Hennell on 16 April 1857 of the illustrated letter she had received with "wonderful descriptions from Barbara Smith of the glorious scenery and strange picturesque life she finds in Algiers. . . . She dashes down sketches with her pen and ink, making arrow heads to indicate the bark of Jackals!" G. S. Haight, ed., *The George Eliot Letters* (London: Oxford University Press/Yale University Press, 1954), 2.320.

3 "Intoxication" recurs in Bodichon's first article on Algiers, "Algiers, First Impressions," *English Woman's Journal* 6 (September 1860): 21–32. In a later letter to her sister, Annie, (1865) she wrote, "It is really one of the most intoxicating places under the sun"; quoted in Hester Burton, *Barbara Bodichon, 1827–1891* (London: John Murray, 1949), 83.

4 Jacques Derrida, *La Dissémination* (Paris: Editions du Seuil, 1972), 124–26. Translated by Barbara Johnson as *Dissemination* (Chicago: Chicago University Press, 1981).

5 Gayatri Chakravorty Spivak, "The Rani of Sirmur: An Essay in Reading the Archives," *History and Theory* 24 (1985): 251.

6 The textual and visual archives of this group are widely dispersed, and many of

their writings and artworks have not survived. None of Fox's or Osborn's Algerian works have been traced and are known only from exhibition titles and occasional reproductions. Locations of Bodichon's works are given where known.

7 Roger Benjamin, ed., *Orientalism: Delacroix to Klee* (Sydney: Art Gallery of New South Wales, 1997); Briony Llewellyn, *The Orient Observed: Images of the Middle East from the Searight Collection* (London: Victoria and Albert Museum, 1989); John M. Mackenzie, *Orientalism: History, Theory and the Arts* (Manchester, England: Manchester University Press, 1995); Maryanne Stevens, ed., *The Orientalists, Delacroix to Matisse: European Painters in North Africa and the Near East* (London: Royal Academy, 1984); John Sweetman, *The Oriental Obsession: Islamic Inspiration in British and American Art and Architecture, 1500–1920* (Cambridge, England: Cambridge University Press, 1988); Lynne Thornton, *The Orientalists: Painter Travellers, 1828–1908* (Paris: ACR Editions, 1983).

8 For a thoughtful analysis of "an uneasy alliance between feminist and postcolonial critiques of European cultural authority," see Zeynep Çelik and Leila Kinney, "Ethnography and Exhibitionism at the Expositions Universelles," *Assemblages* 13 (December 1990): 34–59; quotation on 35.

9 Rana Kabbani, *Europe's Myths of the Orient* (London: Macmillan, 1986); Reina Lewis, *Gendering Orientalism: Race, Femininity and Representation* (London: Routledge, 1996); Lynne Thornton, *Women as Portrayed in Orientalist Painting* (Paris: ACR Editions, 1985); Mary Roberts, "Contested Terrains: Women Orientalists and the Colonial Harem," in this volume.

10 Gayatri Chakravorty Spivak, "Criticism, Feminism and the Institution" (1984), in Spivak, *The Post-Colonial Critic: Interviews, Strategies, Dialogues,* ed. Sara Harasym (New York: Routledge, 1990), 1. It must be emphasized that "worlding" was not presented by Spivak as a unified concept, although she elaborated her ideas on it in several articles and interviews in the mid-1980s.

11 Spivak, "The Rani of Sirmur"; Martin Heidegger, "Der Ursprung des Kunstwerkes" (1935–1936), translated by A. Hofstadter as "The Origin of the Work of Art," in *Poetry, Language, Thought* (New York: Harper and Row, 1971), 63. *Riss* may be translated as tear, rent, fissure, schism, breach, as well as (of interest in this context) design, technical drawing, plan, elevation.

12 Linda Nochlin, "The Imaginary Orient," in *The Politics of Vision: Essays on Nineteenth-Century Art and Society* (London: Thames and Hudson, 1991), 33–59; W. J. T. Mitchell, *Landscape and Power* (Chicago: University of Chicago Press, 1994).

13 Edward Said, *Culture and Imperialism* (1993; London: Vintage, 1994), 5.

14 Mahfoud Bennoune, *The Making of Contemporary Algeria, 1830–1987* (Cambridge, England: Cambridge University Press, 1988); David Prochaska, *Making Algeria French: Colonialism in Bone, 1870–1920* (Cambridge, England: Cambridge University Press, 1990); Alfred W. Crosby, *The Biological Expansion of Europe, 900–1900* (Cambridge, England: Cambridge University Press, 1986); Neil Smith, *Uneven Development: Nature, Capital and the Production of Space* (Oxford: Blackwell, 1984); David C. Gordon, *The Passing of French Algeria* (London: Oxford University Press, 1966).

15 Bennoune, *The Making,* 43–45; Agnes Murphy, *The Ideology of French Imperialism,*

1871–1881 (New York: Howard Fertig, 1968). On the similarities and differences between French and British writings and imagery, see Deborah Cherry, "Algeria Inside and Outside the Frame: Visuality and Cultural Tourism in the Nineteenth Century," in *Visual Culture and Tourism,* ed. Nina Lübbren and David Crouch (Oxford: Berg, forthcoming).

16 Listed in a separate classification at the Bibliothèque Nationale in Paris are numerous publications on Algeria. Midcentury guides include Pauline de Noirfontaine, *Algérie: Un regard écrit* (Le Havre: Aumale, 1856); Charles Desprez, *L'hiver à Alger: Lettre d'un compère à sa commère* (Meaux, France: Imprimerie Carro, 1861). J. R. Morrell, *Algeria* (London: Nathaniel Cooke, 1854) was consulted by Bodichon on her first visit. *L'Algérie pittoresque by Clausolles with engravings by Jacob* (Toulouse, France, 1843); P. Christian, *L'Afrique française (illustré): L'Empire de Maroc et les deserts de Sahara. Histoire nationale des conquêtes, victoires et nouvelles decouvertes des Françaises, depuis la prise d'Alger jusqu'à nos jours* (1846; Paris, 1853).

17 Arjun Appadurai, *The Social Life of Things: Commodities in Cultural Perspective* (Cambridge, England: Cambridge University Press, 1986).

18 Spivak, "The Rani of Sirmur," 253. She takes issue with Fredric Jameson's reading of the Heidegger essay in "Postmodernism, or the Cultural Logic of Late Capitalism" reprinted in his collection, *Postmodernism, or the Cultural Logic of Late Capitalism* (London: Verso, 1991), 66–68.

19 Timothy Mitchell, *Colonising Egypt* (Cambridge, England: Cambridge University Press, 1998), 57.

20 Pam Hirsch, *Barbara Leigh Smith Bodichon* (London: Pimlico, 1999); Deborah Cherry, *Beyond the Frame: Feminism and Visual Culture, Britain, 1850–1900* (London: Routledge, 2000).

21 B. L. S. Bodichon, *Algeria Considered as a Winter Residence for the English* (London: *English Woman's Journal,* 1858); B. L. S. Bodichon, "Algiers, First Impressions"; "Cleopatra's Daughter, St Marciana, Mama Marabout, and Other Algerian Women," *English Woman's Journal* 10 (February 1863): 404–14; "Kabyle Pottery," *Art Journal* (1865): 45–46; E. Bodichon, "Society in Algiers," *English Woman's Journal* 6 (October 1860): 95–106; "Algerine Notes, Part 1: Algerine Animals," *English Woman's Journal* 8 (September 1861): 31–37; "Algerine Notes, Part 2: Algerine Animals," *English Woman's Journal* 8 (October 1861): 90–96; B. R. Parkes, "Moustapha's House," *English Woman's Journal* (November 1861): 173–77; "Mme Luce, of Algiers," *English Woman's Journal* 7 (May 1861): 157–68 (June 1861): 224–36; (July 1861): 296–308. Parkes contributed "French Algiers" to the *Waverley Journal* in 1857, a precursor to the *English Woman's Journal,* which she edited from May 1857. The issues for 1857 seem not to have survived; those for 9 August 1856 to 10 January 1857 are in Glasgow University Library and those for 1–15 January 1858 are in the British Library, Newspaper Division, Colindale, London. B. R. Parkes, *Mme Luce: A Memoir, with an Addendum by Bodichon* (London, 1862).

22 J. Crabbe, "An Artist Divided: The Forgotten Talent of Barbara Bodichon," *Apollo* (May 1981): 311–13.

23 J. S. Maas, *Gambart: Prince of the Victorian Art World* (London: Barrie and Jenkins,

1975). Gambart, whose London business was established by 1843, published and distributed French engravings and prints after daguerrotypes, including views of Algeria.

24 B. R. Parkes to B. Bodichon, 19 April 1861, Parkes Papers, Girton College Cambridge, v, 104; *English Woman's Journal* 7 (May 1861): 216. See also Kate Perry, *Barbara Leigh Smith Bodichon 1827–1891* (Cambridge, England: Girton College, 1991), 14.

25 Deborah Cherry, *Painting Women: Victorian Women Artists* (London: Routledge, 1993), 104–9. Bodichon's donations to Girton College included many Algerian watercolors for the college walls. Emily Mary Osborn's portrait of her (now lost) was presented to the college.

26 [B. R. Parkes], review of *Algeria Considered, English Woman's Journal* 3 (March 1859): 66.

27 Haight, *George Eliot Letters,* 2.337, 3.402. Thanking her correspondent in April 1861 for three drawings of Parkes, Evans was "pleased to be remembered in this way and amused with the images of dear Bessie."

28 Bessie Rayner Parkes to Mary Merryweather from Algiers, 11 January 1857, Parkes Papers, Girton College Cambridge, vi, 71. On women travelers and Western travel narratives, see Mary Louise Pratt, *Imperial Eyes: Travel Writing and Transculturation* (London: Routledge, 1992), and Sara Mills, *Discourses of Difference: An Analysis of Women's Travel Writing and Colonialism* (London: Routledge, 1991). On urban mobility, see Lynne Walker, "Vistas of Pleasure: Women Consumers of Urban Space in the West End of London, 1850–1900," in *Women in the Victorian Art World,* ed. C. C. Orr (Manchester, England: Manchester University Press, 1995), 70–85.

29 Spivak, "The Rani of Sirmur," 253. For her discussion of the "female militant subject," see "Three Women's Texts and a Critique of Imperialism," *Critical Enquiry* 12 (autumn 1985): 243–61.

30 Bessie Rayner Parkes, "The Condition of Working Women in England and France," *English Woman's Journal* 8 (September 1861): 1–9, reprinted in Candida Ann Lacey, ed., *Barbara Leigh Smith Bodichon and the Langham Place Group* (London: Routledge, 1987), 190–99. The factory was probably owned by Arles-Dufour, a wealthy silk manufacturer in Lyons, a supporter of women's rights, and a friend of Richard Cobden and Joseph Parkes (Bessie's father). The girls and young women were under the supervision of the Sisters of Charity of the Order of St. Vincent de Paul, who ran an orphanage on the outskirts of Algiers.

31 Spivak, "Three Women's Texts," 244–45.

32 B. L. S. Bodichon, *Women and Work* (London: Bosworth and Harrison, 1857), reprinted in Lacey, *Barbara Leigh Smith Bodichon,* 36–73; quotation on 47.

33 Bodichon, *Women and Work,* 47; B. R. Parkes to M. Merryweather, 11 January 1857, Parkes Papers, Girton College Cambridge, vi, 71.

34 Ellen Clayton, *English Female Artists* (London: Tinsley, 1876), 2.86.

35 Parkes, "Moustapha's House"; Bodichon, *Women and Work,* 51.

36 Bodichon, "Cleopatra's Daughter," 416.

37 The concept of pictorializing is developed from Pratt, *Imperial Eyes,* 200–16. Mitchell

(*Colonising Egypt*, 57) also indicates the pictorial perceptions of French commentators on Algeria.

38 Homi Bhabha, "Signs Taken for Wonders," in *The Location of Culture* (London: Routledge, 1994), 109.

39 *Illustrated London News*, 16 July 1864, 55.

40 *The Spectator*, 3 April 1858, 380; *The Athenaeum*, 19 February 1859, 258; *The Athenaeum*, 13 April 1861, 502; *The Spectator*, 20 April 1861, 417–18; *The Academy*, 18 June 1874, 675.

41 Bodichon, in "Cleopatra's Daughter," reported a visit to Mme Adelaide, "the model colonist's wife" (405).

42 Now lost or unidentified, Bodichon exhibited these subjects in 1858, 1861, and 1874. For many travelers, including Parkes, the telegraph represented the speed of modernity; see Parkes to Merryweather, 26–28 January 1857, Parkes Papers, Girton College Cambridge, VI, 72. *L'Algérie au point du vue Belge* (Paris: Librarie Centrale, 1867) was one of several guidebooks to inform its readers that the Belgian who loves his country can go abroad "avec la certitude de pouvoir rentrer rapidement au moyen des chemins de fer et des bateaux à vapeur, et rester en communication, à chaque instant, avec elle par le télégraphe électrique [with the certitude of being able to return rapidly by railway and steamship and of staying in communication (with his country) by the electric telegraph]" (5). Engravings of mining settlements and the bay of Algiers are housed in the collection of the Département des Estampes et de la Photographie, Bibliothèque Nationale, Paris.

43 Anne McClintock, *Imperial Leather: Race, Gender and Sexuality in the Colonial Conquest* (New York: Routledge, 1995), 252–53. She points out that this discourse is a "realm of contestation" and a mark of resistance.

44 Lewis, *Gendering Orientalism*, 89.

45 On the Sisters of Charity, see the following essays, all in *English Woman's Journal*: B. R. Parkes, "What Can Educated Women Do," 4 (December 1859); "A Year's Experience of Women's Work," 6 (October 1860): 112–21; "Letter from Paris," 5 (June 1860): 259–68; M.M.H., "Florence Nightingale and the English Soldier," 1 (April 1858): 73–79. See also Anna Jameson, *Sisters of Charity and The Communion of Labour, Two Lectures on the Social Employments of Women: A New Edition . . .* (London: Longman, Brown, Green, 1859), 19–40; Martha Vicinus, *Independent Women: Work and Community for Single Women, 1850–1920* (London: Virago, 1985), chap. 2.

46 See Lewis, *Gendering Orientalism*, 127–90, for a discussion of Henriette Browne's harem paintings.

47 Sara Suleri, *The Rhetoric of English India* (Chicago: University of Chicago Press, 1992), 18.

48 Morrell, *Algeria*, 62, 114–15.

49 *The Spectator*, 20 April 1861, 417.

50 Nochlin, "The Imaginary Orient," 38.

51 Osman Benchérif, *The Image of Algeria in Anglo-American Writings 1785–1962* (New York: University Press of America, 1997).

52 Derrida, *Dissemination,* 193.

53 Spivak, "The Rani of Sirmur," 263–64.

54 Bhabha, "Signs Taken for Wonders," 110.

55 The phrase is taken from Gayatri Chakravorty Spivak's essay on the gendered formation of the self in relation to landscape and history: "Sex and History in 'The Prelude,'" in *In Other Worlds: Essays in Cultural Politics* (1987; London: Routledge, 1988), 46–76; quotation on 58.

56 Mitchell, *Colonising Egypt,* 59.

57 Bodichon's *View of the Coast Looking West, Rocky Island off the Coast, West of Algiers,* and *Point Pescade* were exhibited in 1861 (*Observer,* 14 April 1861).

58 Jacques Derrida, *La Vérité en Peinture,* translated by G. Bennington and I. Macleod as *The Truth in Painting* (Chicago: University of Chicago Press, 1987), 69–74, 45, 64, 73, 63, 55.

59 Ibid., 69–74.

60 Bhabha, "Signs Taken for Wonders," 112.

61 Spivak, "The Rani or Sirmur," 253–54.

HENRI REGNAULT'S WARTIME ORIENTALISM

Hollis Clayson

Orientaliste: homme qui a beaucoup voyagé.
—Gustave Flaubert[1]

Henri Regnault (1843–1871) was a Parisian by birth, upbringing, and education. He also died in Paris. But his artistic commitments crystallized as he progressively distanced himself from the Île de France and the Christian and Classical cultures of Western Europe during the final four years of his brief life. Indeed, his travel itineraries mirrored his mounting enthusiasm for Islamic artifacts and cultures located to the south of the French hexagon. But if we take the link between exotic travel and artistic maturation in Regnault's case at face value, we might read his "conversion" to the Orient through the lens of Flaubert's ironic platitude. That would be a mistake, for Regnault was no Occidental Orientalist serenely nurtured by memories of travel to an Oriental *ailleurs*. The *idée reçue* in question is a Procrustean bed for the Orientalist work of Regnault's last year, and especially inappropriate to the watercolors he painted during the last months of his life, spent in wartime Paris, the subject of the present essay.

I argue that Regnault's very last paintings in an Orientalist idiom shatter the Saidean orthodoxy which holds that the nineteenth-century European artist routinely imposed a univocal and supremely self-confident Occidental colonial perspective on the Orient, and caricatured and distorted Arab men and women in the process. Regnault's watercolors ex-

emplify instead a probing and unstable way of representing the North African odalisque and Moor, seen through the doubled optic of thwarted French military masculinity and shipwrecked artistic agency. Indeed, I argue here that Regnault's return to Paris at the end of his life which entailed both military and professional despair, disrupted and transformed the artist's central project, Andalusian history painting headquartered in Morocco, and its distinctive idea of exotic Oriental femininity and masculinity, especially the latter.

By 1870, Regnault's Orientalism was still inchoate but plainly idiosyncratic. The idioms he was developing went firmly against the grain of the realist Orientalisms of his day, exemplified by the ascendant school of Jean-Léon Gérôme. Regnault's work had instead a romantic, retrospective cast, and often an overheated, even violent character. Inspired by monuments and events associated with thirteenth-, fourteenth-, and fifteenth-century Moorish Spain, defeated (reconquered) at Granada by the Christian Crown for good in 1492, Regnault was attempting to forge a distinctive Andalusian Orientalist history painting in the crucible of Tangier, a city he called home for a scant nine months.

His Moroccan idyll ended abruptly when he returned to Paris in August 1870. The distinctive features of his Orientalist works of the autumn of that year are rooted in his vexations with the artistic practice he stitched together upon his unexpected return to his *ville natale* and his frustrated response to war. Unlike the cases of most of his traveling contemporaries and distinguished romantic predecessors—Eugène Delacroix, Alexandre-Gabriel Decamps, and Théodore Chassériau, for example—Regnault's work in an Orientalist vein was visibly *détraqué* (thrown into disorder) by his Parisian homecoming. Describing and explaining that disorder are the twin aims of this essay.

Henri Regnault had it all.[2] He was handsome, charming, athletic, and talented. The second son of cultivated, intellectual parents, he resolved as a child to become an artist, and technical gifts backed up his determination. A virtuosic draftsman and gifted colorist capable of disciplining his fiery romantic sensibilities, he rose quickly in the Second Empire art establishment. Trained by Louis Lamothe and then Alexandre Cabanel, he won the Prix de Rome on his third try in 1866 at the age of twenty-two with his *Thétis apportant à Achilles les armes forgées par Vulcain*. He left for Rome in the spring of 1867 to take up his scholarship. He was disappointed by the architecture and most of the painting he saw in Rome,

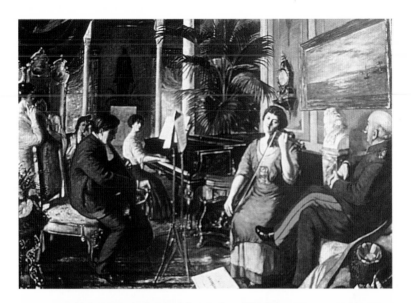

PLATE 1. Prince Abdülmecid, *Beethoven in the Palace*, ca. 1900. Museum of Painting and Sculpture, Istanbul.

PLATE 2. Eugène Delacroix, *Les Femmes d'Alger dans leur appartement*, 1934. Musée du Louvre.

PLATE 3. Mohammed Racim, *Galleys Fleeing the Storm (Galères fuyant la tempête)*, ca. 1937. Gouache heightened with gold, 22.6 × 17.5 cm. Collection Tayeb Zahzah, Paris.

PLATE 4. Henri Regnault, *Haoua, intérieur de Harem*, October 1870. Watercolor, 75 × 53 cm. Current whereabouts unknown. Photo courtesy Mme. Sophie de Juvigny.

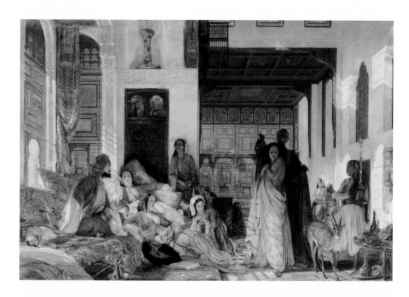

PLATE 5. John Frederick Lewis, *The Hhareem*, 1849. Watercolor and body-color on paper, 47 × 67.3 cm. Private collection, Japan.

PLATE 6. Henriette Browne, *Une Visite (intérieur de harem, Constantinople, 1860)*, 1861. Oil on canvas, 86 × 114 cm. Private collection. © Christie's Images Ltd.

but he was overwhelmed (*"broyé"*) by the example of Michelangelo [3] and drawn to the Orientalist work of his Spanish contemporary, Mariano Fortuny, also living in Rome. An outbreak of cholera in Italy provided an excuse for the *pensionnaires* of the Villa Médicis to head back to Paris, where Regnault spent five months. The enthusiasm for the Orient inaugurated by the encounter with Fortuny was enhanced by what he saw at the 1867 Exposition Universelle in Paris, particularly the displays from India, Egypt, Turkey, and Persia.[4]

He returned to Rome at the end of 1867 to dig into the manufacture of his annual *envoi,* changed from *Judith et Holopherne* to *Automédon ramenant les coursiers d'Achille des bords du Scamandre.* A bad fall from a horse in July prompted a doctor to order him to leave Rome and its insalubrious climate, but rather than returning to Paris, he set off via Marseille for Spain in late 1868 (visiting Bilbao, Burgos, Avila, Toledo, and finally Madrid), supported by his Prix de Rome bursary.

He made a brief obligatory return to Rome in the spring of 1869, but was keen to return to Spain and to proceed to Morocco, to the "Orient," in any case: "It is the Orient that I call for, that I demand, that I want. Only there, I believe, will I feel that I really am something."[5] His attachment to Spain led him to return there in late 1869, traveling to Granada in the company of his best friend, Georges Clairin, motivated in part by a plan to study Islamic ornament on behalf of his father, Victor Regnault, the distinguished scientist and director of the Sèvres ceramics factory.

He found Spain enthralling, equal to more fabled destinations: "The country is superb; it is Africa, Egypt."[6] He was captivated by the structures he found there, especially the Alhambra, and overflowed with admiration for the Islamic artists who made them[7] and Mohammed who inspired them: "Ah! My friend, if you could see the Alhambra! Since I saw it, this fantasy, this dream . . . I can do nothing but sigh. Nothing is as beautiful, as delirious, as intoxicating as that. . . . This Alhambra has effaced all of our preceding emotions, all our former enthusiasms. In the name of the Father, the Son and the Holy Spirit. So be it. Amen. Ah! Mohammed, you alone are great, you alone are God, you who inspired a work like this one. Next to the artist who made that, we are barbarians, savages, monsters."[8] Indeed, the famous honeycomb ceiling of the Alhambra palace provided the setting for his otherwise fanciful *Exécution sans jugement,*[9] discussed below.

In October 1869, he apparently mentioned his plan to move to Mo-

rocco for the first time. At that date, he had hoped to secure some kind of official post in the imperial capital of Fez, an ambition he outlined in a letter to his influential father, dated October 17, 1869:

> I am dreaming of a trip to Morocco. It is absolutely necessary that I go there. Here in abbreviated form are the reasons that I want to go.
>
> 1. I want to study the types that are well preserved there, because since the conquest of Granada, the Moors took refuge there for the most part.
> 2. To see the palace in Fez, the winter and summer palace, constructed in much the same style and plan as the Alhambra, since it was built by Abu-Abdil-lah (I don't know what number), the last Moorish king of Granada.
> 3. To see the arms, horses, fabrics, rugs, dogs, etc., etc., customs, etc., etc. Without that everything that I did at the Alhambra will do me no good and I won't be able to put it to use.
>
> I need a stronger recommendation than the one I have to the ambassador's staff in Morocco. I need a mission to the Emperor of Morocco; even though this would be for the matter of women. I am a trustworthy man and will stop at nothing to obtain permission to work in the palace of the Emperor of Morocco, in his stables, in his harem as needed.
>
> It would be of great benefit for me to see these things up close, especially among the Moroccan upper class, there where they may still have some souvenirs of their forefathers, like in the treasuries, galleries of the palace, arms, etc.
>
> I am not asking for money, but either a mission or a strong recommendation that will permit me to obtain an escort and the right to work where I please. We are not schemers, you or I, but in this case, I beg you to become one.
>
> X. or some other fashionable artist will say to you perhaps that Morocco is not interesting. I am certain of the contrary. Fortuny spent two months there in the context of the expedition to Morocco of Prim and O'Donnell, and he brought back incredibly interesting studies. There are certain corners of Spain that I would want to keep to myself. For those spots, I would gladly say to everyone that they are ugly, very dangerous, that one could never work there, etc.[10]

The letter makes it clear that Regnault's emergent professional dream, to find and study the living traces of the vanquished Moors of late medieval Spain in North Africa, kindled his desire to move to Morocco, a goal against the grain of his increasingly ethnographic French Orientalist contemporaries. Though Regnault could not recall the name of the last king of Granada (Boabdil, or Muhammad XI), he displayed his ample knowledge of the waves of Muslim exiles, Arabs and Jews, who moved to Morocco following the Christian conquest of Granada in 1492.[11] Indeed, the Kingdom of Morocco had long provided political support and military recruits to the beleaguered last Muslim principality in Spain.

Morocco was nonetheless not quite as exotic a land as the young artist's letter implied. It is not surprising that Regnault intended to work through diplomatic channels, for although Morocco was still an independent state in 1870 and was the only Arab state never assimilated by the Ottoman Empire, it was accessible to European visitors like Regnault because of its increasing subjugation by France.[12] Indeed, the decade of the 1860s marks a period that Janet Abu-Lughod has called "the birth of urban capitalism in Morocco."[13] No more than a few hours' boat ride from the doorstep of Europe in Spain, Morocco was still construed as culturally and social alien; "other."

The city in which Regnault put down roots in mid-December, Tangier, was the most accessible and indeed Westernized of Moroccan cities at the time. Its relatively easy access and picturesque qualities attracted artists, but so did its fabled similarity to Andalusia.[14] According to one of Regnault's biographers, "It was in Tangier that he would find the country of his dreams."[15] By choosing Tangier rather than Fez, Regnault was following in the footsteps of Fortuny and Alfred Dehodencq. He rented a Moorish house, not far from the Petit Socco in Tangier where Dehodencq had lived on and off between 1854 and 1863.[16] But unlike Dehodencq, who took a realist perspective on contemporary Moroccan life, Regnault sought out traces of Granada's glorious Islamic past in contemporary Tangier.

Regnault was joined by Clairin, posted to the French embassy there as an attaché;[17] he was a diplomat as well as an artist. With unrelenting ardor, Regnault and Clairin threw themselves into life à l'Orientale.[18] "My eyes," Regnault reported breathlessly, "finally see the Orient!"[19] He did studies of everyday life as he had in Italy and Spain. But in Morocco, his highest priority was fashioning a link through his art between present

and past Arab society, and thereby between genre and history painting. Clear in the artist's mind as early as his October 1869 letter to his father was his belief that studies of contemporary Moroccan social life and artifacts, whether or not they descended directly from the survivors of the defeated kingdom of Granada, could provide the empirical foundation of a new kind of history painting, one that would invoke a noble and sublime Andalusian Oriental past.

He restated this ambition in a letter to his friend (and eventual biographer), Henri Cazalis, where he expressed his hope that the imagery he would create in North Africa would resonate back in the French hexagon: "But before returning [to France] I want to revive the true Moors, terrible and voluptuous at the same time, those one no longer sees except in the past." [20] Regnault's projection recalls elements of Delacroix's parallel "discovery" of the nobility of the ancient Greeks among the Algerians he observed, drew, and painted starting in 1832. What young Regnault accomplished toward this singular goal is discussed in what follows.

The two young friends—Regnault and Clairin were the same age—studied Arabic, attended Ramadan festivals, and participated in other regional rituals and spectacles. They furnished their *patio,* roofed in glass, as a studio in *le style mauresque.* [21] One wonders how they dressed. In May 1870, Regnault made a big splash, his first (his last), in the Paris Salon with the exhibition of his widely discussed *Salomé,* [22] finished in Morocco, which garnered a medal. In June he bought a sizable studio in Tangier where he painted the *Exécution sans jugement.* He planned to stay in Tangier permanently, returning to Paris for only several months a year. As a Prix de Rome winner, Regnault was exempt from military service, but following the declaration of war between France and Prussia in late summer of 1870 he traveled back to Europe to fight, reaching Paris in late August.

In an egalitarian gesture, he refused the rank of officer to which he was entitled and joined the Sixty-ninth *bataillon de marche,* later joining briefly a corps of *francs-tireurs,* but returned to the Sixty-ninth company, which performed grueling winter service at various outposts (*aux avant-postes*) in the outskirts of Paris. [23]

The worst fears of his fiancée, Geneviève Bréton, about his decision to fight in the war were realized: he was only twenty-seven years old when killed in one of the last sorties of the war at Buzenval on January 19, 1871. The battle was a risky venture he insisted on joining, and, coupled with a knowledge of the violent imagery he fancied in his art, his early death

encouraged the forging of a link thereafter among his life, his art, and the theme of recklessness, even the possibility of suicide. Listen to Théophile Gautier, for example: "It seems as though sinister omens had been meant to foretell the young artist's heroic and violent death."[24]

Regnault's achievement in Tangier is exemplified by its most dramatic completed product, the *Exécution sans jugement sous les rois maures de Grenade* (Fig. 1), based on studies made in the Alhambra in Granada but painted in Tangier and shipped to Paris in July 1870.[25] Sent along with his copy of Diego Velásquez's *Surrender at Breda* (started in Madrid in September and November 1868 and finished during a subsequent visit to the Prado in October 1869), it was his third envoi. The picture represents an imagined royal execution in Granada of yore rather than a nineteenth-century North African drama. That a painting on a late medieval Islamic Spanish subject could encapsulate his Moroccan campaign should come as no surprise, insofar as Regnault was on a quest for Moorish Andalusia in modern Morocco. Nor should the fact that it was imagined despite its basis in the architectural research that the artist completed in Granada.

In fact, prior to painting the *Execution,* Regnault had conceived an even more ambitious Andalusian canvas, the work he hoped would represent him one day in the Luxembourg Museum.[26] As he wrote his father from Tangier in January, "Finally, I am going to do my last envoi, a picture of which I dreamt at Granada and whose execution will be easy here. . . . My intention, in fact, is to concentrate in my last envoi all my efforts to do a history painting."[27] In a revealing May 1870 letter that the painter wrote to Cazalis from Granada, he gave his most complete description of the project and betrayed his disinterest in working from exact historical events and personnages. The imaginative artwork came first; historical verisimilitude might add surplus value to the tableau but was not his point of departure or exclusive goal. He forthrightly projected a primary role for imaginative invention in his plan for his never-to-be-completed last envoi.

> I would like at least, before I die, to have created an important and serious work, of which I am dreaming at this time, and where I would struggle with all the difficulties that excite me. Whatever turns out to be the product of this battle, when you come to Tangier, you will find me facing an immense canvas, where I want to paint the entire character of the Arab dominion in Spain, and those powerful

FIG. 1. Henri Regnault, *Exécution sans jugement sous les rois maures de Grenade* (Execution without Trial under the Moorish Kings of Grenada), oil on canvas, 1870, 3.02 × 1.46 m., Paris, Musée d'Orsay. Reproduced in James Thompson, *The East Imagined, Experienced, Remembered: Orientalist Nineteenth Century Painting,* Dublin: National Gallery of Ireland, 1988, fig. 39, p. 132. Photo Roman Stansberry.

Moors of yesteryear, those who still have the real blood of Moham-
med of the third, fourth, fifth and sixth generations in their heads. I
hope to find in the histories of the Moors a historical fact or a name
that will match what I want to do to satisfy everyone. I'll start any-
way, and if I find a way to baptize my tableau before I finish it, so
much the better; if not I'll invent something and send the critics to
chapter 59,999 of an undisputed Arab history, but destroyed in the
fire or sack of a city. . . . I'll divert the critic by doing neither the
Alhambra nor the Alcazar of Seville.[28]

The details of the intended colossal canvas were also conveyed to Gau-
tier by Clairin in Paris after Regnault's death, but missing from Gautier's
fulsome and outlandishly detailed "description" is any acknowledgment
of the element of pure invention that routinely shaped the artist's vision.
According to Gautier, the canvas was to have been thirty-three feet long
(the size of Veronese's *Noces de Cana*) and a "sort of personification and
triumph of Islam in the times of the Caliphs of Spain":

> The background of the picture was to be filled with a palace
> adorned with all the wonders of Arab architecture: slender pillars,
> heart-shaped arches, panels of lace-work wrought in stucco, niches
> with painted and gilded stalactites, inscriptions from the Koran in
> Cufic characters mingled with flowers, and overlaid azulejos; in a
> word, a summary of the Alhambra at Granada and the Alcazar at
> Seville: fountains splashing in basins of ribbon alabaster, tall vases in
> which grew rare flowers, all the fairy marvels that the East accumu-
> lates in the palace of the Caliphs. In the center opened out a great
> archway, its cedar gates forming complicated symmetries miracu-
> lously worked out and inlaid with silver. To this superb archway led
> a broad stair of white marble, the lower steps of which were laved by
> the water of a stream. A gilded galley with quaint prow and poop,
> its striped carpets and draperies dipping in the current, brought to
> the foot of the steps the tributary chiefs, the vassals from Africa and
> Spain, dressed in brilliant armor, starred with rubies and turquoises,
> draped in velvet, brocade, silks, and fine white woolens, resplendent
> with gold and silver under a flood of light.
> On the steps of the stair stood groups of slaves, prisoners and
> captive females of every race, some half nude, others disappearing
> partly under the quivering, sparkling shimmer of golden gauze rayed

with a sunbeam, beauteous as Judith, weird as Salome, to say nothing of the new types discovered or dreamt of by the artist. Add to all this coffers inlaid with mother-of-pearl, from which stream strings of pearls, perfume burners in filigree work, cups filled with dinars and tomaums, silver vases, jasper ewers, dishes of Balearic earthenware, iridescent with all the colors of the rainbow, floods of stuffs, embroidered, striated, laminated with gold or silver wire, saddles and harness bossy with gold, quantities of weapons more precious than gems, flowers that would make the nightingale unfaithful to the rose, pigeons, their necks ringed with diamonds, gazelles gazing with wide-eyed amazement, and you will have some idea of what Regnault intended to paint.

In the center of the picture, through the half-opened doors, was seen in a transparent penumbra, like an idol within its temple, the Emir El Mumenim, receiving the tribute and the homage, impassible and apparently unnoticing.

This mysterious figure . . . was to secure the unity of the composition by centering in itself the display of luxury and splendor. . . .

Alas! Regnault's marvellous dream will never be realized, but as I closed my eyes, I fancied I could see it, with the poet's inner vision, radiant in its great gilded frame on the walls of the Great Room in the coming Exhibition.[29]

Gautier's inner vision was on the lookout for the factual and the overwrought in equal measure. Where Regnault aimed to invent his own Andalusian palace, Gautier saw a synthesis of the Alhambra and the Alcazar. Another mismatch between the Clairin-Gautier description and the young artist's own words written to Cazalis can be found in the Clairin-Gautier projection of "prisoners and captive females of every race," a capricious enlargement of Regnault's more well-defined vision of "a group of captive women. The most beautiful Christian women of the conquered province; they will be presented to the king and offered undraped; those upon whom his regard will deign to descend will be led to the harem."[30] But in the end, the vast work never progressed beyond the stage of studies and canvas acquisition before the painters left for France.

James Thompson linked Regnault's stated goals for the enormous unfinished tableau to the completed *Execution,* Regnault's actual final envoi on a Moorish theme. According to Thompson, Regnault wished primarily

to express two Arab qualities, civilization and cruelty, in his unfinished work, and "the simplified message [of the *Execution*] is one of the richest civilisation and the keenest cruelty coexisting in titanic, frightful splendour."[31]

Five things are most striking about the exceptionally theatrical and violent *Exécution sans jugement sous les rois maures de Grenade:*[32] its verticality; the intense orange and intricacy of the Alhambra interior; the expansive muscular torso of the self-possessed, frontal Moorish executioner; the brutal hauteur of his sword-wiping gesture; and the aggressive foreground gore of the bloody decapitated body on the steps. As an avatar of Arab masculinity, the executioner is indeed a figure of both exquisite civilization and grotesque cruelty. Gautier found his look "indefinable," both "disdainful and melancholic."[33] The executioner epitomizes athletic barbarity, decisiveness, absolute physical and political power, ruthlessness, swagger, and elegance, but also aloofness, even dreaminess. The Oriental man can be read to function in part as an antifigure that articulates by absolute contrast a profile of desired traits for the nineteenth-century bourgeois Frenchman: as he is brawny, dark, violent, and yet dreamy, a proper *français* would be Cartesian, pale, restrained, but emotionally sentient.[34] The Oriental executioner may be seen as a heterogeneous figure who functions both as the locus of Orientalism qua cultural genre and as a screen on which Regnault projects a radical model of socially and racially alternative masculinity, but poised nonetheless between condemnation of the other (self-affirmation) and admiration (self-critique).

The extraordinary large Orientalist watercolors that Regnault painted during the time of his wartime service in Paris, *Haoua, intérieur de harem* and *Hassan et Namouna,* exist in a vexed relationship with a work such as the *Exécution sans jugement.* They are just barely assimilable as products of the same artistic consciousness. Unpacking the watercolors requires a two-pronged approach. Familiarity with a prior canvas like the *Exécution sans jugement* is indispensable, but we also need to understand Regnault's mounting dissatisfaction with the meagerness of the role he played in the war in Paris. The latter helps to explain his total disinterest in painting episodes of the actuality of war. A word on that disinclination before returning to the sphere of Orientalism.

"It would naturally be supposed that the young painter [Regnault], excited by the spectacle of war, which was new to him, reproduced some

episode in the fights in which he had taken part so actively and so brilliantly; yet this is not the case."[35] *Pace* Gautier, the distinguished literary Orientalist and Regnault's most fervent posthumous supporter, Regnault never once tried his hand at a dramatic imagery of the Franco-Prussian War. Gautier was right that the dramatic subjects of modern war held no interest for Regnault in 1870–1871,[36] but he misinterpreted the grounds of the artist's indifference. Believing war to be a model of anarchic and dramatic representation perfect for the romantic pictorial intelligence of a Regnault, heir to the spirited colorist traditions of Baron Gros, Gautier thought that it would have been a natural subject for Regnault. Therefore, his lament casually maneuvers an assimilation of the dismal realities of French combat in the Franco-Prussian War into a standard romantic template. But Gautier not only misconstrued the nature of warfare in the Franco-Prussian conflict, he misunderstood and evidently underestimated Regnault's sustaining passion and need for art making in an Orientalist vein, and was coincidentally mistaken about the distinction of the young artist's military role in the war against Prussia.

To wit, remembering their war service, Henri Regnault's Pylades, Georges Clairin, recalled their frustration: "It seemed to us that they could have made better use of us; we fumed about not feeling more effective, when we would have—that was the idea—given all the energy we had. Regnault was particularly angry. He needed activity; on days off, he was furious."[37] Clairin's disappointment with the indolence and ennui of a soldier's lot in 1870 goes straight to the heart of the difficulties Regnault and his privileged retinue encountered in tolerating the widening discrepancy between the war service they sought and the petty military duties they were obliged to carry out. It also sheds light on the particular nature of the challenges and frustrations entailed in their efforts to straddle the divergent worlds of art and war in Paris in 1870. This pattern of mounting dissatisfaction left its traces in Regnault's art, a small corpus of work that also instances the artist's search for solace in an imaginary painted Orient.

The stark contrast between the sobriety and discomfort of their daily lives as soldiers billeted in wartime Paris and the absorption and freedom they had enjoyed as up-and-coming French artists living in North Africa in the late 1860s was a constant, but unsurprising, vexation for Regnault and Clairin. Realizing that what they were called on to do in the army was largely inconsequential was the disheartening insight. The

circumstances in which the newly baptized soldiers found themselves in Paris went totally against the grain of their expectations and youthful eagerness for strenuous, heroic, masculine military action. The situation became progressively more dispiriting, especially for Regnault.[38] His disappointment, enforced indolence, longing for Morocco, and growing feelings of frustration, even impotence, set the stage for the autumn 1870 watercolors.

Though his patriotism never flagged during the war, Regnault nevertheless detested having to shift back and forth between the independent timetable of an artist and the rigors of the scheduled duties of a soldier. He resented the disruptions entailed by the necessary shuttling between the divergent modes and spaces of his existence. As he was also a lovestruck young man, the interruption of his only recently formalized courtship of Geneviève Breton was also exasperating. In Cazalis's words, "How short was the time for those mutual joys and high spirits!"[39]

"Jojotte," the nickname given Clairin by the Bréton family circle, described the logistical inconvenience posed by army service for painters trying to remain focused on art in 1870: "During our days off, we returned to painting. . . . Then we had to take up again our knapsacks, cartridge pouches, and rifles, setting out again for the horrible reality of the war, its absurd peril and patriotic anguish. . . . An intolerable thing which exasperated Regnault was this perpetual rotation between military life and bourgeois life."[40]

Determined to surmount the logistical obstacles posed by the siege, Regnault was intrepid in his resolve to keep making art during the war.[41] The young artist's tenacity is the theme of Alexandre Bida's extraordinary graphite drawing, *Portrait of Henri Regnault Painting in His Unheated Studio, Paris, 1870* (Fig. 2), the only known image of a painter at work during the war. Bida (1813–1895) was a well-established Orientalist draftsman trained by Delacroix and intimate friend of the Bréton family, through which Regnault first made his acquaintance in 1867. He served at the age of fifty-seven in the National Guard during the Siege to set a good example.

The drawing captures the practical difficulties faced by the young, ambitious Orientalist trying to paint while serving his country in an unfortunate and inconveniencing war, all the while cut off from his preferred North African milieu—its motifs and warm climate—during the coldest French winter on record. As Jean Alazard reminds us, Regnault hated

FIG. 2. Alexandre Bida, *Portrait of Henri Regnault Painting in His Unheated Studio, Paris, 1870,* soft graphite on off-white wove paper, 1870, 29.6 × 26 cm., New York, Collection of Mr. and Mrs. Jean-Marie Eveillard. Photo courtesy Shepherd Gallery.

cold, gray weather: "'Hatred of gray,' that was his 'battle cry.'" Indeed, again quoting Alazard, "Few artists had the passion for the Orient to the same degree as Regnault."[42]

Bida's drawing shows a heavily clad Regnault seated in profile—a glimpse of the artist's handsome bearded face can be seen—leaning in toward a work in progress to which he applies a brush while clutching a palette in his left hand, in spite and in defiance of the evident discomfort of studio conditions. He is seated on a three-legged campstool, fortified against the cold by a heavy, shaggy coat with an upturned collar. A blanket is wrapped around his legs and draped across his lap, and he wears a makeshift head-warmer composed of a hat tied with a scarf (uncannily resembling an improvised burnoose).

The luminous, strange, large Orientalist watercolors illustrated here (Plate 4, Fig. 3), two of three Regnault did over a period of several weeks in October or November in Paris and presented to Geneviève Bréton, are stunning examples of his virtuosic watercolor technique.[43] They bear wit-

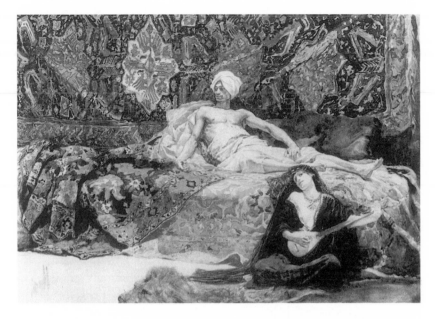

FIG. 3. Henri Regnault, *Hassan et Namouna,* watercolor, gouache and black pencil on paper, 1870, 56.5 × 79 cm. Paris, private collection. Reproduced in Roger Benjamin, *Orientalism: Delacroix to Klee,* Sydney: The Art Gallery of New South Wales, 1997, p. 121. Photo Roman Stansberry.

ness to the apparent contradiction and complex interconnection between Regnault's everyday life and his imagination. He painted them between his two primary fall activities: rounds of increasingly grim and unsatisfying military responsibilities and intermittent meetings with civilian friends. (He was able to see Bréton, for example, every evening between late August and early December.) As such, the watercolors demonstrate the conviction and single-mindedness he evidently mustered during the productive painting sessions he managed to complete in the Rue Chaptal studio, near Place Pigalle in the ninth arrondissement, lent by Albert Goupil,[44] son of Adolphe Goupil, the influential reproductive print publisher, dealer, and taste-maker. Albert Goupil, an enthusiastic Oriental art collector and Orientalist photographer, was the brother-in-law of Jean-Léon Gérome and accompanied Gérome on an extensive trip to the Orient in 1868.[45]

The ad hoc nature of these painting sessions is captured by Clairin: "His military great coat on his back, he made four or five large watercolors,

the most beautiful he ever did. Oriental subjects. He had brought boxes full of drawings with him from Morocco. We had thus several hours, from time to time, several hours of half-forgetting where we were, again enchanted by those luminous memories of Tangier."[46] Although Clairin makes no mention of dejection, according to Arthur Duparc, a friend and the editor of his letters, Regnault's friends persuaded him in October to resume painting to cure his melancholy: "He gave in to their wishes, although he felt no relish for sessions of work undertaken between two rounds of guard duty on the ramparts. But he posed a condition: he would dispense with all labor of the spirit, and he would be presented with all the objects he had to represent and he would simply copy them. The studio of Goupil was decorated for him with rich Oriental hangings, with striking silks, and with carpets in vivid and varied hues."[47]

Viewed through the lens of Duparc's account, the two watercolors acquire the distinctive aura of work by an artist obsessed with and longing for ailleurs, but an Oriental elsewhere at odds with his strained Parisian circumstances. They certainly have the look, albeit labored, of work by a painter determined to carry on as an Orientalist *no matter what* because he sought comfort during his unsatisfactory war experience in memories of Morocco and the effort to prolong the projects he had undertaken there. And the distinctive hothouse atmosphere of the images is especially striking in view of his proclaimed emotionlessness and detachment while he worked. The apt words of Gautier address the contrast between the watercolors and their wartime context: "Modern war, carried on by mathematical means, unornamented weapons, ugly uniforms, and settled evolutions, could have but little picturesque attraction for Regnault, who was in love with Oriental color and fancifulness. Thus it was that, through an operation of the mind easy to follow, his imagination carried him back to the land of light."[48] Or rather, in Clairin's words, a more direct linking of the pursuit of the imaginary Orient to the avoidance of the inadequate "real": "We dreamt, Regnault and I, of those battle paintings of the trenches in Sébastopol [in the Crimean War], and we said to ourselves that the reality of a war resembled not at all what one saw in the museums."[49]

Gautier's appraisal of the watercolors, written in March 1871, appeared in the catalogue of the posthumous exhibition of Regnault's work held in 1872 at the Ecole des Beaux-Arts. It was apparently Gautier who titled the works, linking one to the writings of Eugène Fromentin and the other

to a poem by Alfred de Musset. His reading of *Haoua, intérieur de Harem* (Plate 4) requires full quotation:

> The first of the three watercolors I examine represents a young woman lying on a divan, dressed in a costume composed chiefly of white transparent stuffs with opaque stripes. All this whiteness produces the effect of the camellia surrounded with different flowers that is placed in the center of a ball bouquet; they draw and concentrate the light, and their brilliancy spreads in soft undulations upon the brighter surrounding hues. The woman herself, half lying down in a pose rendered more supple by the languor of the kief, recalls the lovely Haoua, whose exquisite portrait Fromentin has drawn in "A Year in the Sahel," with a literary skill that equals his talent as a painter. It is impossible to admire too much the astonishing harmony of the stuffs, the carpets, the accessories, of colors apparently disparate, but the contrast of which melts into perfect accord. No painter, since Eugène Delacroix painted his *Women of Algiers,* has cast more limpid shadows over the shimmering of a rich Moorish interior.[50]

Gautier was perhaps too immersed in the Orientalist culture of his day and in mourning for the dead painter to discern the stranger aspects of the painting that jar into view once the contrasts Regnault attempted to mask, indeed to hold at bay, are enumerated: the structural difference between its hot motif and the cold climate of its manufacture, between the thematics of languor and lassitude it figures and the hurried painting sessions in which it was carried out, between the male privacy of the harem theme and the busy social space of Goupil's borrowed studio, and between the sultry sexuality of the subject and the artist's proclaimed detachment from the undertaking. And according to Cazalis, who confirms that this was the first watercolor, Regnault was not satisfied with the results: "Despite its merits, it satisfied the artist very little."[51]

Closer scrutiny exposes the contradictory elements that complicate the surface fiction of the painting. Gautier used a flower metaphor[52] to characterize the contrast between the whitened figure and the saturated, darker hues of the surrounding rugs, wall coverings, and hangings, and also to imply, I think, a connection between this odd picture and its metropolitan context ("the camelia at the center of a ball bouquet"). But the implications of the disparity between figure and surroundings do not stop there. The woman appears washed out, ghostly, almost erased by

the strong contrast of value between her whiteness and the multicolored darkness of her milieu. Her small scale and uniformly pale tonality relative to the size and intricacy of the dark and ornate setting make her appear overwhelmed and dwarfed by her surroundings, rather than appearing set off or enveloped by them in a balanced or mutually enhancing manner. Cazalis underscored her frailty and languidness by characterizing her as "slackly or indolently sinking into a cushion."[53]

But the strength of her bodily individuality, encompassing her stiffly cocked head, tilted upper body, tentatively inquisitive and oblique gaze, and cross-legged sitting position, is also striking in its self-possession. The perfectly paired harem slippers in the left foreground strike another unusual note and deserve their gloss. The shoes set in motion a narrative of work rather than sensual abandon. Their inclusion and prim placement could be seen to invoke the orderly labor of a professional model, carefully removing and setting aside her footwear to assume the mandated pose in a methodical fashion. The whiteness of the model's skin privileges this reading, while, at the same time, the shoes are a signifier of the Orient, referring to the Oriental practice of removing one's shoes at the edge of carpets — an aspect of the painting that helps to establish the heterogeneity of the figure.

Suffice it to say, even at the risk of mouthing a cliché, that Regnault's watercolor does not build the customary intersubjective circuit between a painter's or surrogate onlooker's gaze and a harem woman's seductive replying look, such as that famously engineered by J. A. D. Ingres in his *Grande Odalisque* of 1819 (Musée du Louvre, Paris), for example.[54] Put another way, the woman's singular way of being is not subsumed by the typical ideological and aesthetic logic of the obliging solitary odalisque. Her bodily demeanor and quizzical facial expression resist the proverbial male onlooker. The resulting female figure is an unusual amalgam of ghostly cipher and self-possessed individual. And how different she is from the female figure in Regnault's earlier work. Considered against his North African genre pictures featuring a prominent female, Haoua is without the raw physical sensuality of the half-naked black women in his *Négresse dansant* or the *Slave Girl*. She likewise lacks the sensational capacity for murderessness with which his *Salomé* or several versions of *Judith* were endowed.[55]

Gautier's mention of Delacroix was off-base. Regnault's work descends from *Les femmes d'Algers* only insofar as it employs a rich green and red

FIG. 4. Paul Cézanne,
Une Moderne Olympia, oil
on canvas, ca. 1870,
Paris, private collection.
Reproduced in Hollis
Clayson, *Painted Love:
Prostitution in French Art
of the Impressionist Era,*
New Haven: Yale
University Press, figure
6, p. 17. Photo Roman
Stansberry.

palette and an Oriental mise-en-scène. Regnault's watercolor is a distinc-tively different kind of representation of a staged North African harem scene. One way to characterize Regnault's woman in the first watercolor compared to those of Delacroix might be to call her a sensually disem-powered odalisque. The figure is the specific site of Regnault's struggle to maintain the distinctive femininity of the harem milieu and to uphold the odalisque as the signifier of Orientalism, but she is also the emblem of his inability to preserve the imaginary harem's yielding erotic atmosphere under the trying conditions identified here.

In its withholding or repression of the allure of harem sexuality, it strongly resembles a contemporaneous work from the opposite end of the spectrum of contemporary French art, Cézanne's first *Une Moderne Olym-pia* of 1870 (Fig. 4). Though articulated in a different aesthetic vocabu-lary, a different style, the timorousness and precariousness of the small scale and right-leaning axis of the contorted young woman at the center of Cézanne's puzzling painting resemble the affect and pose of the pale Haoua of Regnault's watercolor. When looked at alongside Regnault's wartime exertions with North African imagery, Cézanne's awkward thematization of the sexual perils of the Parisian *maison de luxe* can be assimilated into the orbit of period Orientalism, generating a novel cate-

gory of the imagination and of iconography: the Orientalism of modern life.

Regarding the second watercolor, *Hassan et Namouna,* the authoritative Gautier again wrote at length, and the text deserves quotation in full.

> The subject of the second watercolor is also an interior, but wholly different in meaning and values. On a divan covered with brocade, silk, or morocco leather cushions, is seated, or rather is squatting, a young man, bare to the belt, almost as dark as a mulatto and resting his arm on his knee with a movement at once most bold and skillful. It is a strange figure. A sort of carelessly wound turban covers his brow with its broad folds and casts mysterious shadows over his eyes. He looks like an Eastern Manfred or Don Juan who has perchance been acquainted with some other civilization, and has sought a new experience in his weariness. As I looked on that frame, spare, muscular, consumed by passion, I thought of Hassan, the hero of Alfred de Musset's "Namouna," who, exchanging the cigar for hasheesh, had repaired to the Land of the Sun to impart some warmth to his scepticism. It is not likely that the artist had this in mind, but his watercolor does suggest the notion: the weariness of voluptuousness, the longing for the unknown, the lassitude of artificial paradises, as Baudelaire called them, are visible on his worn face, still youthful in spite of the excesses he has indulged in.
>
> On the thick carpets that cover the floor is stretched out a young woman, who, leaning her shoulders against the divan, and dressed in a black gandourah with hood, half opened on the bosom, of a whiteness recalling the moon emerging from behind a cloud, is nonchalantly touching the cords of a guzla with her henna-tinted fingers as she accompanies herself. The song issues sigh-like from her inattentive lips; she feels that she is not being listened to, and is following out her dream. Wide apart indeed are these two beings, both young and beautiful, who are placed at each end of a divan.
>
> In spite of the violence of the tones maintained in the shadow with a superb mastery of color, the luxury that surrounds them is dulled in its richness, marked by somber ardor and has something of a funereal seriousness. It is a wealth of curtains and portières made of stuffs wrought by the most perfect art of the Orient, magnificent tissues, Smyrna, Kabylia, or Turkey carpets, trays inlaid with

mother-of-pearl, arms studded with gems, Khorassan narghilés, and yet there is something tragical in all that mass of splendor. The room might well be the scene of a mad fit of jealousy or of a murder, and blood would not show upon the somber purple carpets.[56]

In his lengthy commentary, Gautier annexed Regnault's painted world to the literary domains of Musset and Baudelaire via his detection of a drug-induced lassitude in the figures and a mood of funereal seriousness or even foreboding. It is not surprising that Gautier's touchstones were writers rather than other painters of the Orient in view of the oddities of the iconography and confusing dramaturgy of Regnault's watercolor. Indeed, aligning Regnault's unnamed reclining Moor with Musset's Hassan was an extraordinarily bold act (an association he admits was unlikely to have been made by Regnault) because the protagonist of Musset's turgid 1832 poem "Namouna" is a half-European figure of all-consuming narcissicism and sexual cruelty. But in so doing, Gautier courts an alignment between the self-indulgent and cruel Hassan, and an expatriate Frenchman like Regnault, an affiliation that interests me in ways I discuss below. To Gautier's credit, in this piece of criticism, unlike his reading of *Haoua, intérieur de harem,* the author acknowledged and strove to characterize the eccentricities he confronted, especially the palpable separation between the two figures ("wide apart indeed are these two beings"), more on which follows.

Cazalis's assessment of the second watercolor echoed the general tone of Gautier's findings by emphasizing the lassitude, self-absorption, and voluptuousness of the Moor, perceptions based in part on period clichés about Arabic men (and enhanced, perhaps, by Gautier's reference to Musset). Cazalis also observed the "mournful languor" of his female companion:

> The painter finished up with a masterpiece: this bestial Moor, perhaps sodden with opium, with a swarthy body, whose obliquely glancing eyes, black too and burnt by the sun, with their mournfully dazed condition express the lassitude of light, the fatigue of voluptuousness, the implacable and sometimes ferocious ennui that sleeps in the eyes of the entire Orient. He has the impassibility of animals vanquished by the sun, and who focus on empty space with a vacant stare. It is without doubt that no desire, no sensation or thought could distract him: not even this delicious slave in her black

haïck, crouched at the end of his couch, and who, with bent neck, gently turned head, inflated breast that breathes, in a pose of merciless and mournful languor, touches the chords of a Moorish guitar with a distracted finger, and seems to produce a note sharp like a bite. The sultry air of the harem, charged with the perfume of musk exhaled by all the cloths, makes the atmosphere of this interior even heavier, in which the décor, the rugs, the hangings are rendered with an incomparable strength.[57]

It is evident that the contrasts between motif and material and psychological conditions of manufacture negotiated by Regnault in *Haoua* were confronted again and adjudicated anew in *Hassan et Namouna*. Though we will never know if models posed for either work. Let us turn directly to Gautier's ascription of high drama to *Hassan et Namouna*, not experienced, evidently, by Cazalis. It seems obvious when encountering the picture at the opening of the twenty-first century that the primary basis of the aura of tragedy or some form of drama that Gautier felt in the painted space was Regnault's (unwitting?) reversal of the dominant trope of gender in the two-figure harem painting, exemplified by Ingres's *Odalisque with a Slave* (1839; Fig. 5). The beautiful, languorous man in Regnault's watercolor, with the perplexing, dissimilar hands—one actively gripping, the other loose and open—usurps the stock role played by the reclining female odalisque, albeit in a sulky and inattentive fashion. Both his inactivity and pose are conspicuous, but also the mere fact of his central role. But the gender reversal is only partial, of course. The subsidiary figure, the musician/servant, is female in both pictures. And while the use of two women in a picture like that of Ingres positions a heterosexual viewing subject outside the space of the painting, Regnault's use of a man and woman carries the promise of some erotic attraction or connection between his two figures (especially, again, in view of the link suggested to the Hassan and Namouna characters in Musset's poem).

The racial difference alone between the two figures would seem to provide the ground for an erotic connection in view of an Orientalist trope used, for example, in a studio photograph by Jacques-Antoine Moulin (1802–after 1875). In his *Study: Seduction* (1852; Fig. 6), a half-naked white woman inclines onto the lap of an Orientalized black man.[58] The photograph's title informs us that a seduction is underway, but the man makes no response.

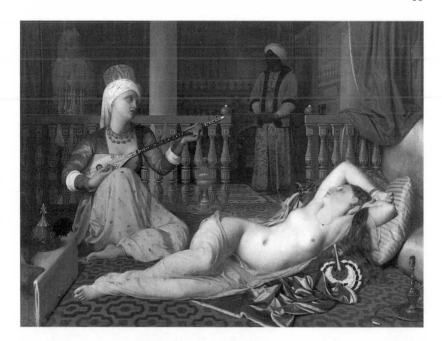

FIG. 5. J.A.D. Ingres, *Odalisque with a Slave*, oil on canvas, 1839–1840, 72.07 × 100.33 cm., Fogg Art Museum, Cambridge, Massachusetts. Photo courtesy of Photographic Services, Fogg Art Museum, Harvard University Art Museums, Bequest of Grenville L. Winthrop, copyright President and Fellows of Harvard College, Harvard University.

The elaborately costumed dark man in Moulin's photograph is not a generic Moor like Regnault's Hassan. He is a uniformed Turco, as Algerian riflemen serving in the French army were called.[59] Unlike the Zouave, who was a native Frenchman, the Turco was an indigenous Algerian, recruited by France as a skirmisher in the infantry. (The word Turco was an 1852 Russian coinage because from a distance they apparently looked Turkish.) They wore a uniform of sky blue trimmed in bright yellow, with a wide red belt and a white or red turban. Hence, although Moulin's 1852 photograph may appear at first glance to thematize sexualized interracial relations in an imaginary Orient, it is actually embedded in the interest of white Parisian women in sexy Algerian soldiers during the Second Empire. As Elizabeth Childs has explained, "The attractions of the turcos to the opposite sex were increased by their associations with exotic love."[60] They fought for the French in the War of 1870, and the

FIG. 6. Antoine-Jacques Moulin, *Study: Seduction*. Photograph: salt print, 1852, 35.6 × 27.1 cm. Bibliothèque Nationale de France, Paris. Reproduced in *After Daguerre: Masterworks of French Photography (1848–1900) from the Bibliothèque Nationale,* New York: The Metropolitan Museum of Art, 1980, figure 105. Photo Roman Stansberry.

sight of uniformed Turcos was common in Paris and elsewhere in France during the Franco-Prussian War.

Like the woman in Moulin's photograph, the Occidental guitarist in Regnault's scenario coexists with a dyspeptic dark-skinned Oriental man, but she makes no overture to him. If her tilted head and exposed neck constitute an overture or at least vulnerability, it is directed at "us," not her companion. Thus the instatement of a sexual or romantic connection between the two figures in Regnault's picture is foreclosed, creating a strong tension in the picture and giving it a disjointed character. The distance between the two figures, as Gautier indicated, is further served by the incongruities in the woman's own figure, especially by her inattentive musicianship, most evident in the mismatch between her strumming fingers and angular, dramatic, moody head. The contrast between her activity and the imperturbable, staring, glass-eyed head of the nearby dead lion serving as a carpet is also unsettling.

The question is whether Regnault's Hassan is an alternatively costumed Turco. If so — this is impossible to verify — the "languorous Moor" would acquire a contemporary Parisian military valence and an even more secure North African identity. Even if the identification of his Hassan as a Turco were secure, his willful recostuming and dehistoricization by Regnault are what count. The matter opens back up again if one speculates about the political significance of Regnault's having rendering a costumed Turco soldier inactive in his tableau.[61] In any case, in the register of artistic genre and rhetoric, the man's passivity and languid pose, not to mention his horizontality, strike odd notes in Orientalist art of the period, not to mention the vivid contrast he makes to the standing Moorish executioner in Regnault's own *Exécution sans jugement*. The Oriental man in Regnault's work can be seen as a figure of cultural and self-criticism insofar as Regnault's retreat from academic art and the metropole was an explicit escape from certain aspects of bourgeois convention.[62] But, as in the case of the Moorish executioner of the *Exécution sans jugement,* Regnault's identification with the male protagonist of *Hassan et Namouna* must be found ambivalent or fractured insofar as the governing mise-en-scène of the picture is Oriental and therefore alien. But can we ever call the Orient as summoned up in Orientalist representations fully alien insofar as the Orient imagined through Western representation is an artifact of European consciousness rooted, if only

indirectly, in colonialism?[63] In *Hassan et Namouna* we are again witnessing Regnault's complex straddling of the poles of identification and objectification, of self-critique and self-affirmation.

But the differences between the Oriental males in the two 1870 paintings are most striking. As an avatar of Oriental masculinity, Hassan is the countertype of the decisive Arab executioner of the earlier canvas. The shocking agency of the arresting Oriental murderer differs sharply from the inactivity of his beardless Parisian brother, the listless reclining Moor. Hassan may even be likened to the disenfranchised soldier, Regnault himself. Indeed, the resonance between Regnault's boredom and protracted waiting for something to happen, on one hand, and the muscular impassivity of his oriental Don Juan with his telltale tensed left arm, on the other, is also striking. In his conceptualization of this particular male figure, there might have been an unusually strong vector of identification, if identification is understood to combine admiration and inchoate envy and to enable an imaginary intersubjective exchange.[64] Objectification is simultaneously at work in this process, insofar as objectification entails the recognition of the otherness of the object of sight.[65] Regnault might have been projecting his own feelings of frustration with the passive regimes of his military service onto his invention of the beautiful Oriental man arrayed on a luxurious couch waiting for something to happen. The uncanniness of Gautier's naming the figure after Musset's restless Euro-Arab Hassan becomes ever more striking. Regnault's likely familiarity with Turco soldiers fighting with the French may have strengthened the bond of identification or at least of empathy. The imaginary link between the artist and his constructed Moor edges ever closer to the province of overdetermination.

Another difference between Regnault's Moroccan-Andalusian Orient and its transposed Parisian forms is the dramatic alteration in the mise-en-scène. Both Parisian watercolors are densely packed, to the degree of patent horror vacui, with carpets and their hectic, brightly colored ornamental patterns.[66] The *Execution without Trial* was set in a specific room of the late medieval Alhambra palace in Granada, but how may we characterize the settings of *Haoua, intérieur de Harem* and *Hassan et Namouna*? Their array of carpets gives them a generically Oriental appearance, but their projected localities cannot be named with any confidence or precision. Andalusia? Morocco? Certainly not, but where? Turkey? Perhaps, or simply a spot amid Goupil's vast carpet collection in Paris. The richness

and ambiguity of the generic carpet-laden interiors evacuate the works of historical or cultural specificity. History painting to invoke the grandeur of medieval Andalusia on behalf of contemporary North African descendants of the Moors gives way to cloistered improvisation, an exotic form of Parisian bricolage.

Returning to the matter of the contrast between the two male figures: unlike the invention of the Moorish executioner, the depiction of the languorous reclining Moor was bound up with a discourse of militarized masculinity in mobilized Paris in 1870. Hassan is figured through the discourse invoked by Gautier and Cazalis about languorous, drug-besotted Oriental men and the pictorial rhetoric of Oriental harem painting, but also through the discourse of martial male identity in wartime (encompassing Occidental and Oriental soldiers), a web of concern and consciousness in which Regnault was deeply embedded at the moment the watercolor was painted. Hassan is the antithesis of the ideal French soldier and, as such, the opposite of the young man portrayed in Bida's second portrait of Regnault, discussed below. But, to repeat, Hassan's indolence resembled the state into which the restless artist felt himself to have been thrust.

Likening the reclining Oriental man to the frustrated Regnault is not the same as arguing that even the closest friend would have detected any exterior sign of diminished masculine vigor in the young mobilized Regnault. To the degree that men can swagger standing still, Regnault is certainly shown doing so in his portrait drawn by Bida in late October 1870 (Fig. 7).[67] Regnault presents a jaunty and informal figure, looking as though he wore a costume rather than a uniform. With his left leg crossed over the right, kepi pushed back casually on his head, and vigorously crossed arms, his whole body leans forward (implausibly) against his impressively (impossibly) lengthy rifle. His gaze is focused off to the side, projecting an active, manly, though youthful enthusiasm for upcoming military adventure.

The novelty of new clothing and equipment may have given him the rakish look played up by Bida, but the equipment Regnault and his friend Clairin carried apparently remained foreign to them. According to Clairin's sartorial inventory, their uniforms consisted of "brown great coat, brown trousers with red stripe, brown kepi with red band, breech-loading rifle which we didn't know how to use."[68] Indeed, Clairin frequently mentioned the unfamiliarity of their hardware and the degree

FIG. 7. Alexandre Bida, *Portrait de Henri Regnault en uniforme* (Portrait of Henri Regnault in Uniform), pencil drawing, 1870 (inscription: "69e bataillon de marche, 2e compagnie, 29 octobre 1870"). Reproduced in Geneviève Bréton, *Journal, 1867–1871* (Paris: Éditions Ramsay, 1985), frontispiece. Photo Jay Crawford.

to which the eager young soliders were unprepared for military duty. Pointedly he observed:

> The young men of the Second Empire were not prepared for the job of being soldiers. Every detail of military life escaped us.
>
> We had never been soldiers. At that time, young men who did not plan a career in the army bought replacements. Nevertheless we were all involved.
>
> Regnault and I and so many others! had never held a rifle; the use of a breech-loading rifle escaped us. Plus, both of us were left-handed. Our maladroitness was ridiculous, comic and depressing.[69]

To repeat, no maladroitness figures in Bida's portrait of the uniformed Regnault. There is no fracture or contradiction in this jaunty image of military suavity and savoir-faire. It was nonetheless clever of Bida under

the circumstances to have used the apparently vexing rifle as a signifier of militarism and male potency rather than as a weapon per se in his drawing.

Regnault's preliminary plans for *Hassan et Namouna* were certainly otherwise, based on the evidence of a surviving study (Fig. 8). As Roger Benjamin aptly observes, "Regnault's charcoal and wash figure study seems closer to this dramatic intent [that proposed by Gautier] than the final version."[70] One rightly wonders if the drawing was brought from Morocco or fashioned in Paris. Its ferocious eroticism and explicitly Delacroixesque dramaturgy persuade me that this undated study was done before Regnault uprooted from Morocco. The half-reclining young female nude, draped (or unmodeled?) only below the groin, hovers between yielding and being forced into position. She is in remarkably precise conformity with the bodies of the cognate women participants of the distinctively sexy and violent Oriental realms of Delacroix's masterpieces of the 1820s, *The Massacre at Chios* and *The Death of Sardanapalus.* The active physicality of the two figures in Regnault's drawing—they both gesture

FIG. 8. Henri Regnault, *Study for Hassan et Namouna,* engraving after a drawing of circa 1870 whose whereabouts are unknown. Reproduced in Roger Marx, *Henri Regnault, 1843–1871* (Paris: J. Rouam, 1886), 81. Photo Roman Stansberry.

toward and face one another—unambiguously link them in a closing or emerging narrative of sex or violence; a highly charged, physical connection, in any case. The overall atmosphere of the figure drawing and the triangular wedge of space between the two figures in the boudoir setting exude carnality and lurking (or a potential for) danger. The study underscores the intersubjective, gender, racial, and genre tensions that prevail in the Parisian watercolor that eventually succeeded the drawn study.

In view of their complex figurations of ethnicity and gender identity, one wonders what Geneviève Bréton thought of her fiancé's Orientalist watercolors.[71] On November 8, 1870 she mentioned one of the paintings in the context of a self-avowed vulnerability to the intoxicating powers of luminous painting:

> My head spins to look at painting. I become positively drunk with light [and] color, just as others are by wine and absinthe, words and music. I've seen what he's doing.
>
> Bida has just taken me to [Henri's] studio. Merely being there, not as a stranger, but as his friend, his *betrothed,* was in itself sheer happiness. *"It's very fine,"* I said simply. He replied with a few sweet words in Spanish, and that was all. But I'm very happy that since me he's remained such a great painter. My reign has not marked a decline or deterioration in his talent. In short, my love hasn't made his art conventional (bourgeois). I can't analyze these watercolors of his, nor say exactly what they represent. I seem to see only a fantastic flower amid wonderful vegetation, its calyx shaped like a woman's head in the center of an inflorescence of the richest colors. It's a dream of tapestry tints whose rich colors have never achieved such brilliance and power, or such extremes side by side such exquisite delights.[72]

Though short on details, the final paragraph suggests that she was studying the first watercolor, *Haoua, intérieur de harem.* The news that a romance with her did not result, in Bréton's jubilant formulation, in a disabling *embourgeoisement* of Regnault's art is certainly telling. She was evidently reassured by the mere fact of his ongoing work, gratified that his capacity for artistic work had not been spoiled or compromised by his hasty return to Paris, headquarters of the two aesthetic models he especially disliked: city-based academic painting and the art of modern life.

She also apparently believed that an assiduous, continuing exploration of Oriental themes including women, coupled with the overarching fact

of Regnault's ongoing labor within his métier as artist, confirmed that his art had not been domesticated or feminized by his romantic attachment to her. The satisfaction she expressed with her discovery that his art was not domesticated by his engagement to her does not eliminate the possibility, of course, that she cherished the hope that *he* would become *embourgeoisé* by her and the institution of marriage once he became her husband. This subtext raises another issue of importance to our discussion of Regnault's Orientalist watercolors. Was his work in this vein also embedded in the dynamics of romantic love? Was it an effort to hold at bay the inevitable domestication entailed by being engaged? Mightn't this have been the anxiety that drove the clever young Bréton to decide that a vetting of her fiancé's pictures was a necessary undertaking of verification, one that would help her to size up where she stood vis-à-vis Regnault's devotion? And that this was the real reason she felt the need to reassure herself that there was nothing to worry about: that if his art was intact, his connection with her was likewise unbroken? Was the sphere of Orientalism thus a realm of imagined freedom for him in yet another sense? If the answers to these highly speculative questions are affirmative, we have detected another *décallage* between life and art, and one more frontier of yearning and displacement to be teased out of Regnault's wartime Orientalism.

The inference that Bréton drew from the vigor of the watercolors invites still further commentary. Her stated line of reasoning—that the Orientalist works demonstrate that Regnault had eluded an embourgeoisement of his project and of his spirit—points straight back, paradoxically, to the similarities between Regnault's first watercolor and Cézanne's first *Une moderne Olympia*. The resemblance between their joint refusal of an imagery of Baudelairean-Delacroixesque harem ecstasy may instead gainsay Bréton's confident and reassuring reading of the proverbial masculine vigor of Regnault's wartime enterprise. Concerning Cézanne's painting, I have observed that Cézanne was negotiating the clash between "the fabled allure of the stylized, romantic forms of eroticism offered in the deluxe brothel of the 1870s" and the more modern forms of venal sex for sale in the contemporary metropolis, the "simulation of bourgeois romance."[73] Might the awkwardness of Regnault's products bespeak a similar clash? But in his case, the conflicting impulses were, on the one hand, the reflexes of committed Orientalism based in its established tropes and his Moroccan experiments and, on the other hand, the

disabling vexations of his wartime service and his preoccupation with his love for his close-at-hand fiancée. From which emerges another loose thread. Perhaps my analysis has underestimated Bréton. Maybe she anticipated my reading, and saw what I have claimed to see. In that case, the wartime absence of harem ecstasy from her fiancé's imagination was what she might have found reassuring.

The war eventually prevailed and made it impossible for Regnault to keep painting. Once Regnault's company moved to the avant-postes in Arcueil in early December, he no longer had access to a painting studio and was dislodged once and for all from *la vie bourgeoise*. But the movement of troops that pulled the painter out of the disjointed routines he had established in Paris did not produce the long awaited action. Quite the contrary. In a December 11, 1870 letter to Bréton, he complained openly: "The stupid fatigue duty of our nonsensical work help us to pass our days and nights somehow or other. I haven't suffered too much from the cold, I've gotten used to it well enough and I'll not end up frozen if I have to keep doing this guard duty for long."[74]

Regnault's accelerating frustration and disgust are evident in his *jour de l'an* letter to Bréton describing his January posting at Colombes: "Tomorrow afternoon at 4 o'clock, we begin picket duty, the day after, [it's] guard duty. Our commanders have taken steps to restrict such outpost duty to twelve hours. In practice that means that a company mounts guard duty from 5 in the evening until 6 in the morning, and will be relieved during the day by half a company [when conditions are less dangerous]. Don't ask me to tell you anything other than: I'm bored, I'm bored, ad infinitum."[75] The restlessness and discouragement that led to his somewhat impulsive participation in the Buzenval sortie were building. Clairin described their mounting frustration: "Only one thing was excruciating and almost intolerable for us: inertia. But, in spite of ourselves, ignorant and naïve, we tried to comprehend what was expected of us. In every one of our sorties, we hoped to seize the very knot of the action. When finally we would return, feeling that we hadn't done anything useful in spite of all our effort, our chagrin weighed even more heavily upon us."[76]

Private jottings, written in the field in mid-January, according to Clairin, were found on Regnault's dead body. They expressed a grim new resolve articulating a determination to adopt an altered habit of mind in

order to become a *combatant,* not just a soldier, and to shake off thereby the unbearable passivity of idleness. To crudely align this struggle with the imagery in his art: Hassan, the ambivalent figure of self-indulgence and discontent, was itching to become the Moorish executioner, a man of action.

Regnault had always aligned artistic productivity and indeed well-being *tout court* with self-absorption, but also with freedom of action. He came to the realization at a critical point in the war being fought just outside Paris that egotism was incompatible with the group ethos necessary for effective combat. In the sobriety of mid-January, he wrote:

> We have lost many men; we must replace them with even better and stronger ones. We must learn a lesson from this. Don't let easy plea-sures make us soft. The life of the solitary self is no longer allowed. There was a time, not long ago, for belief in nothing other than plea-sure and all the wicked passions. Egotism must flee and take with it that fatal vainglorious scorn for everything that was honest and good. Today the Republic requires of everyone a pure life, honor-able, serious, and we must pay everything for the *patrie,* and even above the *patrie,* to free humanity the tribute of our body and soul.[77]

The solidarity and sobriety required for battle were at odds with the romantic individualism that Regnault found necessary for making art, and indeed, for enjoying social life. His characterization of "the right stuff" needed for the individual to rise to the challenge of armed combat was the acceptance of the need to dissolve his individuality in a group identity. Only in January did he embrace an ethos of cooperation in an effort to escape the unbearable torpor and uselessness of military rou-tine. He certainly expected the transformation of his identity to be a brief instrumental episode, following which he could resume his normal life, reclaim his old self, and get back to work. That he would lose his life on January 19 could not have been foreseen.

Gautier intuitively grasped the probable link between Regnault's changed attitude and what was intended as a temporary suspension of painting and drawing on Regnault's part in January. Gautier's grasp of the situation that Regnault faced emerged in the context of his own think-ing about Regnault's disinterest in documenting his immediate circum-stances:

Thus it was that, through an operation of the mind easy to follow, his imagination carried him back to the land of light. The gray heavens, the ground, muddy or glazed with livid snow against which stood out the silhouettes of the combatants, the smoke of powder mingling with the fog, did not offer tones rich enough for his glowing palette. It is possible that if he had lived longer the poetry of such somber and gloomy effects would have impressed itself upon him and inspired him with a subject for a wonderful sketch. But the feeling of duty, hatred of the invader, chivalrous courage, and the all-powerful attraction of danger, to which Regnault was peculiarly sensible, alone filled his mind at that time when the artist in him disappeared in the citizen. A few notes found on his person after the battle testify to his manly and firm resolve on this point; he had accepted all the consequences of the sacrifice he had made.[78]

Regnault's unforeseen death notwithstanding, Gautier was surely right to see the artist's January resolve as a personal obstacle to making art at that moment, an impediment that in all probability would have vanished had Regnault lived. Whether or not the "subjects" of the war would have ever engaged his interest is an open question. Gautier's most interesting move was to connect Regnault's disinclination to paint with *manliness,* with an embrace of a full-blown military masculinity as the artist became a citizen. Even the emotional succor and release sought in imagining the Orient had to be foresworn.

> If selves are constituted through networks of institutional, symbolic, and material everyday practices, then given the homologies between psychic and social structures, sufficiently disrupting the first must, in some corresponding way, rattle the latter. —Laura Kipnis[79]

To venture a corollary to Kipnis's formulation: if social structures are disrupted, mustn't psyches and their precipitate in cultural practice be transformed in the process? This sediment is, of course, what we have been trying to excavate in this investigation, the loose ends of which I will now try to tie up.

Gautier's invocation of manliness underscores the difficulty of defining a stable, unitary, normative, male military subjectivity in 1870–1871. For Gautier and his generation, the self-sacrifice required by the nation at war was the embodiment of an admirable, heroic, and indeed obligatory

masculinity, and, as such, its requirements could legitimately eclipse the demands of art because in war, the spheres of labor and self were held to be irreconcilable. But is Gautier's model of selflessness exclusively male, let alone martial? Indeed, we can see Regnault's particular version of a foreswearing of egotism and self-absorption in a different light. It was surely meant as a secular and instrumental embrace of army-specific male solidarity, but it was at the same time a yielding or dissolving of self in a higher cause that echoes the ethos of Christian altruism. Paradoxically, Regnault's conversion to the collective sphere of identification can also be seen as an alignment with the mandates of feminine behavior. Indeed, his capitulation to the imperative of battlefront selflessness is a somber emulation of Geneviève Bréton's ecstatic surrender of her freedom to the gendered requirements and consequences of the mutuality of romantic love: "*I belong* to someone. I'm no longer free, and in my conscience I'm as indissolubly tied as if Law and Church had sanctioned my promise. I've allowed someone else in the world to say *my Geneviève,* to use this possessive word. From anyone else it'd make me protest, but from him it makes me proud and *fulfilled.* The proud, the solitary, *the only,* I am now the other half of somebody. Since yesterday I've come *alive.* Before, I was *asleep,* and now I've woken forever."[80]

The accord between Bréton's loved female self and Regnault's group-oriented militarized male might seem a startling parallel, but there are surprises in store when subjects shuttle among redrawn spheres of love, art, and war. The convergence pulls us straight back into the realm of the composite identity of the Oriental man in *Hassan et Namouna,* and into the mirrored room of gender in the art world and the army in Paris during the War of 1870.

The dreamy Hassan ursurps the role of the female odalisque and in-carnates a languorous, indolent, self-absorbed, sensuous Oriental mas-culinity in the process of enacting an image of selfhood that must have briefly resonated with Regnault's own discontented, martial European male self that was chafing to do something militarily effective while en-gulfed by apparently soothing and productive Moroccan reveries. The figure of Hassan that joined self and other in a heterogeneous figure of Orientalized self-absorption was, however, an unstable point of identi-fication for Regnault. The figure could be only a fleeting touchstone for him, because Hassan was a feminized and alien ego ideal from the cul-tural standpoint of a European enmeshed in the countervailing discourse

of military manhood that required action in the form of selfless devotion to the cause of war, a dedication, paradoxically, worthy of a *bourgeoise* in love.

Georges Clairin, the compleat comrade-in-arms, best friend, traveling companion, Orientalist painter, roommate, fellow soldier, bereft and devoted survivor,[81] earned the last word on the dire contrast between the young artists' North African paradise and their Parisian torment of danger, inaction, and ignominy: "Here we were, transported abruptly from that apotheosis [life in Tangier] to the horrible reality of an unhappy and humiliating war. Defeat took the place of security."[82]

Notes

Sincere thanks for guidance on the topics of Henri Regnault's art and Orientalism and for advice on matters of interpretation go to Jill Beaulieu, Christine Bell, Roger Benjamin, Petra Bopp, Elizabeth Childs, Tracy Davis, Diane Dillon, Adrian Fielder, Marc Gotlieb, Julie Harris, Robert Kashey, Françoise Lionnet, Susan Manning, Angela Miller, Mary Roberts, Christopher Robinson, Ming Tiampo, Susan Waller, Martha Ward, and Jane Winston. A recent presentation of some of this material to a Northwestern University seminar (February 2000) elicited very helpful suggestions from Whitney Davis, Jongwoo Kim, Lyle Massey, Claudia Swan, Andrew Hemingway, Michael Stone-Richards, Karl Werckmeister, and especially Michael Schreyach.

1 Gustave Flaubert, *Dictionnaire des idées reçues* (1913; Paris: Flammarion Librio, 1997), 70.

2 I have drawn on the following sources for biographical and career information: Jean Alazard, *L'Orient et la peinture française* (Paris: Librairie Plon, 1930); Henri Baillière, *Henri Regnault, 1843–1871* (Paris: Didier et Cie., 1872); Roger Benjamin, ed., *Orientalism: Delacroix to Klee* (Sydney: Art Gallery of New South Wales, 1997); Henri Cazalis, *Henri Regnault: Sa vie et son oeuvre* (Paris: Alphonse Lemerre, 1872); Philip Gilbert Hamerton, "Henri Regnault," in *Modern Frenchmen: Five Biographies* (London: Seeley, Jackson and Halliday, 1878), 334–408; *Henri Regnault, 1843–1871* (Saint-Cloud, France: Musée Municipal de Saint-Cloud, 1991); Donald A. Rosenthal, *Orientalism: The Near East in French Painting 1800–1880* (Rochester, NY: Memorial Art Gallery of the University of Rochester, 1982); and James Thompson, *The East Imagined, Experienced, Remembered: Orientalist Nineteenth Century Painting* (Dublin: National Gallery of Ireland, 1988).

Throughout the text, the translations are mine except where other translators are specifically credited.

3 According to Baillière in *Henri Regnault,* "Regnault avait trouvé Rome une ville aux petites proportions; il n'avait vu que les aspects pittoresques et les côtés anecdotiques" (39), and "A Rome, la peinture italienne, avec son grand style, ne pouvait

charmer H. Regnault qui n'était point un contemplatif" (44). According to *Henri Regnault,* "Il n'appréciera jamais réellement Rome, aura la sensation d'y étouffer et n'y reviendra, au cours de ses voyages, que contraint par le règlement de la Villa Médicis" (18).

4 Cazalis, *Henri Regnault,* 37. Baillière confirms this pattern: "Mais, au palais du Champ de Mars, c'était l'Orient qui le séduisait et l'attirait avant tout" (*Henri Regnault,* 36).

5 Benjamin, *Orientalism,* 120. "C'est l'Orient que j'appelle, que je demande, que je veux. Là seulement, je crois, je me sentirai vraiment quelque chose" (letter to M. de Montfort, Rome, April 1869, quoted in Alazar, *L'Orient et la peinture française,* 176). Geneviève Bréton's grandaughter, Daphné Doublet-Vaudoyer, recalled, however, that these sentiments had been sent to Regnault's friend, Stéphane Mallarmé, according to her foreword to *"In the Solitude of My Soul": The Diary of Geneviève Bréton, 1867–1871,* ed. James Smith Allen, trans. James Palmes (Carbondale: Southern Illinois University Press, 1994), xii.

6 Hamerton, "Henri Regnault," 364; letter to his father from Alicante, 25 or 26 August, 1869: "Ce pays est superbe, c'est l'Afrique, l'Egypte," in Arthur Duparc, ed., *Correspondance de Henri Regnault* (Paris: Charpentier et Cie., 1872), 297.

7 In an October 1869 letter to his father, he restates his intoxication with medieval Moorish architecture in Spain, and his wild admiration for the Moors who made it: "Voilà des gens civilisés et travailleurs!" But with a critical qualification in the same sentence: "Il est vrai que depuis ils ont baissé" (Duparc, *Correspondance,* 318).

8 "Ah! Mon ami, si tu avais vu l'Alhambra! Depuis que je l'ai vue, cette féerie, ce rêve . . . je ne peux plus que soupirer. Rien n'est beau, rien n'est délirant, rien n'est enivrant comme cela. . . . Mais toutes nos émotions précédentes, tous nos anciens enthousiasmes, tout a été effacé par cette Alhambra! Au nom du Père, du Fils du Saint-Esprit. Ainsi soit-il. Ah! Mahomet, toi seul es grand, toi seul es Dieu, qui as inspiré une oeuvre comme cell-là. Nous sommes, à coté des artistes qui ont fait cela, des barbares, des sauvages, des monstres" (September 12, 1869) letter to M. Butin in ibid., 302–3.

9 See Benjamin, *Orientalism,* 122.

10

Je rêve un voyage au Maroc. Il est de toute necessité que j'y aille. Voici en abregé les raisons qui m'y poussent.

1. Je veux étudier les types qui se sont assez bien conservés, vu qu'après la conquête de Grenade, les Maures s'y sont en grande partie refugiés.

2. Voir le palais de Fez, palais d'hiver et d'été, construit à peu près dans le même style et le même plan que l'Alhambra, puisqu'il a été bati, dit-on, par Abu-Abdil-lah (je ne sais quel numéro), dernier roi maure de Grenade.

3. Voir les armes, chevaux, étoffes, tapis, chiens, etc., etc., usages, etc., etc.

4. Sans cela tout ce que j'ai fait à l'Alhambra ne me servirait de rien et je ne pourrais pas l'appliquer.

Il me faut une recommandation plus puissante que celle qu'j'ai pour les ambassades du Maroc. Il me faut une mission auprès de l'Empéreur du Maroc,

quand même ce serait pour affaire de femme. Je suis homme de confiance et ne reculerai devant rien pour obtenir la faculté de travailler dans le palais de l'Empéreur du Maroc, dans ses écuries, dans son harem au besoin.

Il est de toute utilité que je voie les choses de près, surtout dans la haute classe marocaine, la où il peut y avoir quelques souvenirs des anciens, comme dans les trésors, galéries de palais, armes, etc.

Je ne demande pas d'argent, mais soit une mission, soit une récommandation puissante, qui me permette d'obtenir une escorte et le droit de travailler où je voudrai. Nous ne sommes intrigants ni l'un ni l'autre: mais dans le cas présent, je te prie de l'être un peu.

X., ou tel autre artiste à la mode, te diront peut-être, que le Maroc n'est pas intéressant: j'ai la certitude du contraire. Fortuny y a passé deux mois, lors de l'expedition du Maroc par Prim et O'Donnell et il a rapporté des études excessivement intéressantes. Il y a certains coins de l'Espagne que je tiens à garder pour moi. Pour ceux-là, je dirais volontiers à tout le monde qu'ils sont laids, très dangereux à baniter [sic], et qu'on n'y peut travailler, etc. (Duparc, *Correspondance,* 323–25)

11 A Regnault specialist may want to investigate the likely connection between Regnault's passion for Andalusia and the fact that the principal nineteenth-century scholar of Muslim Spain, especially Andalusia, was French, Reinhart Pieter Anne Dozy (1820–1883), as was his intellectual inheritor, Evariste Lévi-Provençal (1894–1956). Thanks to Julie Harris for explaining this historiography to me.

12 Adrian Fiedler, "The Politics of the Picturesque: Representations of Urban Morocco from Orientalism to Tourism," paper presented at Northwestern University seminar, June 1998.

13 Janet L. Abu-Lughod, *Rabat: Urban Apartheid in Morocco* (Princeton, NJ: Princeton University Press, 1980), 102.

14 According to Linda Nochlin, "The picturesque is pursued throughout the nineteenth century like a form of peculiarly elusive wildlife, requiring increasingly skillful tracking as the delicate prey—an endangered species—disappears farther and farther into the hinterlands, in France as in the Near East. . . . The very notion of the picturesque in its nineteenth-century manifestations is premised on the fact of destruction. Only on the brink of destruction, in the course of incipient modification and cultural dilution, are customs, costumes, and religious rituals of the dominated finally *seen* as picturesque." See "The Imaginary Orient," in *The Politics of Vision: Essays on Nineteenth-Century Art and Society* (New York: Harper and Row, 1989, 50). Nochlin's argument bears on the works of a veristic French Orientalist like Gérôme, but it is an uncomfortable fit with Regnault's effort to imagine an admired Spanish past in modern Morocco. See also Alazar, *L'Orient et la peinture française,* 23.

15 "C'est à Tanger qu'il trouvera le pays de ses rêves" (Baillière, *Henri Regnault,* 65).

16 Alazar, *L'Orient et la peinture française,* 159–68.

17 Allen, "In the Solitude of My Soul," 235.

18 Though he journeyed back to Granada for the month of May to finish his studies of artifacts, according to *Henri Regnault,* 20.

19 "Mes yeux, enfin, voient donc l'Orient!" (letter to a friend from Tangier dated February 25, 1870, quoted in Cazalis, *Henri Regnault,* 82).

20 "Mais, avant d'y rentrer, je veux faire revivre les vrais Maures, riches et grands, terribles et voluptueux à la fois, ceux qu'on ne voit plus que dans le passé" (Cazalis, *Henri Regnault,* 82).

21 One of the paintings shown in Regnault's posthumous exhibition at the Ecole des Beaux-Arts was entitled *Patio à Tanger,* 1870.

22 See Marc Gotlieb's essay, "The Three Dances of Henri Regnault's 'Salomé,'" in *Salomé, Queen of Decadence,* ed. Charles Bernheimer and Richard Kaye (Chicago: University of Chicago Press, in press).

23 There's some disagreement in the literature about the container of Regnault's service. According to Duparc, "Engagé d'abord dans un bataillon de francs-tireurs, il céda peu après aux instances de ses amis, et s'enrôla dans la garde nationale sédentaire; bientôt après, il voulut faire partie des bataillons de marche" (*Correspondence,* 394). And Clairin quotes a letter he received from Regnault announcing his decision to leave the battaillon de marche to join the francs-tireurs, but he later returned to the original unit. According to Charles Blanc (quoted in Roger Marx, *Les Artistes Célèbres: Henri Regnault* [Paris: J. Rouam, 1886], 79), Regnault was put off by the men in the independent unit: "Mais, bientôt, il s'aperçut qu'il s'était glissé, parmi ces partisans, des hommes d'une tout autre éducation que la sienne et même des gens tarés."

24 Théophile Gautier, "Three Unpublished Watercolors," in *Paris Besieged,* vol. 6 of *The Travels of Théophile Gautier,* ed. and trans. F. C. de Sumichrast (Boston: Little, Brown, 1912), 202. Cazalis, for example, expressed a similar view: "Regnault eût-il parfois de sinistres pressentiments? En vérité, on le croirait, quand on se rappelle ces tristesses fréquentes, que, malgré bien des joies dont nous parlerons plus loin, ses amis en lui observaient alors. Chose bien étrange—et on l'a vu déjà—l'idée de la mort, et d'une mort violente, traversait souvent son esprit, et cette idée est marquée même en de fréquents passages de ses lettres" (*Henri Regnault,* 94).

25 Petra Bopp's study of the painting in the context of the Franco-Prussian War, "Das Historienbild als Ort der Gewalt: Henri Regnaults 'Exécution sans jugement sous les rois maures de Grenade," in *Fern-Gesehen: Französische Bildexpeditionen in den Orient 1865–1893* (Marburg, Germany: Jonas Verlag, 1995), 13–31, came to my attention only after I had completed this essay.

26 Thompson, *The East Imagined,* 132.

27 Ibid., quoting and translating Regnault's letter from Duparc, *Correspondance,* 340, 355.

28 Cazalis, *Henri Regnault,* 89–90:

> Je voudrais au moins, avant de mourir, avoir créé une oeuvre importante et sérieuse, qui je rêve en ce moment, et où je lutterai avec toutes les difficultés qui m'excitent. Quelle que puisse être l'issue de cette bataille, quand tu vien-

dras à Tanger, tu me trouveras en face d'une toile immense, où je veux peindre tout le caractère de la domination arabe en Espagne, et les puissants Maures d'autrefois, ceux qui avaient encore à leur tête le vrai sang de Mahomet à la troisième, quatrième, cinquième et sixième génération. J'espère bien recontrer dans les histoires des Maures un fait historique on un nom qui se rapportera à ce que je veux faire et contentera tout le monde. Je commercerai toujours, et si je trouve à baptiser mon tableau, avant qu'il ne me quitte, tant mieux; sinon j'invente et je renvoie les critiques au chapitre 59,999 d'une historie arabe indiscutée, mais détruite dans l'incendie ou le sac d'une ville. . . . Je détourne la critique en ne faisant ni l'Alhambra, ni l'Alcazar de Séville.

29 Gautier, "Three Unpublished Watercolors," 207–10:

Une sorte de personnification et de triomphe de l'Islam au temps des califes d'Espagne.

Le fond du tableau était rempli par un palais arné de toutes les merveilles de l'architecture arabe, — sveltes colonnettes, arcs évidés en coeur, panneaux de pguipures découpées dans le stuc, niches à stalactites dorés et peints, inscriptions du Koran en caractères cufiques entremêlés de fleurs, application d'azulejos: un résumé de l'Alhambra de Grenade et de l'Alcazare de Séville; fontaines grésillant sur des vasques d'albâtre rubané, grands vases surmontés de fleurs rares, toutes les féeries que l'Orient entasse au palais des kalifes. Au milieu s'ouvrait un grand arc dont les portes de cèdre formaient des symétries compliquées d'un travail miraculeux et rehaussées de nielles d'argent. A cet arc superbe aboutissait un large escalier de marbre blanc don't les dernières marches trempaient dans l'eau d'un fleuve. Une galère dorée à proue et à poouppe fantasques, laissant traîner au fil de l'eau des tapis et des draperies bariolés, amenait au bas de l'escalier les chefs tributaires, les vassaux d'Afrique et d'Espagne, revêtus d'armures étincelantés, étoilés de rubis et de torquoises, drapés de velours, de brocart, de soie et de fine laine blanche, ruisselant d'or et d'argent sous une pluie de lumière.

Sur les maraches de l'escalier s'étageaient des groupes d'esclaves, des prisonniers et de captives de toutes les races, les unes demi-nues, les autres disparaissant à moitié sous l'éclat tremblant et grenu des gazes d'or égratignées d'un rayon de soleil, belles comme la Judith, étranges comme la Salomé, — sans compter les types nouveaux rêvés ou trouvés par l'artiste; ajoutez à cela des coffrets incrustés de nacre laissant échapper des fils de perles, des cassolettes de filigrant, des coupes remplies de dinars et de tomans, des vases d'argent, des buires de jaspe, des plats de poterie des Baléares, iris'es de toutes les couleurs de l'arc-en-cile, des ruissellements d'étoffes brodées, striées, lamées, des selles et des harnais bosselés d'or, des entassements d'armes plus précieuses que des bijourx, des fleurs pour lesquelles Bulbul ferait des infidelités à la rose, des pigeons au col cerclé de diamants, des gazelles regardant de leur grand oeil étonné, et vous aurez à peu près une idée de ce que voulait faire Regnault.

Au centre du tableau, parles portes de cre entrebâillées, comme une idole

au fond de son temple, on entrevoyait dans une pénombre transparente le calife, l'Emir-el-Mumenim recevant ces tributs et ces hommages, impassible et n'ayant pas l'air de s'en apercevoir.

Cette figure mystérieuse . . . devait donner de l'unité au tableau en ramenant à elle tout ce déploiement de luxe et de faste. . . .

Ce merveilleux rêve, hélas! ne sera jamais réalisé; mais en fermant les paupières il nous semble le voir, par l'oeil intérieur du poëte, briller largement encadré d'or sur la paroi du grand salon à l'Exposition prochaine. (Théophile Gautier, "Trois aquarelles inédits," in *Tableaux de Siége: Paris, 1870–1871*, 2d. ed. [Paris: Charpentier et cie., 1872], 197–200)

"The Emir El Mumenim" is a standard Arabic honorific title, not the name of any specific individual. Indeed, the Taliban Supreme Leader in present-day Afghanistan is called the Amir-ul-Momenin.

30 Cazalis, *Henri Regnault*, 91: "Un groupe de femmes captives. Les plus belles chrétiennes de la province conquise; elles seront présentées au roi et offertes après les drapeaux; celles sur qui son regard daignera descendre seront conduites au harem."

31 Thompson, *The East Imagined*, 133. Nochlin, "The Imaginary Orient" (52–53), sees a stereotype of arbitrary Arab violence in the painting.

32 Eugène Delacroix's *Execution of the Doge Marino Faliero* of 1826 (Wallace Collection, London), *The Death of Sardanapalus* of 1827 (Musée du Louvre, Paris), and *The Beheading of St. John the Baptist* of 1858 (Kunstmuseum, Bern) were obvious precedents for Regnault's *Exécution sans jugement*, but Alfred Dehodencq's *Le massacre de la juive* of 1860 (Musée des Arts Africains et Oceaniens, Paris) may have been a more immediate point of reference for Regnault's concentration on the work of a lethal Moorish sword borne by a swarthy and red fez–wearing executioner.

33 "Un regard indéfinissable à la fois dédaigneux et mélancolique": Théophile Gautier, *Ouevres de Henri Regnault exposées à l'École des Beaux-Arts, notice* (Paris: J. Claye, 1872), 29.

34 I acknowledge my heavy reliance on Lisa Lowe's analysis of Flaubert: "Orient as Woman, Orientalism as Sentimentalism: Flaubert," in *Critical Terrains: French and British Orientalisms* (Ithaca, NY: Cornell University Press, 1991), 78.

35 Gautier, "Three Unpublished Watercolors," 201. "On pouvait croire que le jeune lauréat [Regnault], excité par le spectacle de la guerre, nouveau pour lui, aurait reproduit quelque époside des combats où il prenait une part si active et si brillante; il n'en est rien" (Gautier, "Trois aquarelles inédits," March 1871, 191).

36 But apropos of *l'Exécution sans jugement*, Thompson has written, "It is easy to imagine Regnault essaying a major work on the horrors of the siege of Paris, had he survived it" (*The East Imagined*, 133).

37 ". . . il nous semblait qu'on aurait pu nous utiliser davantage; nous ragions de ne pas nous sentir plus efficaces, quand il aurait fallu—c'était notre idée—faire donner toute l'énergie disponible. Regnault surtout se fâchait. Il avait besoin d'activité; les jours de loisir, il était furieux" (André Beaunier, *Les souvenirs d'un peintre: Georges Clairin* [Paris: Charpentier et Cie., 1906], 150–51).

38 Or, as A. Angellier, *Étude sur Henri Regnault* (Paris: L. Boulanger, 1879), 83, characterized Regnault's temperament: "Il avait cette grande force d'être de ceux qui s'amusent et de n'appartenir pas à la secte des ennuyés."

39 ". . . que les instants furent courts pour ces joies et ces fiertés mutuelles!" (Cazalis, *Henri Regnault,* 97).

40 "Pendant nos jours de loisir, nous retournions à peindre. . . . Puis il fallait reprendre le sac, la giberne et le fusil, repartir vers l'horrible réalité de la guerre, du péril absurde et de l'angoisse patriotique. . . . Une chose insupportable et qui exaspérait Regnault, ce fut cette perpétuelle alternance de vie militaire et de vie bourgeoise" (Beaunier, *Les souvenirs d'un peintre,* 149–50).

41 Duparc, in *Correspondance de Henri Regnault,* reports that he had to be coaxed, but other sources belie that reading. This matter is discussed below. Several of Regnault's portrait drawings of his friends, also done in Paris during the war, are discussed in my book, *Paris in Despair: Art and Everyday Life under Siege (1870–71)* (Chicago: University of Chicago Press, 2002).

42 "'Haine au gris,' voilà son 'cri de guerre.'" (Alazard, *L'Orient et la peinture française,* 174, 175).

43 *Henri Regnault,* 103–4. Cazalis believed that they were undertaken specifically as gifts for Geneviève Bréton because "les fleurs à ce moment étaient rares" (*Henri Regnault,* 97). According to Alazard in *L'Orient et la peinture française* (81), they were exhibited in February 1872 at the Cercle de l'Union Artistique and then at the memorial exhibition at the Écoles des Beaux-Arts in March. I have failed to locate the third, *Intérieur de Harem,* but we have Gautier's and Cazalis's descriptions of it. According to Gautier: "The third water-colour is a mere palette bouquet, a mystic nosegay of Oriental colours that have bloomed out in a beam of light. It represents a cade's wife or an odalisque standing in the centre of her room and apparently enchanted with her beauty and the sheen of her costume. And it has been dashed off with incomparable freshness and limpidity; the painter, while utilising the happy chances of water-colours, has kept to his purpose" ("Three Unpublished Watercolors," 206). Henri Cazalis compared the third unfavorably to the other two: "La troisième au contraire d'un ton sombre, semblait indiquer que des souvenirs sanglants se mêlaient endormis en la pensée de ce Maure à des souvenirs de volupté" (*Henri Regnault,* 99). His long description tallies with Gautier's: "Une jeune femme marocaine debout, les mains sur les hanches, dans un haïck blanc, ouvert sur la poitrine. Une ceinture jaune, rouge et verte enserre la taille. Des cheveux noirs coulent le long du sein droit. Sur la tête et le front, un voile blanc replié derrière les oreilles; pendants d'oreilles et colliers de sequins d'or. Sur le fond, deux rideaux, l'un rouge piqué de noir, l'autre rouge aussi avec de larges fleurs bleues et jaunes, dans le style de l'ornementation persane" ("Trois acquarelles inédites," 195).

44 Beaunier, *Les souvenirs d'un peintre,* 149.

45 *Album de Voyage: Des Artistes en expédition au pays du Levant* (Paris: Musée Hébert, 1993), 219. Goupil's home was a completely Oriental space, as seen in A. E. Duranton's undated painting, *Chez la famille Goupil,* oil on canvas, 64 × 91 cm., private col-

lection, reproduced in color in Lynne Thornton, *Les Orientalistes: Peintres voyageurs* (Paris: ACR Editions, 1993), 11.

46 "Sa capote militaire sur le dos, il [Regnault] fit quatre ou cinq grandes aquarelles, les plus belles qu'on ait de lui. Sujets orientaux. Il avait rapporté du Maroc de pleins cartons de croquis. . . . Nous avions ainsi quelques heures, de temps en temps, quelques heures de demi-oubli où de nouveau nous enchantaient les souvenirs lumineux de Tanger" (Beaunier, *Les souvenirs d'un peintre*, 149).

47 "Il céda à leurs désirs, quoiqu'il ne se sentît aucun goût pour ces travaux faits entre deux gardes aux remparts. Mais il posa une condition: on le dispenserait de tout labeur de l'esprit, on présenterait tous les objets qu'il aurait à représenter et il ferait simple acte de copiste. L'atelier de M. A. Goupil fut orné pour lui de riches tentures orientales, de soieries éclatantes, de tapis aux couleurs vives et variées; Regnault se mit à l'oeuvre" (Duparc, *Correspondance*, 403).

48 "La guerre moderne, telle qu'elle se fait avec ses moyens mathématiques, ses armes sans ornement, ses laids uniformes et ses évolutions calculées, devait pittoresquement peu séduire Regnault, amoureux de la couleur et de la fantasia orientales. Aussi, par une récurrence de pensée facile à comprendre, son imagination l'emportrait-elle au pays de la lumière" (Gautier, "Trois aquarelles inédits," 191–92; "Three Unpublished Watercolors," 201).

49 "Nous songions, Regnault et moi, à des tableaux de bataille, aux tranchées de Sébastopol, et nous nous disions que la réalité d'une guerre ne ressemble pas du tout à ce qu'on voit dans les musées" (Beaunier, *Les souvenirs d'un peintre*, 167).

50 La première représente une jeune femme couchée sur un divan, dans un costume où dominent des étoffes aux blancheurs transparentes traversées de raies mates. Ces blancheurs font l'effet du camélia entouré de fleurs variées qu'on place au milieu des bouquets de bal; elles attirent et concentrent la lumière, et leur éclat se répand par douces ondulations sur les teintes fraîches qui les environnent. La femme, à demi allongée par les langueurs du kief, rappelle cette délicieuse Haoua dont Fromentin, dans "une année au Sahel," trace un si délicieux portrait avec une plume qui vaut son pinceau. On ne saurait trop admirer l'étonnante harmonie de ces étoffes, de ces tapis, de ces accessoires de couleurs disparates en apparence, mais dont les contrastes se résolvent en accord parfait. Depuis "Les femmes d'Alger," d'Eugène Delacroix, aucun peintre n'a su mieux baigner d'une ombre limpide le chatoiement d'un riche intérieur moresque." (Gautier, "Trois aquarelles inédites," 193–94; "Three Unpublished Watercolors," 203–4)

51 Malgré ses mérites, elle satisfait très peu l'artiste" (Cazalis, *Henri Regnault*, 97).

52 Cazalis also had recourse to flower imagery in his description of the woman: "cette molle fleur de harem" (this soft or indolent harem flower; ibid., 98).

53 Mollement affaissée sur un coussin" (ibid., 97).

54 See Carol Ockman, "A Woman's Pleasure: The Grande Odalisque," in *Ingres's Eroticized Bodies: Retracing the Serpentine Line* (New Haven: Yale University Press, 1995). An exhaustive study of the harem topos, one not undertaken here, would of course

require a comment on the pioneering postcolonial analysis of the 1980s: Malek Alloula, *The Colonial Harem,* trans. Myrna Godzich and Wald Godzich (Minneapolis: University of Minnesota Press, 1986). An unpublished German master's thesis would also need consultation: Regina Quardfasel, "Das Thema der Odaliske in der französischen Malerie des 19. Hahrhunderts" (Hamburg, 1988).

55 *Négresse dansant* (M. B. Vaudoyer Collection, Paris) is reproduced in *Henri Regnault,* 102, and the *Slave Girl* (Minneapolis Institute of Arts) is reproduced in Rosenthal, *Orientalism,* 84. See the reproductions of various versions of and studies for the *Judith et Holopherne* project in *Henri Regnault,* 61–62.

56

La seconde de ces aquarelles a pour sujet un intérieur encore, mais d'une signification et d'un valeur toutes différentes. Sur un divan encombré de carreaux de brocart, de soie ou de maroquin, est assis ou plutôt accroupi un jeune homme nu jusqu'à la ceinture, basané presque comme un mulâtre, et le bras s'appuyant au genou avec un mouvement plein de science et de hardiesse. C'est une figure étrange. Une espèce de turban négligemment enroulé lui recouvre le front de ses larges plis et projette sur ses yeux une ombre mystérieuse. On dirait un Manfred ou un don Juan oriental ayant peut-être connu une autre civilisation et ayant voulu changer de blasement. En regardant ce corps maigri et nerveux, consumé d'ardeur, nous pensions au héros de Namouna, à cet Hassan, d'Alfred de Musset, qui s'en était allé réchauffer son scepticisme au pays du Soleil, quittant le cigare pour le haschich. Le peintre n'a probablement pas eu cette idée, mais son aquarelle la suggère: l'ennui de la voluptè, le désir de la volupté, le désir de l'inconnu, la fatigue des paradis artificiels, comme les appelle Baudelaire, se lisent sur ce visage amaigri, mais jeune encore malgré les excès.

Sur les épais tapis qui jonchent le sol est étendu une jeune femme qui, les épaules adossées au divan, enveloppée d'une gandourah noire à capuchon, entr'ouverte à la poitrine, dont la blancheur ressemble à la lune sortant d'un nuage sombre, laisse errer nonchalamment ses dogts teints de henné sur les cordes d'une guzla dont elle s'accompagne. Le chant s'exhale comme un soupir de ses lèvres distraites. Elle sent qu'elle n'est pas écoutée et suit son rêve. Rien de plus séparé que ces deux êtres, tous deux jeunes et beaux, placés aux deux bouts d'un divan.

Le luxe qui les entoure a une richesse sourde, une ardeur sombre, et comme une gravité funèbre malgré la violence des tons conservés dans l'ombre avec une superbe maestrai de coloris. Ce ne sont que rideaux et portières d'étoffes où s'est épuisé l'art de l'Orient, que tissus magnifiques, que tapis de Smyrne, de Kabylie ou de Turquie, plateaux incrustés de nacre, armes constellées de pierreries, narghilés du Khorassan, et cependant il y a quelque chose de tragique sous cet amoncellement de splendeurs. Cette chambre pourrait servir de fond à quelque scène de jalousi et de meurtre. La sang ne ferait pas tache sur ces tapis d'une pourpre sombre. (Gautier, "Trois aquarelles inédits," 195–96; "Three Unpublished Watercolors," 204–6)

57 Le peintre finit par un chef-d'oeuvre: ce Maure bestial, peut-être abruti d'opium, au corps basané, et dont les regards obliques, noirs aussi et brûlés de soleil, expriment par leur hébétude morne la lassitude de la lumière, la fatigue des voluptés, l'ennui implacable, et parfois féroce, qui dort aux yeux de tout l'Orient. Il a l'impassibilité des animaux vaincus par la chaleur, et qui fixent l'espace d'un oeil vide. Nuls désirs sans doute, nulles sensations ni pensées ne le sauraient distraire: pas même cette délicieuse esclave en son haïck noir, accroupie aux pieds de sa couche, et qui, le cou penché, la tête mollement renversée, le sein gonflé et qui soupire, dans une pose de cruelle et douloureuse langueur, touche d'un doigt distrait les cordes d'une guitare mauresque, et semble en faire sortir une note aiguë comme une morsure. L'air étouffé du harem, chargé du parfum de musc qui s'exhale de toutes les étoffes, alourdit encore l'atmosphère de cet intérieur, dont le décor, les tapis, les tentures sont rendus avec une incomparable puissance." (Cazalis, *Henri Regnault,* 98–99)

58 In an American exhibition catalogue in which Moulin's photograph appeared, the entry on the striking image reads "[The] model . . . appears inspired by either love or depravity" (*After Daguerre: Masterworks of French Photography [1848–1900] from the Bibliothèque Nationale* [New York: Metropolitan Museum of Art, 1980], number 105). From Moulin's photographs in the exhibition, *L'Art du nu au XIXe siècle: Le photographe et son modèle* (Paris: Hazan/Bibliothèque nationale de France, 1997), it is clear that the model for the 1852 photograph was "Amélie," a woman who posed regularly for Moulin. Thanks go to Susan Waller for educating me about Moulin's photography.

59 I learned about the Turcos from Elizabeth Catharine Childs. Everything I have to say about them comes from her "Honoré Daumier and the Exotic Vision: Studies in French Culture and Caricature, 1830–1870" (Ph.D. diss., Columbia University, 1989).

60 Ibid., 153.

61 This is Claudia Swan's interesting idea.

62 See Richard Terdiman, *Discourse/Counter-Discourse: The Theory and Practice of Symbolic Resistance in Nineteenth-Century France* (Ithaca, NY: Cornell University Press, 1985), part 2, chap. 5, quoted in Lowe, *Critical Terrains,* 93. I hope that scholars working on the French artists' colony in Tangier ca. 1870 will unearth information about Regnault's and Clairin's everyday life.

63 This is Michael Schreyach's important (Saidean) question.

64 According to Freud, "A path leads from identification by way of imitation to empathy, that is, to the comprehension of the mechanism by means of which we are enabled to take up any attitude at all towards another mental life." See Sigmund Freud, "VII. Identification," from "Group Psychology and the Analysis of the Ego," 1921, in *Civilization, Society and Religion,* vol. 12: *Group Psychology, Civilization and Its Discontents and Other Works,* ed. Angela Richard and Albert Dickson (Harmondsworth, England: Penguin, 1985), 140.

65 Freud also notes that the process of identification can involve its opposite, what I

am calling objectification: "Identification, in fact, is ambivalent from the very first; it can turn into an expression of tenderness as easily as into a wish for someone's removal" (ibid., 134).

66 Hats off to Jongwoo Kim for making me think about the carpets in the watercolors, which had been invisible to me hitherto. A proper identification of the carpets' origins and styles should be undertaken because a specific nation or culture may perhaps be defined or invoked by the richly ornamented interiors.

67 Geneviève Bréton's journal allows us to date Bida's drawing of Regnault in uniform with precision. On October 28, she reported, "This morning at ten o'clock he [Regnault] was already here [at the Brétons' apartment], posing for Bida's sketch of him" (Allen, *"In the Solitude of My Soul,"* 135). The balance of her journal entry from that day confirms that Bida's drawing followed closely on Regnault's production of the Goupil studio watercolors.

68 Capote brune, pantalon brun à bande rouge, képi brun à bande rouge, fusil à tabatière — dont nous ignorions le maniement" (Beaunier, *Les souvenirs d'un peintre,* 146).

69

Les jeunes gens du Second Empire n'avaient pas été préparés au métier de soldat. Tout le détail de la vie militaire nous échappait.

Nous n'avions jamais été soldats. A cette époque-là, les jeunes gens que ne comptaient pas faire leur carrière dans l'armée se procuraient des remplaçants. Cependant, nous nous sommes tous engagés.

Nous n'avions — Regnault et moi et tant d'autres! — jamais tenu un fusil; la manoeuvre de la tabatière nous échappait. En outre, nous étions, tous les deux, gauchers. Notre maladresse était ridicule, comique et désolante." (Beaunier, *Les souvenirs d'un peintre,* 168, 146, 149)

70 Benjamin, *Orientalism,* 121.

71 A proper job on this issue would require a lengthy consideration of female spectatorship of Orientalist art. On this complex matter, not seriously investigated here, see Reina Lewis, "'Only Women Should Go to Turkey': Henriette Browne and the Female Orientalist Gaze," in *Gendering Orientalism: Race, Femininity, and Representation* (London: Routledge, 1996), and Emily Apter, "Female Trouble in the Colonial Harem," *Differences* 4, no. 1 (spring 1992): 205–24.

72 Allen, *"In the Solitude of My Soul,"* 139:

Voir de la peinture, cela me tourne la tête, je suis positivement grise de lumière, de colorations comme d'autres le sont de vin, d'absinthe, de paroles ou de musique. J'ai vu ce qu'il fait; tantôt, Bida m'a emmenée à son atelier. Rien que d'être là, non comme une étrangère mais comme une amie, comme sa *fiancée,* cela seul était déjà un bonheur. *C'est très beau,* ai-je dit simplement, il m'a répondu quelques douces paroles en espagnol et ce fut tout. Mais je suis si heureuse que, *depuis moi,* il soit resté aussi grand peintre, que mon règne ne soit pas une ère de décadence ou d'infériorité pour son talent. Que mon amour ne l'ait pas embourgeoisé, enfin! Je ne sarais analyser ses aquarelles, ni

dire exactement ce qu'elles représent. Je crois voir seulement une fleur fantas-
tique d'une végétation merveilleuse, dont le calice serait formé d'une tête de
femme au centre d'une inforescence de plus riches couleurs, rêve de tentures de
tapis dont les riches couleurs n'on jamais eu tant d'éclat et de puissance dans la
réalité même. Je n'ai jamais vu l'aquarelle arriver à cette puissance. (Geneviève
Bréton, *Journal, 1867–1871* [Paris: Éditions Ramsay, 1985], 169–70)

73 Hollis Clayson, *Painted Love: Prostitution in French Art of the Impressionist Era* (New
Haven: Yale University Press, 1991), 19.

74 Allen, *"In the Solitude of My Soul,"* 150: "Les stupides corvées de notre bête de métier
nous aident à passer tant bien que mal nos jours et nos nuits. Je n'ai pas beau-
coup souffert du froid, je m'y acclimate assez bien et je finirais par ne plus être
frileux si je devais faire longtemps le service des grandes gardes" (Bréton, *Journal,*
182).

75 Allen, *"In the Solitude of My Soul,"* 163: "Demain, à partir de quatre heures de l'après-
midi nous sommes de piquet, après-demain de grande garde. Nos chefs ont ob-
tenu que nos grandes gardes ne fussent plus que de douze heures. C'est-à-dire
qu'une compagnie monterait en faction de cinq heures du soir à six heures du matin
et serait relevée par une demi compagnie pour le jour. Ne me demandez pas de
vous dire autre chose que: je m'ennuie, je m'ennuie, etc." (Bréton, *Journal,* 199–
200).

76 "Une seule chose nous était pénible et presque intolérable: l'inertie. Mais, malgré
nous, ignorants et naïfs, nous essayions de comprendre ce qu'on attendait de nous.
A chacune de nos sorties, nous espérions saisir le noeud même de l'action. Lors-
que ensuite nous rentrions, avec le sentiment de n'avoir rien fait d'utile, en dépit
de tout notre effort, notre chagrin pesait plus lourdement sur nous" (Beaunier, *Les
souvenirs d'un peintre,* 172).

77 "Nous avons perdu beaucoup d'hommes; il faut les refaire, et meilleurs et plus forts.
La leçon doit nous servir. Ne nous laissons pas amollir par des plaisirs faciles. La
vie pour soi seul n'est plus permise. Il était, il y a quelque temps, d'usage de ne plus
croire à rien qu'à la jouissance et à toutes les passions mauvaises. L'égoïsme doit
fuir et emmener avec lui cette fatale gloriole de mépriser tout ce qui était honnête
et bon. Aujourd'hui la République nous commande à tous la vie pure, honorable,
sérieuse, et nous devons tous payer à la patrie, et au-dessus de la patrie à l'humanité
libre, le tribut de notre corps et de notre âme" (Duparc, *Correspondance de Henri
Regnault,* 398–99, and Marx, *Les Artistes Célèbres: Henri Regnault,* 82).

78
Aussi, par une récurrence de pensée facile à comprendre, son imagination l'em-
portait-elle au pays de la lumière. Ce ciel gris, ces terrains boueux ou glacés
d'une neige livide sur laquelle se découpait les noires silhouettes des combat-
tants, ces fumées de poudre se mêlant au brouillard n'offraient pas des tons
assez riches à cette palette ardente. Peut-être, s'il eût vécu, la poésie de ces
effets sombres et tristes se fût-elle révélée à lui et lui eût-elle fourni le sujet de
quelque admirable esquisse. Le sentiment du devoir, la haine de l'envahisseur,
le courage chevaleresque et l'attrait du danger si puissant sur Regnault l'occu-

paient seuls en ce moment où l'artiste s'effaçait derrière le citoyen. Quelques notes retrouvées sur lui, après la bataille, expriment sur ce point sa mâle et ferme résolution. Il acceptait toutes les conséquences du sacrifice. (Gautier, "Trois aquarelles inédits," 191–92; "Three Unpublished Watercolors," 201–2)

79 Laura Kipnis, "Adultery," *Critical Inquiry* 24, no. 2 (winter 1998): 310.

80 *"J'appartiens* à quelqu'un, je ne suis plus libre, et dans ma conscience je me trouve aussi indissolublement liée que si la Loi et l'Eglise avaient sanctionné ma parole. Il y a quelqu'un dans le monde à qui j'ai permis de dire *ma Geneviève,* qui peut employer ce mot possessif qui, d'un autre, me ferait bondir de révolte; et qui me rend fière, heureuse et tout à fait *comblée.* Je suis donc l'autre moitié de quelqu'un; moi, l'orgueilleuse, la solitaire, la seule. Je *vis* depuis hier, je dormais avant et me voici pour toujours éveillée" (Bréton, *Journal, 150;* Allen, *"In the Solitude of My Soul,"* 122).

81 Clairin outlived Regnault by almost fifty years. He kept working as an Orientalist, did a segment of the painted decorations of the Paris Opera House, and became a society portraitist, most notably of Sarah Bernhardt. He never returned to North Africa, and he died in 1919. For an expanded discussion of Regnault's *Hassan et Namouna* set within the framework of Regnault and Clairin's intense friendship, see my speculative analysis of its homoerotic subtext in Clayson, *Paris in Despair.*

82 "Or, brusquement, nous voici transportés de cette apothéose [life in Tangier] vers l'horrible rélité d'une guerre malheureuse et humiliante. A la sécurité succède la défaite" (Beaunier, *Les souvenirs d'un peintre,* 173).

CONTESTED TERRAINS: WOMEN

ORIENTALISTS AND THE COLONIAL HAREM

Mary Roberts

When John Frederick Lewis exhibited his magnificent painting *The Hha-reem* (Plate 5) at the Old Watercolour Society exhibition of 1850, the critic for the *Illustrated London News* responded with the following comment: "[This] is a marvellous picture: such as men love to linger around, but such as women, we observed, pass rapidly by. There is nothing in the picture, indeed, to offend the finest female delicacy; it is all purity of appearance; but, at the same time, it exhibits woman, to a woman's mind, in her least attractive qualities."[1] This critic suggests what has become well understood in the early twenty-first century by postcolonial and feminist writers: that the nineteeth-century European fantasy of the harem was primarily addressed to a male audience.[2] What this interpretation belies is women's unique access to harems in this period and their fascination with the space to which European men were forbidden entry. Throughout the century a number of European women painted harems, and others wrote about their harem visits in their published travel diaries. The recent discovery of these texts and images, which offer a fascinating and complex engagement with the male-defined fantasy of the colonial harem, has enabled a reassessment of this genre of Orientalist representation.

Reina Lewis has made an important contribution to this reassessment of the colonial harem through her analysis of Henriette Browne's harem paintings of 1861, particularly *Une Visite (intérieur de harem, Constantinople,*

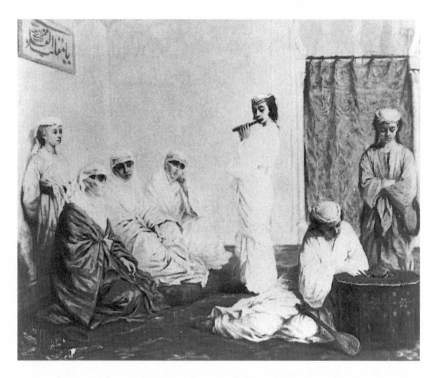

FIG. 1. Henriette Browne, *Une joueuse de flûte (intérieur de harem, Constantinople, 1860)*. Oil on canvas, dimensions unknown, 1861 (whereabouts unknown).

1860) (Plate 6) and *Une joueuse de flûte* (Fig. 1), which represent the harem as a space of social interaction among women rather than a space of sexual pleasures for men.[3] Analyzing the critical reception of these works, Reina Lewis argues that the perceived ethnographic accuracy of these paintings caused them to be contentious. For instance, she cites Théophile Gautier, for whom Browne's paintings were praiseworthy as veridical harem representations, whereas a number of other critics were ambivalent about their ethnographic authority because they threatened cherished masculine fantasies. Gautier insisted that "from the Orient [Browne] reports news fresher than that of the *Thousand and One Nights* . . . finally, *A Visit* shows us the interior of a harem by someone who has seen it, a thing rare and perhaps unique, because while male painters often make odalisques, none may boast of having worked from nature."[4] By contrast, in describing Browne's harems as populated with "silent and bored women . . . chaste in the muslin of their long dresses which barely show their

frail and languishing bodies," Olivier Merson admits "that these paintings somewhat disrupt our dreams of the Orient."[5] According to Reina Lewis, these paintings prioritize a female gaze—an ethnographic gaze that establishes the harem as a social realm with parallels to European bourgeois domestic space.[6] Lewis supports her argument by analyzing the travel diaries of Western and non-Western women that challenge existing preconceptions of the Islamic harem and inscribe it as a familial and social space.[7]

Although Reina Lewis examines women's harem visits primarily as ethnographic accounts, I argue that they are not *only* ethnographic texts but a rich source of feminine fantasy. This feminine fantasy does not exclude all aspects of masculine fantasy; instead, it is selectively appropriated. The dominant masculine harem fantasy encompasses narratives of erotic intrigue and scopic pleasures for the male viewer or reader through the objectification of Eastern women.[8] The diarists also use these two modalities; however, they are transformed by the centrality of a female subject who was both an eyewitness to and a participant in the harem. What the diaries reveal is the negation of the more extravagant sexual tropes of masculine fantasy but a continued investment in the harem as a place of mystery and intrigue. This fantasy encompassed all the mystique of harems as conveyed in the *Arabian Nights Tales*.

The women's perceptions of the harems they visited were informed by the preexisting discourse associated with the popular *Arabian Nights Tales,* and what they experienced in harems enlivened this fantasy. The trope of the *Arabian Nights* had much currency in women's travel writing. From Lady Montagu on, many female travel writers invoked analogies between their harem experiences and the *Arabian Nights,*[9] thus transforming their experiences of the East into a feminine version of the "imaginary Orient."[10] The exotic decor, women's beauty, luxurious clothing, and sensory experiences propelled them into the *Arabian Nights* fantasy, while what transpired during their visits enabled the diarists to playfully imagine themselves as participants in exotic adventures. This was a notion of the exotic "rendered suitably 'respectable'" for a feminine audience.[11]

In the first part of this essay, I examine how these diaries articulate a unique feminine fantasy by means of descriptive detail and the mythology of the harem adventures. In the second part, I discuss alternative harem representations determined by the demands of the women of the harem. Mary Walker's accounts of the process of portrait painting in

harems disclose the extent to which these women could determine how they were to be represented. Contesting the British women's approach, the harem women intervened to ensure that these images conformed to their tastes and cultural precepts. Examining these diaries provides an opportunity to reassess our understanding of the role of Occidental and Oriental women as agents in the gendered discourse of the harem.

The diarists persistently dismissed the more lurid masculine sexual fantasies of the harem while emphasizing it instead as a respectable domestic space to which they alone had access.[12] In these texts the British women often assume the position of the ethnographic participant-observer, extensively recording the "manners and customs," kinship structures, and domestic routines in the Islamic households they visited.[13] These texts contain a plethora of descriptive detail that functioned to convince their readers that these were real harems rather than imaginary places. These accounts of the harem are also inflected with the middle-class values and prejudices of their authors. Their notions of bourgeois domesticity became the normative measure for their harem visits; it was often a moral framework for a critique of the cultural differences they encountered in harems.[14] However, in some cases, bourgeois etiquette also provided a code of behavior by which they felt their visit should be mutually entertaining. For instance, in E. C. C. Baillie's diary of 1873 bourgeois etiquette was instrumental in shifting relations from a distanced observation to domestic intimacy. Baillie offered to sing "a simple English air" to the Turkish ladies she visited and recounted that "a few musical notes [broke] the ice; they saw that we had come not merely to look at them, but were willing to give pleasure in our turn; and they grew quite at home with us."[15]

Although these texts appear to preclude fantasy by persistently dismissing Western preconceptions of the sexualized harem and replacing it with the more prosaic pleasures of bourgeois visiting etiquette, they by no means dispensed with fantasy. Instead, they appropriated aspects of harem fantasy, particularly the popular trope of the *Arabian Nights,* which enabled transformation of their experience in the harems into the "imaginary Orient." This transformation is evident in Mary Herbert's diary when she concludes the account of her harem visit: "The *soirée* lasted till

two o'clock in the morning, when the royalty withdrew; and the English ladies returned home, feeling the whole time as if they had been seeing a play acted from a scene in the 'Arabian Nights,' so difficult was it to realise that such a kind of existence was possible in the present century."[16] Travel writers such as Herbert could assume their audience's familiarity with the *Arabian Nights* because of its enormous popularity in Britain throughout the eighteenth and nineteenth centuries. To the Victorian audience the *Arabian Nights* signified a timeless world of exotic adventure. Within this imaginary scenography of the East, harems were exotic, sumptuous places of limitless enchantments and intrigues and the women who inhabited them were either beautiful tragic victims or scheming femmes fatales. Popular with both adults and children, the *Arabian Nights* conjured up a dreamlike world "of wonder and wish fulfilment."[17] For the Romantics (whose approach to the *Tales* was very influential in the early decades of the nineteenth century), the *Arabian Nights* provided the opportunity for imaginary identification with their dramatis personae.[18] Read as a complex mix of fact and fantasy by the Victorian audience, the tales were persistently interpreted as a record of the "manners and customs" of the East as well as a fictitious account of magic and the supernatural, an approach encouraged by Edward Lane's ethnographically annotated translation of 1838–1841.[19] Given this ethnographic reading, it is not surprising that the *Arabian Nights Tales* were to color travelers' descriptions of Eastern life and that these preconceptions were to influence the way harems were represented by women travelers.[20]

For instance, Emilia Hornby's visit to the harem of Riza Pasha was framed by reference to the *Arabian Nights,* thus facilitating the transformation of her experience into fantasy. At various points in her text she claimed that what she and her female companions experienced in the harem they "could hardly believe . . . to be real: 'It is so like an Arabian Night!'" Similarly, she concluded her account with the observation: "It seemed as if we had had a dream." These references to the *Arabian Nights* enable Hornby to enter into this fantasy and to imagine herself and her companions as protagonists in adventures in the harem. In her text domestic and exotic narratives are intermingled, creating a complex negotiation between fantasy and "reality." She entered the harem of Riza Pasha with two friends, Mrs. Brown and Madame la Vicomtesse de Fitte de Soucy (who were recent arrivals in Constantinople and novices

in the matter of harem visitation), and she took great delight in initiating them into the harem. The difficulty of communicating with the women they met was cause for trepidation on the part of Hornby's companions, whereas for Hornby herself, who was more knowledgeable about harem visits, it enabled playful, erotic speculation. She wrote:

> The slaves laughed and clapped their hands, and two or three of the principal ones rushed out of the room. We could not think what they were about, and poor Madame de Souci became very nervous. "I hope to goodness they won't undress us," said she, colouring up, and every ringlet shaking with fright; "I was told that perhaps they would." "Never mind if they do," said I, laughing; "the room is very warm, and it would not hurt us. We must look out though that they do not divide our garments among them, and that they turn out these black men." Just at this moment, unluckily for the fears of poor Madame de Souci, our hostess made a sign to be allowed to look at her dress, which she pronounced to be *"chok ghuzel"* — "very pretty"; the fair Circassian then quietly lifted up Mrs. Brown's dress to look at her petticoats. Poor Madame de Souci certainly thought that the dreaded moment had arrived. "But they are such pretty creatures," said I, jesting; "it will be like being undressed by fairies."[21]

For Hornby this encounter with the harem women is the catalyst for a sapphic fantasy.[22] There is an important role here for the joke. Due to Hornby's prior knowledge, humor transformed the harem visit into a game. Through playful euphemism, she could enjoy the fantasy of being undressed by the harem "fairies" (the imaginary transgression of Victorian proprietorial taboos) precisely because she knew that there was no possibility of its happening during their visit.

Hornby extended her erotic speculations further when the harem servants entered with large shawls by playfully asking, "Which of us was to be rolled up in them when stript of our decent European garments?"[23] When the shawls were thrown over the heads of the harem women rather than the British, it instigated a new twist to Hornby's imaginings: speculation that the Pasha may be about to enter with the intention of bidding for them as his new harem acquisitions. Instead of recoiling at the prospect of becoming the object of the Pasha's desire, this possibility prompts Hornby's question: "I wonder if he is good-looking?" A certain narrative tension is developed at the prospect of a male entering the harem:

All the young and pretty slaves had now disappeared, as silently and swiftly as so many mice, behind one of the hangings, and only the old and plain ones remained. Two huge black men entered, and stood, like sentinels, mute and upright, by a little white fountain in the recess. "What dangerous person is coming?" said we: "with no cashmeres to protect us, how are we to stand such a blaze of manly beauty?" We could not help laughing, in spite of ourselves, when again the curtain was lifted, and, guarded by another Black, entered the meek, white-whiskered little beau of seventy-five, our kind escort M. Robolli.[24]

This scene (the disappearance of the pretty slaves and entrance of the black guards) is described as if it were a piece of exotic theater and, as such, is the prompt for Hornby's supposition of an erotic intrigue. Once their Armenian guide has entered there is renewed speculation; this time Hornby playfully entertains the idea that an intrigue is about to develop between him and one of the older women of the harem.

Hornby's text is surprisingly sexual in its attitudes to the Oriental men she meets (or hopes to meet) inside the harem. Evidently the experience of being in this exotic place liberated feminine desire, allowing the English woman to imagine herself as participant and witness to forbidden adventures. However, this feminine version of Orientalist eroticism is embedded in a prosaic narrative of the harem as a social realm. After this speculative interlude, conversation with her harem hosts resumes, with the interchange returning to a discussion of domestic matters, in particular exchanging stories about their children. At this point in Hornby's narrative there is a return to a perception of the harem as a familial and social structure in which some form of mutual exchange among women is emphasized. This shift in register from fantasy to domestic narrative is characteristic of these texts in which the women travelers' experience of the harem visit is intermingled with fantasy.

Hornby's indulgence in these fantasies was encouraged by the luxurious surroundings of the harem and her knowledge of the harem tradition associated with the *Arabian Nights Tales*. Through her playful engagement with harem fantasy, she can be both in the respectable harem and a part of the *Arabian Nights* exotic fantasy; the mise-en-scène of the former is a catalyst for imagining the latter. This is also evident in Annie Jane Harvey's diary where she describes the audience hall and apartments in

the harem of the daughter of Ali Agha. The exotic decor of this place enabled her to imagine that she had stepped into the *Arabian Nights* and escaped to the realm of childhood memory:

> The great height of these rooms, the brilliancy of the colouring, the lavish decoration, the shaded light, the sweet scent of the flowers, and the soft splashing of the fountains, make one feel on entering as if suddenly transported into the scenes of the old stories of childhood. As the fairy palaces of the Arabian Nights' are real, so must be their fairy owners. Good Genii or beneficent Perizades could alone be meant to dwell in such quaint Oriental magnificence; and it seemed but right that the ugly old lamp in the corner, should be the identical one by which Aladdin summoned his faithful slave; and then how we should have rubbed it, to have been able to carry away so pleasant an abode! [25]

For other diarists, participating in the rituals of the visit enabled them to playfully imagine their entry into the harem fantasy. It was precisely the fantasy of becoming part of the exotic harem that appealed to Theresa Grey when she and her traveling companion, the Princess of Wales, were dressed in the veil in the harem of the Viceroy of Egypt. Entering into the spirit of the fantasy, she was amused when their hosts encouraged Princess Alexandra to return to her husband dressed in this fashion and with this disguise to pretend that "his Princess has been kept, and a slave sent instead!" [26] Again the possibility of a romantic intrigue with the master of the harem is hinted. Just as their unique proximity to the harem enabled these writers to assert authority over their countrymen in relation to the ethnographic claim, it also enabled a unique articulation of fantasy. The very fact of being there and being involved heightened the fantasy, and traditional harem accoutrements were deployed to stress the women's involvement in this fantasy.

Just as there is a feminine narrative equivalent to imaginary male adventures in harems in these travel diaries, there is also an indulgence in scopic pleasures which is evident in the numerous lengthy descriptions of the beauty of the harem women. Whereas the masculine harem fantasy often emphasized a superabundance of female beauty, the nineteenth-century diarists insisted that beauty was rare, thus requiring a search for the unique beauty by the persistent female visitor. This notion of the search constituted another strategy for privileging the British woman's

point of view, due to her ability to enter the harem and arbitrate. These writers provided lengthy ethnographic portraits of the appearance and costume of the women they met. When they discovered a woman whom they judged beautiful, their descriptions display an exuberance and undisguised fascination. For example, Harvey wrote:

> Nothing could be more decorous than the appearance and manners of every woman there present, but in one respect we were disappointed. There was a remarkable want of beauty. With the exception of the pretty Georgian, there was scarcely a good-looking woman in the room. The handsomest were, beyond all question, some coal-black Nubian slaves. One of them had the most beautiful figure we had ever seen. Tall, lithe, and supple, her small head exquisitely poised on a throat round and shapely as that of a statue, she moved about with the undulating grace of some wild animal. Coal-black though she was, her features had none of the unseemly coarseness and grotesqueness of the negro; on the contrary, the nose was delicately cut, while her mouth, though full, had the waving lines of beauty, only seen in the Egyptian sphinx.[27]

Similarly, Emilia Hornby provides her readers with a sensuous description of the Pasha's second wife, a Circassian woman. Where she had earlier endeavored to converse with her hosts, here she has shifted register to objectification of the women:

> She was very tall; but it is impossible to describe her winning beauty, or the exquisite grace of her movements. We were all three instantly charmed with her, and no longer regretted their not understanding English; it was such a pleasure to exclaim every now and then, "Oh you pretty creature!" "Did you ever see such a figure?" "Do look at the shape of her head and throat." "There's a plait of glossy hair! quite down to her feet it must be when unbound!" This pretty creature . . . we instantly named "the fair Circassian" . . . I must now tell you her dress. Her trousers, and the robe which twists round the feet, and trails behind, were of the most brilliant blue, edged with a little embroidery of white. Her cashmere jacket was of pale lilac (like the double primroses), lined with a gold-coloured fur. A delicate lilac gauze handkerchief was twined round her head; among the fringe of which, diamond heartseases, of the natural size, glittered on golden

stalks which trembled at the slightest movement. Lilac slippers, embroidered with seed-pearls, completed her toilette. No, I must not forget the shining plaits of black hair which escaped from the handkerchief and hung down behind, and a diamond of enormous size and great beauty, which glittered on one of her white fingers. We decided that this must be a present from the Sultan, and that it must also be one of the stones spoken of in Eastern fairy lore as "lighting the chamber," etc.

In Hornby's account of the "fair Circassian" there is a blending of ethnographic realism (an exhaustive account of her clothing and demeanor) and delight at these visual pleasures. Several pages later she resumes her description of this woman, enchanted by what seems to conform very closely to Western pictorial stereotypes:

> The beautiful Circassian seemed to feel cold, and half sat, half knelt by the enormous *mangale* (a kind of brazen tripod, filled with charcoal) in the centre of the room. I thought I had never seen anything more lovely and graceful, as she dreamily smoked her chibouque, and her great diamond flashed on her white hand, and she lifted up her head now and then to join in the conversation of the other two, or to laugh in the low, musical tone which had charmed us so much at first. Our visit seemed very like a tale of the Arabian Nights, especially when the slaves entered with tambourines, and, sitting down cross-legged at the further end of the apartment, entertained us with a concert of "music." [28]

The scene Hornby describes conforms to the formulaic Western picture of the exotic harem woman (albeit more like John Frederick Lewis's clothed exotic beauties than French nudes). And yet for Hornby this living picture is exciting because it has a purchase in reality and is grounded in a scene she has experienced. In this text descriptive detail (the "reality effect") heightens the fantasy for the British woman by making it more vivid. The ethnographic detail plays an important role in signifying that a real place, to which European women uniquely had access, was the catalyst for this feminine fantasy.

Even more striking than Hornby's description of the "fair Circassian" is her description of another woman whose appeal she attempts to encapsulate through a whole range of pictorial and literary references:

Although not beautiful, I think she was one of the most striking persons I ever beheld. She had none of the almost invariable softness of the Turkish women, but a face of the most marked talent and decision, and satire, and with a decisive authoritative manner to correspond, and yet perfectly courtly, and with that exquisite ease and grace which is so enchanting in Turkish women. She had piercing black eyes, of immense size and lustre, with thick eyebrows; and hair of so raven a hue that I instantly thought of the younger and more flattering portraits of Charles II. A large, dark mole on the somewhat sallow cheek, made the picture still more striking, and added to this she had tied a rich lace handkerchief round her neck, just after the fashion of a beau of the Vandyke school, the ends hanging down. She held a lighted Havannah cigar between her fingers, and we admired her rich lace and ruffles as she smoked with the air of a Rochester. Her dress and trousers were of amber-coloured silk, her waistcoat blue, embroidered richly in silver; round her slight waist she wore a many-coloured cashmere scarf, into which a massive gold chain and Turkish watch was comfortably tucked. Her hair was dressed in what they tell me is the old Turkish fashion, cut in steps, as it were, down the forehead; about an inch long by the parting, below that a little longer, by the ear longer still, — which has a very curious effect, and gives a rather masculine look. A light-blue handkerchief was twisted gracefully round her head, fastened on with six or seven splendid stars of brilliants. Between the two centre ones, on the forehead, was a long piece of white muslin, about the breadth of one's hand, which, thrown back over the head, fell nearly to her heels behind. A ruby of enormous size flashed and glistened on the finger. To us she seemed a striking "picture of the East," as she sat pleasantly chatting with Riza Pasha's wives. She and the chief wife sat, or rather reclined, on the divan.[29]

Hornby struggles to characterize her admiration for this "masculine" woman through a series of analogies familiar to her European audience. The early portraits of Charles II, a beau of the Vandyke school, Charlotte Brontë's aloof and enigmatic Rochester are all brought into play. However, none of these analogies entirely encapsulates the exotic appearance of this woman, and it is precisely her difference from European prototypes (encapsulated in her exotic clothing, jewelry, and even hair

style) that constitutes her appeal. Because her difference can be assimilated through inherited Orientalist notions of the exotic, she becomes for Hornby a "striking 'picture of the East.'"

In these diaries, conventional signifiers of the harem, in particular traditional clothing, feminine beauty, and harem accoutrements such as the pipe, prompt the fantasy. Because their fantasy was entrenched in traditional notions of harems, not all harems were to invoke these pleasures for the British traveler. Ethnography and fantasy were coimplicated only when they encountered harems that conformed to preconceived Western stereotypes. Thus we find that the increasingly prevalent Western influences in clothing and customs disrupted feminine fantasy. For instance, the woman traveler quoted in Murray's guidebook of 1854 wrote: "The most remarkable harems are of two kinds—those where European notions and manners have been engrafted on Asiatic splendour, and those which retain with religious scrupulousness all the ancient customs of the Turks. In the former no Arabian Nights reminiscences will be called up, and disappointment will probably be felt when a spurious imitation of our own drawing-rooms will alone be found behind those trelliced screens and lattice-work, which were supposed to conceal a whole world of a novel fashion." [30] The distinction indicates the author's desire for the traditional harem that could conjure up fantasy. The British women were particularly offended by what they interpreted as a mimicry of Western fashion, especially the tendency of the harem women to misappropriate elements of bourgeois dress. Sophia Lane-Poole complained when she was visited by a group of harem women dressed in scarlet harem trousers, because the "beauty and grace" of this garment "was lost in the expansion caused by a monstrous cage crinoline introduced within it, which gave the otherwise sylph-like figures of the wearers the appearance of a shapeless balloon supported on large pairs of gentlemen's patent-leather boots." [31] Lucy Cubley's illustration for her diary of 1860 (Fig. 2) is a rare representation of these hybrid fashions that were to become popular in the late nineteenth century; [32] in this case it is the English skirt that is worn with a traditional bodice. Cubley is unusual in approving of this new fashion as both "graceful and convenient." [33]

In these instances there is a conflict between what the British women observed in the harems and what they desired to see—in particular, the picturesque dress. The Western women's preconceptions about how the harem women should look and how they should be represented were a

FIG. 2. Lucy Matilda Cubley, *A Turkish Lady* Plate 17. Lithograph from Lucy Matilda Cubley, *The Hills and Plains of Palestine. With Illustrations and Descriptions by Miss L. Cubley* (London: Day and Son, January 1860). Collection of the British Library, London. Reproduced by permission of the British Library.

matter of controversy in the portrait sittings that Mary Walker wrote about in her diary of 1886. In Walker's accounts we begin to see that the British woman's privilege of proximity was challenged by her harem sitters, who rigorously controlled the context in which these paintings would be viewed and how they themselves should be depicted in these portraits.

As an amateur artist who lived in Turkey for over thirty years, Walker had numerous opportunities to paint the women she visited in harems. She was commissioned to paint a number of portraits of the Sultan's family and wealthy Turkish elites.[34] Walker was not the only woman Orientalist to receive such commissions; the Danish Polish artist Elisabeth Jerichau-Baumann and Englishwoman Margaret Murray Cookesley had also been invited to paint portraits.[35] However, Walker's diary is particularly significant because she provides rare insights into the negotiations that took place through the process of painting these portraits.

The invitation to European artists to paint portraits in harems was part

FIG. 3. David Wilkie,
Mehemet Ali, 1841, Tate
Gallery, London. Oil on
board, 61 × 50.8 cm.
© Tate Gallery London.

of a long-standing tradition of portraiture in the Ottoman courts, and
one that demonstrates that in this context the Islamic injunction against
figural representation was not rigorously adhered to.[36] The tradition was
initiated by Mehmed II when he invited Gentile Bellini to paint his por-
trait while the artist was resident in Constantinople between 1479 and
1481, and the practice was to become increasingly popular from the eigh-
teenth century onward among wealthy Ottomans.[37] From this early con-
tact, as Günsel Renda has argued, "oil portraiture introduced by Euro-
pean painters who came to the Conqueror's court was transformed by
Ottoman artists into portraiture in the mode of miniature painting," thus
initiating a pattern of selective Western influences in Turkish art.[38]

In the nineteenth century Orientalists such as John Frederick Lewis
and David Wilkie painted portraits of the Ottoman leaders Mehemet Ali
Pasha in 1841 (Fig. 3) and Sultan Abd-ul-Mejid in 1840.[39] Indeed, Walker
was commissioned to paint a portrait of Sultan Abdülaziz, which was ex-
hibited in the Ottoman pavillion at the Exposition Universelle in Paris in
1867. These portraits had both an honorific and a diplomatic function.[40]
In their honorific role they connoted the authority and reaffirmed the

dynastic legitimacy of these leaders.[41] In their diplomatic function they were often presented to foreign courts as a gesture of goodwill between nations. Portraits of the women of the Sultan's harem were another matter altogether; they had no such public function. Housed in the Dolmabahçe, Yildiz, and other Ottoman palaces, these images were for private consumption and have only been on public display since the demise of the sultanate in the twentieth century and the transformation of their palaces into museums. Respectable Muslim women would not pose for European male painters; thus European women were commissioned to undertake their portraits.

A major priority for the harem women was that these portraits were not to be seen by men. This requirement necessitated that the paintings were entirely executed within the harem, including the varnishing and framing, and that they be covered at all times.[42] Walker noted that the large three-quarter-length portrait of Zeïneb was hung in a sitting room of her summer palace on the Bosphorus veiled by a curtain of white silk. Explaining the rationale for this as a form of religious observance Walker states: "As the features of women are veiled, so also, according to orthodox custom, must a female portrait be hidden from the gaze even of the men who perform the rough work of the house."[43]

It is not only the restricted visibility of these portraits that reflect Islamic cultural influences but also the conventions of pictorial representation derived from the miniature tradition. When Walker painted a portrait of a woman she refers to only as "a handsome Circassian" she sought to convey the solidity of the figure through the use of tonal contrasts, whereas her sitter desired the shading to be reduced. Again Walker was forced to concede, stating that "the softening tones were gradually reduced to imbecile weakness; in short, I yielded, spoilt my work, and contented my model." It was her sitter's tastes (influenced by the linear two-dimensionality of the Islamic miniature) that governed this representation.[44]

What is most striking about the accounts of Walker's portrait sessions are the disputes with her sitter over her costume and pose. Whereas Walker preferred to paint Zeïneb in her traditional Ottoman dress, Zeïneb was interested in recording her modernity by being painted in the latest Parisian fashion. Walker writes: "Such was the appearance of my imperial model: the ease, the grace, the dazzling magnificence of the East lost and dimmed by a painful striving after Western fashions." When

Walker objected to her patron's requirements, the response was an ulti-matum that the "portrait must be done according to her wishes, or — not at all." Walker conceded with the recognition that she "could not risk the 'not at all'" and condescendingly noted that she was not too concerned about this compromise to her work because "the picture when finished would rarely, if ever, be seen by persons competent to judge the mer-its of a painting."[45] One gets a clear sense from Walker's account that it was Zeïneb's tastes and desires that determined the production of her self-image.

Walker's Western preconceptions about what constituted the "pic-turesque" other were consistently foiled by her various sitters' taste for Western dress. When commissioned to paint the portrait of Eminé Ha-num, the only wife of an officer of high rank in the Turkish Army, the artist noted that Eminé was up half the night manufacturing a "Frank" dress copied from a French fashion magazine, which she describes as "a handsome crimson velvet bodice trimmed with white lace, shapely and stiff with whalebone. Ah! how much more fascinating would be the easy flowing cotton 'guidjélik,' in which she usually indulges, than this un-graceful buckram attire! But it is 'à la frança.' I sigh and submit."[46] In con-trast to the pervasive European stereotype of the passive harem woman as the anonymous object of the male painter's fantasy, in the production of these harem paintings the sitters exercise complete control.

Revisiting Zeïneb at her winter palace in the center of Stamboul some years after painting her portrait, Walker was surprised by a request to repaint the dress of this portrait so that it would reflect new trends from a fashion book recently received from Paris.[47] Walker's diary gives us an insight into how these harem women harnessed the skills of European women painters while refusing to conform to their notions of the pic-turesque harem.[48] The period in which Walker was resident in Constan-tinople was one of transition and change in upper-class women's fash-ions. Among women of the Sultan's palace and wealthy Ottomans there was an increasing interest in adopting Western dress for indoor wear. These changing fashions varied from the adoption of Western accessories such as gloves, to more elaborate hybrids and, for some, complete at-tire in Western clothes. Western dresses were either commissioned from Paris or copied by dressmakers in Pera.[49] The women Walker painted adopted Western dress, a sign of their fashionability and modernity, and yet the prohibitions on viewing these portraits suggest that the assertion

of modernity still conformed to Islamic cultural precepts associated with veiling practices.[50]

These portraits relate to the developing interest in family studio photographic portraiture, which was to become increasingly popular among the Turkish elites in Istanbul in the latter part of the nineteenth century.[51] From Walker's account we sense that these portraits had novelty value for some of her sitters, whereas for others their function in the private realm of the Ottoman family was honorific and commemorative. For instance, her portraits of Eminé Hanum and her two children were executed at the request of Eminé's husband, a senior officer in the Turkish Army based at Schumla and thus absent from his family. In their conditions of production and reception, the portraits by Walker, which were governed by a strategy of concealment within the private sphere, could not be further from the staged harem paintings or the postcard photographs of "harem" women produced for the Western tourist market and which reflect as Malek Alloula has noted, the West's collective "phantasm" of the harem.[52]

While in Zeïneb's harem, Walker also compiled a sketchbook of preliminary drawings of the harem women with the intention of using them for subsequent illustrations and paintings. What she most desired to sketch was the women in their traditional costume. Like other diarists, Walker admired the chaste beauty of the women she met and the poetic way their traditional costume made them appear to glide across the room with their long trains "sweep[ing] majestically behind them." She also admired the effect created by the dress of Zeïneb's attendants, who were required to tuck up this train which sometimes "took the classical outline and folds of old Greek statuary."[53] I would argue that for Walker, these traditional dresses were of particular significance because of their role in invoking the picturesque harem fantasy. This connection between the traditional harem and the fantasy encapsulated in the popular trope of the *Arabian Nights* had been most clearly articulated by the woman writer for Murray's guides whom I cited earlier. She demonstrates this connection by lamenting the rupture of the *Arabian Nights* fantasy where Western influences are apparent, insisting that in harems, where "European notions and manners have been engrafted on Asiatic splendour . . . no Arabian Nights reminiscences will be called up."[54]

However, it was not always easy for Walker to sketch what she most desired when inside Zeïneb's harem. At one point, she was summoned to surrender her sketchbook, which was returned sometime later with

"one of the most cherished sketches of the 'classical draperies' scored all over with pencil marks and nearly torn away, and a polite message from the Sultana, who begs that I will not do any more pictures of her women in their morning dresses, 'with their robes all twisted about them; [as] it is ugly, and the Franks will think her harem very ill-dressed.' I may, if I please, draw them in their best clothes—meaning plenty of starch and crinoline. The proposal does not tempt me to further efforts." [55]

Nonetheless, Walker persisted in her attempts to depict the harem women in traditional dress, a desire she evidently shared with Henriette Browne, who visited Zeïneb's harem with her. Walker notes that Browne and she avoided a "ceremonial visit," opting instead to informally visit the harem classrooms in which the girls in their traditional dress were being trained in music and dancing. This was an informal visit, which, she notes, very few foreign ladies had undertaken. The importance of this for Walker and Browne is that they felt they saw an authentic view of the harem, not one self-consciously staged for Western visitors, and that this was the picturesque scene capable of conjuring the popular trope of the *Arabian Nights* fantasy that Western dresses were not capable of invoking. Walker notes that Browne and she, "sat for some time watching the groups so fascinating to an artist, and soon afterwards the art exhibitions of Paris and London were graced by the works of [Browne's] delicate brush, chiefly inspired by the thoughtful studies made in this seraï on the Bosphorus." [56]

I would argue that Browne's two harem paintings produced from this visit, which have thus far resisted interpretation beyond the ethnographic reading, can be seen to encode the feminine fantasy when read in the context of the women's travel diaries. Seeing *Une Visite* in color, we get a sense of its visual and tactile pleasures—the delicate color harmonies of the women's dresses, the soft folds and pleats of the drapery and especially the elegant trains. These are the same visual pleasures in traditional harem costume that inspired Hornby to describe her visit as like a tale of the *Arabian Nights*. What is at stake in Browne's portrayal of traditional dress is the restrained harem fantasy of the bourgeois woman traveler.

The ethnographic authority of this image corroborates this fantasy by conveying the heightened experience of a scene witnessed in a particular place, thus making the fantasy more palpable. As we saw in the travel diaries, ethnography and fantasy are coimplicated. Thus, in the case of

Browne's painting, the ethnographic detail transports the viewer into the harem. Experience is transformed into the fantasy of the *Arabian Nights* and that fantasy is all the more exciting because it is perceived to have a purchase in reality. The overall effect of *Une Visite,* which combines the sparse interior and simple traditional dress, is a harem of austere beauty. What I am suggesting is that in this painting, as in some of the diaries, the harem fantasy has been reinvented by the Western women, this time with an emphasis on respectability and the authority of the woman's ethnographic view.

If we return to Gautier's response to *Une joueuse de flûte (intérieur de harem, Constantinople, 1860)* (Fig. 1), we can see that Browne's representation became a source for Gautier's own fantasy of the harem, and that in this instance, female fantasy augments masculine fantasy. Gautier wrote: "Draped in white muslin, a young musician plays on a derviche's flute one of those melodies of strange charm which seizes you so irresistably, and brings back to you the memories of airs heard in a previous existence; three women cadines or odalisques listen, leaning against the wall in an attitude of ecstatic reverie." [57] Where other critics perceived Browne's harem paintings as a threat to cherished masculine fantasy, in the ethnographic context Gautier is able to conjure an imaginary past through the charming melodies of the derviche's flute. In this instance Browne's representation doesn't preclude masculine fantasy; it is instead a conduit for it. [58]

In these paintings, as in the harem diaries, women Orientalists' role as observer and participant enabled them to introduce a different gaze to the more familiar voyeuristic gaze of male fantasy. Through this subject positioning, Western women claimed the imaginary and literal space of the harem as their domain of expertise and pleasure, demonstrating that, as Marjorie Garber has argued, "more than one kind of western subject looks east and sees [themselves] inscribed there." [59] The complex dialogue in Mary Walker's diary demonstrates the power play between the authority of the Western woman to represent the harem because of her unique access and the authority of the harem women to determine how they would be represented in their portraits. The diaries disclose that the harem visit was a contested terrain, thus complicating even further questions of self-image as produced through the encounter between East and West.

Notes

I would like to express my sincere thanks to Jill Beaulieu for numerous constructive discussions about this essay, as well as for her guidance and astute editorial advice. My thanks also to Roger Benjamin, Zeynep Çelik, Carol Ockman, and Jocelyn Hackforth-Jones for their advice and support. I am grateful to Paul Frecker for his assistance with the French translations. Also, particular thanks to my former head of department at the Canberra School of Art, Gordon Bull, for his encouragement throughout this project. The research for this project has been facilitated by a Visiting Fellowship at the Yale Centre for British Art, New Haven, in 1999 and an Australian Research Council Small Grant.

1 *Illustrated London News,* 4 May 1850, 299–300.

2 The critic's observation that women may have disliked the image because of its morally compromising subject matter exemplifies the distinction between the fantasy of the colonial harem and Victorian patriarchal notions of middle-class femininity.

3 Reina Lewis, "'Only Women Should Go to Turkey': Henriette Browne and Women's Orientalism," *Third Text* 22 (spring 1993): 53, 58; Reina Lewis, *Gendering Orientalism: Race, Femininity and Representation* (London: Routledge, 1996), 127–90.

4 Théophile Gautier, *Abécédaire du Salon de 1861* (Paris: Libraire de la Société des gens de lettres, 1861), 73.

5 *Exposition de 1861: La peinture en France* (Paris: Libraire de la Société des gens de lettres, 1861), 276.

6 Reina Lewis nuances this by suggesting that there are parallels and differences established between European and Oriental domesticity. She also notes that the diaries imply an ethnographic gaze that is construed as experiential and empathetic rather than detached and scientific. See Lewis, *Gendering Orientalism,* 178–79.

7 Ibid., 144–61.

8 In harem paintings such as Delacroix's *Death of Sardanapolus* and Lecomte du Nouy's *Rhamses in his Harem,* the fantasy was premised on the male spectator's identification with the master of the harem, who is the central protagonist and for whose pleasure the multiplicity of women exist. In contrast, in the diaries, women travelers projected themselves as the central protagonists in harem adventures. For an analysis of masculine spectatorship, see Olivier Richon, "Representation, the Harem and the Despot," *Block* 10 (1985): 34–41, and Linda Nochlin, "The Imaginary Orient," *Art in America* 71, no. 5 (May 1983): 118–31, 187, 189, 191.

9 Not all female travelers subscribed to this mythological view of harems; see Billie Melman, *Women's Orients: English Women and the Middle East, 1718–1918. Sexuality, Religion and Work* (London: Macmillan, 1992), 66–67. Isabella Romer exemplifies a more disparaging attitude toward the harem and its inhabitants:

> As I quitted the Pacha's palace, I could not forbear pitying the fate of its female inhabitants . . . without liberty, and (judging from the countenances of above fifty women whom I had just seen) without mind, intellect, or thought! . . . how

inadequately can the luxuries which surround their merely animal existence, compensate for the interchange of thought and communion of soul, which education alone can bestow! . . . Byron and Moore have thrown the *prestige* of their brilliant imaginations over scenes which they never could have beheld, and have led the inhabitants of the West to form fairy dreams of the habits and feelings of the imprisoned inmates of the hareem. But the reality, like almost all realities in 'this working day world' partakes more of the character of prose than of poetry.

See Isabella Romer, *The Bird of Passage; or Flying Glimpses of Many Lands,* 3 vols. (London: Richard Bentley, 1849), 2.263–64.

10 For an extended analysis of the influence of the *Arabian Nights Tales* on British travel literature, see Fatima Moussa-Mahmoud, "English Travellers and the *Arabian Nights,*" in *The* Arabian Nights *in English Literature: Studies of the Reception of the* Thousand and One Nights *into British Culture,* ed. P. Caracciolo (New York: St. Martin's Press, 1988), 95–110.

11 This has parallels with the respectable exoticism in novels by Victorian women such as Elizabeth Gaskell. See Cornelia Cook, "The Victorian Scheherazade: Elizabeth Gaskell and George Meredith," in Caracciolo, *The Arabian Nights in English Literature,* 200.

12 Emphasizing her ability to cross the veiled threshold of the harem, Walker established the veracity of her testimony by discrediting the reports of those who hadn't been inside. She observed that at the time she was in a harem painting the portrait of the favorite of Sultan Abdul Medjid (*sic*), a Western newspaper was printing sensational reports about this woman's recent escape from the harem with her Italian lover and their travels in Europe. See Mary Adelaide Walker, *Eastern Life and Scenery with Excursions in Asia Minor, Mytilene, Crete and Roumania,* 2 vols. (London: Chapman and Hall, 1886), 1.41.

13 Melman, *Women's Orients,* 18.

14 This was particularly the case in their observations about child rearing in harems, as evident in Walker's observation: "The modes of bringing up little children . . . is sadly deficient in the careful moral training which, with religious teaching, we in England consider as the indispensable basis of sound education" (*Eastern Life and Scenery,* 2.45).

15 E. C. C. Baillie, *A Sail to Smyrna, or an English woman's journal, including impressions of Constantinople, A visit to a Turkish Harem and a Railway journey to Ephesus, Illustrated from Original Sketches* (London: Longmans, Green, 1873), 175.

16 Mary Elizabeth Herbert, *Cradle Lands* (London: Bentley, 1867), 16.

17 Muhsin Jassim Ali, *Scheherazade in England: A Study of Nineteenth-Century English Criticism of the* Arabian Nights (Washington, DC: Three Continents Press, 1981), 14.

18 Walter Bagehot wrote: "[There] was a time with us . . . when the *Arabian Nights* were not so much a story as a dream, when, with the same dim mingling of identities which we sometimes have in sleep, it is not Aladdin but ourself, and yet not ourself but Aladdin, who gazes on the jewel-bearing fruit-trees, marries the Vizier's

daughter, and controls the resources of the lamp . . . we suffer and we triumph with Sindbad, taste vicissitude with Cameralzaman, enjoy the shrinking fondness of Zutulbe, travel upon the enchanted carpet, or mount the flying horse." See Walter Bagehot "The People of the Arabian Nights," *National Review* 9 (July 1859): 46–47, quoted in Ali, *Scheherazade in England,* 39.

19 In his book *An Account of the Manners and Customs of the Modern Egyptians* of 1836, Lane wrote: "There is one work . . . which presents most admirable pictures of the manners and customs of the Arabs, and particularly those of the Egyptians; it is 'The Thousand and One Nights,' or 'Arabian Nights Entertainments.' If the English reader possessed a close translation of it with sufficient illustrative notes, I might almost have spared myself the labour of the present undertaking" (Author's Preface, Everyman Library edition, 1963, xxiv–xxv, n.1).

20 Ali, *Scheherazade in England,* 43.

21 Emilia Hornby, *In and Around Stamboul,* 2 vols. (London: Richard Bentley, 1858), 1.316, 320, 305–6.

22 For an analysis of the harem as a focus for European women's sapphic fantasies at the turn of the century, see Emily Apter, "Acting Out Orientalism: Sapphic Theatricality in Turn-of-the-Century Paris," in *Performance and Cultural Politics,* ed. Elin Diamond (London: Routledge, 1996), 15–34 and, Emily Apter, "Female Trouble in the Colonial Harem," *Differences,* 4, no. 1 (spring 1992): 205–24.

23 Hornby, *In and Around Stamboul,* 1.306. I have argued elsewhere that British women travelers challenged their exclusion from the harem fantasy by writing about themselves as a spectacle for their harem hosts. By inscribing themselves as both subject and object of the look inside the harem these texts provide an alternative to the more familiar notion of the harem as spectacle for the Western viewer/voyeur. See Mary Roberts, "Strategic Inversions: Women's Harem Literature and the Politics of Looking," *Australian and New Zealand Journal of Art* 1, no. 2 (2000): 31–41.

24 Hornby, *In and Around Stamboul,* 1.307.

25 Annie Jane Harvey, *Our Cruise in the Claymore with a Visit to Damascus and the Lebanon* (London: Chapman and Hall, 1861), 83.

26 Theresa Grey, *Journal of a Visit to Egypt, Constantinople, the Crimea, Greece &c in the suite of the Prince and Princess of Wales* (London: Smith, Elder, 1869), 134.

27 Annie Jane Harvey, *Turkish Harems and Circassian Homes* (London: Hurst and Blackett, 1871), 79–80.

28 Hornby, *In and Around Stamboul,* 1.302–3, 314.

29 Ibid., 312–14.

30 John Murray, *A Handbook for Travellers in Turkey: Describing Constantinople, European Turkey, Asia Minor, Armenia and Mesopotamia. With New Travelling Maps and Plans,* 3d ed. (London: John Murray, 1854), 88. The connection between traditional costume and the *Arabian Nights* is also expressed by Washington Irving when he writes of his disappointment at seeing a Turkish minister in Barcelona in European dress: "I confess I should rather have seen him in the magnificent costume of the East and I regret that that costume, endeared to me by the Arabian Nights Entertainments, that joy of my boyhood, is fast giving way to the levelling and monotonous preva-

lence of French and English fashions" (July 5, 1844 letter to Mrs. Paris, quoted in Ali, *Scheherazade in England*, 46).

31 Sophia Lane-Poole, *The People of Turkey. Twenty years Residence among Bulgarians, Greeks, Albanians, Turks and Armenians, by a Consul's Daughter and Wife*, 2 vols. (London: John Murray, 1878), 2.63; see also 67, 70.

32 Jennifer Scarce, *Women's Costume in the Near and Middle East* (London: Sydney Unwin Hyman, 1987), 81.

33 In the text that accompanies this illustration Lucy Cubley wrote: "Those ladies in the East who have had much communication with Europeans, very generally adopt the English skirt, without altering any other part of the dress, and this, instead of taking from the picturesque appearance of their national dress, is decidedly more graceful and convenient, as the tails of the *goombaz*, or Arab dress, when pinned up, are very inelegant; and when left dragging on the ground are always in the way. The lady in the drawing had patronized the English skirt, and all of my friends in Syria, none excelled her in elegance or fascination of manner." See Lucy Matilda Cubley, *The Hills and Plains of Palestine* (London: Day and Son, 1860), 33.

34 Mary Walker's sitters include the wife of Riza Paşa, Zeïneb Sultana, Serfiraz Hanim (favorite of Sultan Abdülmecid), Eminé Hanim (wife of Ziya Paşa) and her two children, Eminé Faïka Lutfié Hanim and Mushaver Bey. My thanks to Aykut Gürçağlar and Zeynep İnankur for confirming these names, which are listed only by their initials in Walker's diary. Although Walker describes Zeïneb Sultana as a daughter of Abdülmecid this is a misattribution, as the Sultan did not have a daughter by this name. However, it is possible that she is the daughter of Mehmet Ali Pasha. She was a resident of Constantinople who had close ties with Sultan Abdülmecid.

35 Margaret Murray Cookesley's portrait of the Sultan's son had been held in such high esteem that she was decorated by the Sultan with the Order of the Chefakat (*sic*) and with the Turkish Medaille des Beaux Arts. See Clara Erskine Clement, *Women in the Fine Arts. From the 7 Century BC to the Twentieth Century AD* (New York: Houghton Mifflin, 1904), 85–86. On Elisabeth Jerichau-Baumann's portrait commissions, see Ellen Clayton, *English Female Artists*, 2 vols. (London: Tinsley, 1876), 2.102–6, and Birgitte von Folsach, *By the Light of the Crescent Moon: Images of the Near East in Danish Art and Literature, 1800–1875* (Copenhagen: David Collection, 1996), 86–87.

36 For an analysis of the varied attitudes toward figural representation in Islam, see Isma'il R. al-Faruqi, "Figurative Representation and Drama: Their Prohibition and Transfiguration in Islamic Art," in *Islamic Art: Common Principles, Forms and Themes*, ed. Ahmed Mohammed Issa and Jahsin Ömer Tahaoğlu, Research Centre for Islamic History, Art and Culture, proceedings of the International Symposium, Istanbul, April 1983 (Damascus: Dar-Al-Filer, 1989).

37 Günsel Renda, "Portraiture in Islamic Painting," in Issa and Tahaoğlu, *Islamic Art;* Kıymet Giray, "Introduction to the History of Turkish Painting," in *The Sabancı Collection* (Istanbul: Akbank, Culture and Art Department, 1995), 185; *The Sultan's Portrait: Picturing the House of Osman* (Istanbul: Türkiye İş Bankasi, 2000) (exhibition held at the Topkapi Palace Museum, Istanbul, June 6–September 6, 2000).

38 Günsel Renda, *A History of Turkish Painting* (Geneva, Switzerland: Palasar, 1987), 39.

39 For an analysis of David Wilkie's portrait of Mehemet Ali that focuses on the nego-
tiations between sitter and painter and the differing political messages intended
for British and Egyptian audiences, see Emily M. Weeks, "About Face: Sir David
Wilkie's Portrait of Mehemet Ali Pasha of Egypt," in *Orientalism Transposed: The Im-
pact of the Colonies on British Culture,* ed. Julie F. Codell and Dianne Sachko Macleod
(Aldershot, England: Ashgate, 1998), 46–62.

40 See Salaheddin Bey, *La Turquie à L'Exposition Universelle de 1867* (Paris: Libraire Ha-
chette, 1867), 143; Semra Germaner, "Osmanlı İmparatorluğu'nun Uluslararası
Sergilere Katılımı ve Kültürel Sonuçları," *Tarih ve Toplum* 95 (1991): 36; Kevork
Pamukciyan," 1867 Yılı Paris Sergisine Katılan Osmanlı Sanatkârları," *Tarih ve Toplum*
105 (1992): 37. My thanks to Laurent Mignon and Berfu Aytaç for their assistance
with the English translations of these Turkish texts.

41 Julian Raby, *Qajar Portraits* (London: Azimuth Editions, 1999), 15.

42 Underscoring the uniqueness of her endeavor, Walker noted that for these women
of the harem visiting a painter's studio would also be contrary to "the rules of
orthodox Musselman society" (*Eastern Life and Scenery,* 1.2).

43 Ibid., 1.17. Similarly, portrait photography in harems was rigorously controlled.
Another diarist, Ellen Chennells, wrote about the difficult process of producing
photographs of Princess Zeyneb, daughter of Khedive Ismail, in Cairo. Initially, a
female photographer was commissioned, but, because she was unskilled, the re-
sults were unsatisfactory. A decision was made to engage a male photographer, but
as Chennells states, it was not a European who "might sell her likeness, or send it
back to Europe for sale, [which] would violate all ideas of oriental propriety . . . it
was decided that an Arab photographer . . . should be introduced, and he being an
Egyptian subject, could not possibly either sell or show the portrait to other per-
sons." The photography session took place in the harem gardens because this man
could not be admitted into the harem itself. See Ellen Chennells, *Recollections of an
Egyptian Princess by Her English Governess. Being a Record of Five Years Residence at the
Court of Ismael Pasha, Khédive,* 2 vols. (Edinburgh: William Blackwood, 1893), 2.114.

44 Walker observed that the "grand question of shade had next to be solved" (*East-
ern Life and Scenery,* 1.4). The same issue arose in her portrait of Zeïneb Sultana, in
which she noted: "shade was highly objectionable" (1.16).

45 Ibid., 1.16, 17.

46 Ibid., 1.120–21.

47 Ibid., 1.311.

48 This strategy of concealment of the harem portraits distinguishes them from the
Sultan Abdülhamid II photographic gift to Britain and the United States which was
sent to correct misinterpretations of his country and, as Mounira Khemir has ar-
gued, "to offer the West an alternative self-image" of the Islamic world. See Mou-
nira Khemir, "The Orient in the Photographer's Mirror: From Constantinople to
Mecca," in *Orientalism: Delacroix to Klee,* ed. Roger Benjamin (Sydney: Art Gallery
of New South Wales, 1997), 193.

49 Scarce, *Women's Costume,* 81.

50 Western dress was not uniformly adopted by Islamic women in the capital. Tradi-

tionalists and those who couldn't afford these fashions continued to wear and to advocate traditional styles of dress. For an analysis of the debates in Turkey between modernists and traditionalists about women's adoption of Western fashions, especially in the satirical press, see Nora Şeni, "Fashion and Women's Clothing in the Satirical Press of Istanbul at the End of the Nineteenth Century," in *Women in Modern Turkish Society: A Reader,* ed. Şirin Tekeli (London: Zed Books, 1995), 25–45.

51 Khemir, *Orientalism,* 193. On the photographic studios in Istanbul, see Engin Özendes, *From Sébah and Joaillier to Foto Sabah: Orientalism in Photography* (Istanbul: Yapı Kredi Yayınları, 1999).

52 Malek Alloula, *The Colonial Harem,* trans. Myrna Godzich and Wlad Godzich, in *Theory and History of Literature, Vol. 21* (Manchester, England: Manchester University Press, 1986), especially Chap. 1, "The Orient as Stereotype and Phantasm," 3–5.

53 Walker, *Eastern Life and Scenery,* 1.22.

54 Murray, *A Handbook for Travellers in Turkey,* 88.

55 Walker, *Eastern Life and Scenery,* 1.312.

56 Ibid., 1.10. It is likely that these visits to Zeïneb's harem provided the inspiration for Henriette Browne's two paintings. In particular, *The Flute Player* may well be a representation of the music lessons that Walker describes. This would explain why each of the young girls waits patiently for her turn to play to the women seated on the left.

57 Gautier, *Abécédaire,* 75.

58 Reina Lewis also interprets fantasy in Gautier's response as a masculine reappropriation of women's ethnographic harems (*Gendering Orientalism,* 134–35). I differ from her in asserting that a feminine fantasy is also implicit in this image.

59 Marjorie Garber, "The Chic of Araby: Tranvestism, Transsexualism and the Erotics of Cultural Appropriation," in *Body Guards: The Cultural Politics of Gender Ambiguity,* ed. Julia Epstein and Kristina Straub (London: Routledge, 1991), 245.

BIBLIOGRAPHY

Abu-Lughod, Janet. "The Islamic City: Historic Myth, Islamic Essence and Contemporary Relevance." *International Journal of Middle East Studies* 19 (1987): 154–76.
———. "On the Remaking of History: How to Reinvent the Past." In *Remaking History,* ed. Barbara Kruger and Phil Mariani. Seattle: Bay Press, 1989, 111–29.
———. *Rabat: Urban Apartheid in Morocco.* Princeton, NJ: Princeton University Press, 1980.
Abun-Nasr, Jamil M. *A History of the Maghrib in the Islamic Period.* Cambridge, England: Cambridge University Press, 1987.
After Daguerre: Masterworks of French Photography (1848–1900) from the Bibliothèque Nationale. New York: Metropolitan Museum of Art, 1980.
Ageron, Charles-Robert. *Histoire de l'Algérie contemporaine,* vol. 2. Paris: Presses Universitaires de France, 1979.
Alazard, Jean. *L'Orient et la peinture française au XIXe siècle: d'Eugène Delacroix à Auguste Renoir.* Paris: Librairie Plon, 1930.
Al-Azmeh, Aziz. "What Is the Islamic City?" *Review of Middle East Studies* 2 (1977): 1–12.
Album de Voyage: Des Artistes en expédition au pays du Levant. Paris: Musée Hébert, 1993.
Alexandre, Arsène. *Réflections sur les Arts et les Industries d'Art en Algérie.* Algiers: L'Akhbar, 1907.
L'Algérie au point du vue Belge. Paris: Librarie Centrale, 1867.
L'Algérie pittoresque by Clausolles with engravings by Jacob. Toulouse, France, 1843.
Ali, Bachir Hadj. "Culture nationale et révolution algérienne." *La Nouvelle critique* 147 (1963).
Ali, Muhsin Jassim. *Scheherazade in England: A Study of Nineteenth-Century English Criticism of the Arabian Nights.* Washington, DC: Three Continents Press, 1981.
Allen, William. "The Abdul Hamid II Collection." *History of Photography* 8, no. 2 (April–June 1984): 119–45.
Alloula, Malek. *The Colonial Harem.* Trans. Myrna Godzich and Wlad Godzich. In *Theory and History of Literature, Vol. 21.* Manchester, England: Manchester University Press, 1986.
———. *The Colonial Harem.* Minneapolis: University of Minnesota Press, 1986.

Anderson, Benedict. *Imagined Communities: Reflections on the Origins and Spread of Nationalism.* Rev. ed. London: Verso, 1991.

Angéli, Louis-Eugène. "Les Maîtres de la peinture algérienne: Azouaou Mammeri." *Algéria* 42 (May–June 1955): 40–44.

Angellier, A. *Étude sur Henri Regnault.* Paris: L. Boulanger, 1879.

Appadurai, A. *The Social Life of Things: Commodities in Cultural Perspective.* Cambridge, England: Cambridge University Press, 1986.

Apter, Emily. "Acting Out Orientalism: Sapphic Theatricality in Turn-of-the-Century Paris." In *Performance and Cultural Politics,* ed. Elin Diamond. London: Routledge, 1996, 15–34.

————. "Female Trouble in the Colonial Harem." *Differences* 4, no. 1 (spring 1992): 205–24.

L'Art du nu au XIXe siècle: Le photographe et son modèle. Paris: Hazan/Bibliothèque nationale de France, 1997.

Baillie, E. C. C. *A Sail to Smyrna, or an English woman's journal, including impressions of Constantinople, A visit to a Turkish Harem and a Railway journey to Ephesus, Illustrated from Original Sketches.* London: Longmans, Green, 1873.

Baillière, Henri. *Henri Regnault, 1843–1871.* Paris: Didier et Cie., 1872.

Banham, Reyner. "A Modern Church on Liturgical Principles." *Architectural Review* 128 (December 1960): 400.

Barrucand, Victor [unsigned]. "Aux Arts Décoratifs." *L'Akhbar* (21 August 1925).

————. "Peinture au Salon des Orientalistes." *La Dépêche Algérienne* (16 February 1923).

————. "Peinture: Au Salon des Orientalistes." *La Dépêche Algérienne* (17 February 1923).

———— [unsigned]. "Salon des Orientalistes." *L'Akhbar* (5 March 1921).

————. "Salon d'Hiver." *La Dépêche Algérienne* (21 February 1924).

Beaunier, André. *Les souvenirs d'un peintre: Georges Clairin.* Paris: Charpentier et Cie., 1906.

Behdad, Ali. "Orientalism after *Orientalism.*" *Esprit Créateur* 34, no. 2 (summer 1994).

Benchérif, Osman. *The Image of Algeria in Anglo-American Writings 1785–1962.* New York: University Press of America, 1997.

Bénédite, Léonce. "Avant-propos." *Exposition sous le haut patronage de M. le Maréchal Lyautey des dessins et peintures de Si Azouaou Mammeri.* Paris: Galerie Feuillets d'Art, 2–21 May 1921, [1–8].

Benjamin, Roger. *Orientalist Aesthetics: Art, Colonialism, and French North Africa, 1880–1930.* Berkeley: University of California Press, forthcoming 2003.

Benjamin, Roger, ed. *Orientalism: Delcroix to Klee.* Sydney: Art Gallery of New South Wales, 1997.

Bennoune, Mahfoud. *The Making of Contemporary Algeria, 1830–1987.* Cambridge, England: Cambridge University Press, 1988.

Betts, Raymond F. *Assimilation and Association in French Colonial Theory, 1890–1914.* New York: AMS Press, 1970.

B[évia], J[ean]. "Les Récompenses: Au Salon des Orientalistes." *La Dépêche Algérienne* (17 February 1923).

Bhabha, Homi. "Culture's In-Between." In *Questions of Cultural Identity,* ed. Stuart Hall and Paul du Gay. London: Sage, 1996.

—————. "Difference, Discrimination, and the Discourse of Colonialism." In *The Politics of Theory,* ed. Francis Barker et al. Colchester, England: University of Essex, 1983, 194–211.

—————. *The Location of Culture.* London: Routledge, 1994.

Biln, John. "(De)forming Self and Other: Toward an Ethics of Distance." In *Postcolonial Space(s),* ed. G. B. Nalbantoglu and C. T. Wong. New York: Princeton Architectural Press, 1997.

Bodichon, B. L. S. *Algeria Considered as a Winter Residence for the English.* London: English Woman's Journal, 1858.

—————. "Algiers, First Impressions." *English Woman's Journal* 6 (September 1860): 21–32.

—————. "Cleopatra's Daughter, St Marciana, Mama Marabout, and other Algerian women." *English Woman's Journal* 10 (February 1863): 404–14.

—————. "Kabyle Pottery." *Art Journal* (1865): 45–46.

—————. *Women and Work.* London: Bosworth and Harrison, 1857.

Bodichon, E. "Algerine notes, part 1: Algerine animals." *English Woman's Journal* 8 (September 1861): 31–37.

—————. "Algerine notes, part 2: Algerine animals." *English Woman's Journal* 8 (October 1861): 90–96.

—————. "Society in Algiers." *English Woman's Journal* 6 (October 1860): 95–106.

Bopp, Petra. "Das Historienbild als Ort der Gewalt: Henri Regnaults 'Exécution sans jugement sous les rois maures de Grenade.'" In *Fern-Gesehen: Französische Bildexpeditionen in den Orient 1865–1893.* Marburg, Germany: Jonas Verlag, 1995, 13–31.

Bréton, Geneviève. *"In the Solitude of My Soul": The Diary of Geneviève Bréton, 1867–1871.* Ed. James Smith Allen. Trans. James Palmes. Carbondale: Southern Illinois University Press, 1994.

—————. *Journal, 1867–1871.* Paris: Éditions Ramsay, 1985.

Burn, Ian, and Ann Stephen. "Namatjira's White Mask: A Partial Reinterpretation." In *The Heritage of Namatjira: The Watercolourists of Central Australia,* ed. J. Hardy et al. Melbourne: Heinemann, 1992, 264–82.

Burton, Hester. *Barbara Bodichon, 1827–1891.* London: John Murray, 1949.

Çakir, Serpil. *Osmanlı Kadın Hareketi* (Ottoman Women's Movement). Istanbul: Metis Kadın Araştırmaları, 1994.

Caracciolo, P., ed. *The Arabian Nights in English Literature: Studies of the Reception of the Thousand and One Nights into British Culture.* New York: St. Martin's Press, 1988.

Catalogue officiel. Exposition internationale des arts décoratifs. Paris, 1925.

Cazalis, Henri. *Henri Regnault: Sa vie et son oeuvre.* Paris: Alphonse Lemerre, 1872.

Çelik, Zeynep. "Colonialism, Orientalism and the Canon." *Art Bulletin* 78, no. 2 (June 1996): 202–5.

—————. *Displaying the Orient: Architecture of Islam at Nineteenth-Century World's Fairs.* Berkeley: University of California Press, 1992.

—————. *The Remaking of Istanbul: Portrait of an Ottoman City in the Nineteenth Century.* Seattle, WA: University of California Press, 1986.

————. *Urban Forms and Colonial Confrontation: Algiers under French Rule.* Berkeley: University of California Press, 1997.

———— and Leila Kinney. "Ethnography and Exhibitionism at the Expositions Universelles." *Assemblage* 13 (December 1990): 34–59.

Certeau, Michel de. *The Practice of Everyday Life.* Trans. Steven Rendall. Berkeley: University of California Press, 1984.

Cezar, Mustafa. *Sanatta Batıya Açılış ve Osman Hamdi* (Exposure to the West in art and Osman Hamdi). Istanbul: İş Bankası Yayınları, 1971.

Chennells, Ellen. *Recollections of an Egyptian Princess by Her English Governess. Being a Record of Five Years Residence at the Court of Ismael Pasha, Khédive.* 2 vols. Edinburgh: William Blackwood, 1893.

Cherry, Deborah. "Algeria Inside and Outside the Frame: Visuality and Cultural Tourism in the Nineteenth Century." In *Visual Culture and Tourism,* ed. Nina Lübbren and David Crouch. Oxford: Berg, forthcoming.

————. *Beyond the Frame: Feminism and Visual Culture, Britain, 1850–1900.* London: Routledge, 2000.

————. *Painting Women: Victorian Women Artists.* London: Routledge, 1993.

Childs, Elizabeth Catharine. "Honoré Daumier and the Exotic Vision: Studies in French Culture and Caricature, 1830–1870." Ph.D. diss., Columbia University, 1989.

Christian, P. *L'Afrique française (illustré): L'Empire de Maroc et les deserts de Sahara. Histoire nationale des conquêtes, victoires et nouvelles decouvertes des Françaises, depuis la prise d'Alger jusqu'à nos jours.* 1846; Paris, 1853.

Clayson, Hollis. *Painted Love: Prostitution in French Art of the Impressionist Era.* New Haven: Yale University Press, 1991.

————. *Paris in Despair: Art and Everyday Life under Siege (1870–71).* Chicago: University of Chicago Press, 2002.

Clayton, Ellen. *English Female Artists.* 2 vols. London: Tinsley, 1876.

Clement, Clara Erskine. *Women in the Fine Arts. From the 7 Century BC to the Twentieth Century AD.* New York: Houghton Mifflin, 1904.

Codell, Julie F., and Dianne Sachko Macleod, eds. *Orientalism Transposed: The Impact of the Colonies on British Culture.* Aldershot, England: Ashgate, 1998.

Cook, Cornelia. "The Victorian Scheherazade: Elizabeth Gaskell and George Meredith." In *The Arabian Nights in English Literature: Studies of the Reception of the Thousand and One Nights into British Culture,* ed. P. Caracciolo. New York: St. Martin's Press, 1988.

Cordingly, David. *Pirates: Terror of the High Seas.* Atlanta, GA: Turner Publications, 1996.

Crabbe, J. "An Artist Divided: The Forgotten Talent of Barbara Bodichon." *Apollo* (May 1981): 311–13.

Crinson, Mark. *Empire Building: Orientalism and Victorian Architecture.* London: Routledge, 1996.

Crosby, Alfred W. *The Biological Expansion of Europe, 900–1900.* Cambridge, England: Cambridge University Press, 1986.

Crow, Thomas. "Revolutionary Activism and the Cult of Male Beauty in the Studio of

David." In *Fictions of the French Revolution,* ed. Bernadette Ford. Chicago: Northwestern University Press, 1991, 55–83.

Cubley, Lucy Matilda. *The Hills and Plains of Palestine.* London: Day and Son, 1860.

Davis, Fanny. *The Ottoman Lady.* New York: Greenwood Press, 1986.

Davoodbhoy, T. A. *Faith of the Dawoodi Bohras.* Bombay: Department of Statistics and Information, 1992.

Delvert, Charles. *Le Port d'Alger.* Paris: Dunod, 1923.

Derrida, Jacques. *La Dissémination.* Paris: Editions du Seuil, 1972. Translated by Barbara Johnson as *Dissemination.* Chicago: Chicago University Press, 1981.

———. *La Vérité en Peinture.* Translated by G. Bennington and I. Macleod as *The Truth in Painting.* Chicago: University of Chicago Press, 1987.

Desprez, Charles. *L'hiver à Alger: Lettres d'un compère à sa commère.* Meaux, France: Imprimerie Carro, 1861.

Dinet, Etienne, and Sliman Ben Ibrahim. *The Life of Mohammed, The Prophet of Allah.* Ornamental pages by Mohammed Racim. Paris: Paris Book Club, 1918.

Djebar, Assia. *Les Femmes d'Alger dans leur appartement.* Paris: Des Femmes, 1979.

Duben Aksügür, Ipek. "Osman Hamdi ve Orientalism" (Osman Hamdi and Orientalism). *Tarih ve Toplum,* no. 41 (May 1987): 283–90.

Duparc, Arthur, ed. *Correspondance de Henri Regnault.* Paris: Charpentier et Cie., 1872.

Edwards, Holly, ed. *Noble Dreams, Wicked Pleasures: Orientalism in America, 1870–1930.* Princeton, NJ: Princeton University Press/Sterling and Francine Clark Art Institute, 2000.

Exposition de 1861: La peinture en France. Paris: Libraire de la Société des gens de lettres, 1861.

Exposition des arts marocains. Paris: Pavillon de Marsan, May–September 1917.

Exposition du peintre musulman Azouaou Mammeri, sous le patronage de M. le Maréchal Lyautey. Paris: Galerie Jean Charpentier, 4–19 May 1931.

Exposition Si Azouaou Mammeri — Tableaux et Dessins: Afrique du Nord et Andalousie. Paris: Galeries Georges Petit, 16–31 March 1925.

Fanon, Frantz. *The Wretched of the Earth.* Trans. Constance Farrington. New York: Grove Press, 1963.

Fathy, Hassan. *Architecture for the Poor.* Chicago: University of Chicago Press, 1973.

Fiedler, Adrian. "The Politics of the Picturesque: Representations of Urban Morocco from Orientalism to Tourism." Paper presented at Northwestern University seminar, June 1998.

Flaubert, Gustave. *Dictionnaire des idées reçues.* 1913; Paris: Flammarion Librio, 1997.

Freud, Sigmund. "VII. Identification." From "Group Psychology and the Analysis of the Ego" (1921). In *Group Psychology, Civilization and Its Discontents and Other Works.* Vol. 12 of *Civilization, Society and Religion.* Ed. Angela Richard and Albert Dickson. Harmondsworth, England: Penguin, 1985.

Frishman, Martin, and Hasan-Uddin Khan, eds. *The Mosque: History, Architectural Development and Regional Diversity.* London: Thames and Hudson, 1994.

Garber, Marjorie. "The Chic of Araby: Transvestism, Transsexualism and the Erotics

of Cultural Appropriation." In *Body Guards: The Cultural Politics of Gender Ambiguity,* ed. Julia Epstein and Kristina Straub. London: Routledge, 1991, 223–47.

Gautier, Théophile. *Abécédaire du Salon de 1861.* Paris: Libraire de la Société des gens de lettres, 1861.

———. *Oeuvres de Henri Regnault exposées à l'École des Beaux-Arts, notice.* Paris: J. Claye, [1872?]

———. "Three Unpublished Watercolors." In *Paris Besieged.* Vol. 6 of *The Travels of Théophile Gautier,* ed. and trans. F. C. de Sumichrast. Boston: Little, Brown, 1912, 200–210.

———. "Trois aquarelles inédits." *Tableaux de Siège: Paris, 1870–1871.* 2d ed. Paris: Charpentier et cie., 1872, 190–200.

Germaner, Semra. "Osmanlı İmparatorluğu'nun Uluslararası Sergilere Katılımı ve Kültürel Sonuçları." *Tarih ve Toplum* 95 (1991): 33–40.

Giray, Kıymet. "Introduction to the History of Turkish Painting." In *The Sabancı Collection.* Istanbul: Akbank, Culture and Art Department, 1995.

Goissaud, Anthony. "A l'exposition coloniale, le pavillon de la Tunisie." *La Construction Moderne* (18 October 1931): 34–40.

Gojon, Edmond. "L'Algérie." In *Album de l'Exposition Internationale des Arts Décoratifs de 1925.* Paris: L'Art Vivant, 1925, 132.

Gordon, David C. *The Passing of French Algeria.* London: Oxford University Press, 1966.

Gotlieb, Marc. "The Three Dances of Henri Regnault's 'Salomé.'" In *Salomé, Queen of Decadence,* ed. Charles Bernheimer and Richard Kaye. Chicago: University of Chicago Press, in press.

Grey, Theresa. *Journal of a Visit to Egypt, Constantinople, the Crimea, Greece &c in the suite of the Prince and Princess of Wales.* London: Smith, Elder., 1869.

Haight, G. S., ed. *The George Eliot Letters.* London: Oxford University Press/Yale University Press, 1954.

Hamerton, Philip Gilbert. "Henri Regnault." In *Modern Frenchmen: Five Biographies.* London: Seeley, Jackson and Halliday, 1878, 334–408.

Hammond, Peter. *Liturgy and Architecture.* London: Barrie and Rockliff, 1960.

———. *Towards a Church Architecture.* London: Architectural Press, 1962.

Harvey, Annie Jane. *Our Cruise in the Claymore with a Visit to Damascus and the Lebanon.* London: Chapman and Hall, 1861.

———. *Turkish Harems and Circassian Homes.* London: Hurst and Blackett, 1871.

Haskell, Francis. "A Turk and His Pictures in Nineteenth-Century Paris." *Oxford Art Journal* 5, no. 1 (1982): 40–47.

Heidegger, M. "Der Ursprung des Kunstwerkes" (1935–1936). Translated by A. Hofstadter as "The Origin of the Work of Art." In *Poetry, Language, Thought.* New York: Harper and Row, 1971, 15–81.

Henri Regnault, 1843–1871. Saint-Cloud, France: Musée Municipal de Saint-Cloud, 1991.

Herbert, Mary Elizabeth. *Cradle Lands.* London: Bentley, 1867.

Hikmet, Nazım. *Selected Poems of Nazım Hikmet.* Ed. and trans. Taner Baybars. London: Jonathan Cape, 1967.

Hirsch, Pam. *Barbara Leigh Smith Bodichon.* London: Pimlico, 1999.

Holod, Renata, and Hasan-Uddin Khan. *The Mosque and the Modern World: Architects, Patrons, and Designers since the 1950s.* London: Thames and Hudson, 1997.

Home, Robert. "Building a Mosque in Stepney: Ethnic Minorities and the Planning System." *Rising East* 1 (1997).

Hornby, Emilia. *In and Around Stamboul.* 2 vols. London: Richard Bentley, 1858.

İnankur, Zeynep. "Halil Şerif Pasa." *P* 2 (summer 1996): 72–80.

Issa, Ahmed Mohammed, and Jahsin Ömer Tahaoğlu, eds. *Islamic Art: Common Principles, Forms and Themes.* Research Centre for Islamic History, Art and Culture. Proceedings of the International Symposium held in Istanbul, April 1983. Damascus: Dar-Al-Filer, 1989.

Jacobs, Jane M. *Edge of Empire: Postcolonialism and the City.* London: Routledge, 1996.

Jameson, Anna. *Sisters of Charity and The Communion of Labour, Two Lectures on the Social Employments of Women: A New Edition . . .* London: Longman, Brown, Green, 1859.

Jameson, Fredric. *Postmodernism, or the Cultural Logic of Late Capitalism.* London: Verso, 1991.

Julien, Charles-André. *Le Maroc face aux impérialismes, 1415–1956.* Paris: Editions J.A., 1978.

Kabbani, Rana. *Europe's Myths of the Orient.* London: Macmillan, 1986.

Kahn, Gustave. "Art." *Mercure de France* 160 (December 1922): 762–63.

Khemir, Mounira. "The Orient in the Photographer's Mirror: From Constantinople to Mecca." In *Orientalism: Delcroix to Klee,* ed. Roger Benjamin. Sydney: Art Gallery of New South Wales, 1997, 189–95.

Kipnis, Laura. "Adultery." *Critical Inquiry* 24, no. 2 (winter 1998): 289–327.

Kleinert, Sylvia. "Aboriginal Landscapes." In *Lying about the Landscape,* ed. G. Levitus. Sydney: Craftsman House, 1997, 82–99.

Lacey, Candida Ann, ed. *Barbara Leigh Smith Bodichon and the Langham Place Group.* London: Routledge, 1987.

Lane, Edward. *An Account of the Manners and Customs of the Modern Egyptians.* 1836; London: Everyman Library, 1963.

Lane-Poole, Sophia. *The People of Turkey. Twenty years Residence among Bulgarians, Greeks, Albanians, Turks and Armenians, by a Consul's Daughter and Wife.* 2 vols. London: John Murray, 1878.

Laprade, Albert. "Une ville créée spécialement pour les indigènes à Casablanca." In *L'Urbanisme aux colonies et dans les pays tropicaux, La Charité-sur-Loire,* ed. Jean Royer. Paris: Delayance, 1932, 1.94–99.

Le Corbusier. *La Ville radieuse.* Paris: Éditions Vincent, Fréal, 1933.

Lefebvre, Henri. *The Production of Space.* Trans. D. Nicholson-Smith. Oxford: Blackwell, 1991.

Lewis, Reina. *Gendering Orientalism: Race, Femininity and Representation.* London: Routledge, 1996.

———. "'Only Women Should Go to Turkey': Henriette Browne and Women's Orientalism." *Third Text* 22 (spring 1993): 53–64.

Lionnet, Françoise. "Narrative Strategies and Postcolonial Identity in Contemporary France: Leila Sebbar's *Les Carnets de Shérazade.*" In *Writing New Identities,* ed. Gisela

Brinker-Gabler and Sidonie Smith. Minneapolis: University of Minnesota Press, 1997.

Llewellyn, Briony. *The Orient Observed: Images of the Middle East from the Searight Collection.* London: Victoria and Albert Museum, 1989.

Lowe, Lisa. *Critical Terrains: French and British Orientalisms.* Ithaca, NY: Cornell University Press, 1991.

Maas, J. S. *Gambart: Prince of the Victorian Art World.* London: Barrie and Jenkins, 1975.

Mackenzie, John M. *Orientalism: History, Theory and the Arts.* Manchester, England: Manchester University Press, 1995.

Mammeri. "L'Enseignement: Une classe Marocaine." *France-Maroc* 3 (15 March 1917): 34-35.

————. "Une classe coranique." *France-Maroc* (December 1918): 351-54.

Marçais, Georges. "Mohammed Racim, miniaturiste algérien." *Gazette des Beaux-Arts* 141 (1939): 52-53.

————. *La vie musulman d'hier vue par Mohammed Racim.* Paris: Arts et Métiers graphiques, 1960.

Marx, Roger. *Les Artistes Célèbres: Henri Regnault.* Paris: J. Rouam, 1886.

McClintock, Anne. *Imperial Leather: Race, Gender and Sexuality in the Colonial Conquest.* New York: Routledge, 1995.

Melman, Billie. *Women's Orients: English Women and the Middle East, 1718–1918. Sexuality, Religion and Work.* London: Macmillan, 1992.

Metcalf, Barbara, ed. *Making Muslim Space in North America and Europe.* Berkeley: University of California Press, 1996.

Mills, Sara. *Discourses of Difference: An Analysis of Women's Travel Writing and Colonialism.* London: Routledge, 1991.

Mitchell, Timothy. *Colonising Egypt.* Cambridge, England: Cambridge University Press, 1988.

Mitchell, W. J. T. *Landscape and Power.* Chicago: University of Chicago Press, 1994.

Mithad, Ahmed. *Avrupa'da Bir Cevelan* (A tour in Europe). Istanbul, 1890.

Miyoshi, Masao. "A Borderless World? From Colonialism to Transnationalism in the Decline of the Nation-State." *Critical Inquiry,* no. 19 (summer 1993): 726-51.

Moore-Gilbert, Bart. *Postcolonial Theory: Contexts, Practices, Politics.* London: Verso, 1997.

Morrell, J. R. *Algeria.* London: Nathaniel Cooke, 1854.

Moussa-Mahmoud, Fatima. "English Travellers and the *Arabian Nights.*" In *The Arabian Nights in English Literature: Studies of the Reception of the Thousand and One Nights into British Culture,* ed. P. Caracciolo. New York: St. Martin's Press, 1988, 95-110.

Murphy, Agnes. *The Ideology of French Imperialism, 1871–1881.* New York: Howard Fertig, 1968.

Murray, John. *A Handbook for Travellers in Turkey: Describing Constantinople, European Turkey, Asia Minor, Armenia and Mesopotamia. With New Travelling Maps and Plans.* 3d ed. London: John Murray, 1854.

Nalbantoğlu, G. B., and C. T. Wong, eds. *Postcolonial Space(s).* New York: Princeton Architectural Press, 1997.

Nochlin, Linda. "The Imaginary Orient." *Art in America* 71, no. 5 (May 1983): 118-31, 187-

91. Reprinted in *The Politics of Vision: Essays on Nineteenth-Century Art and Society*. London: Thames and Hudson, 1991, 33–59.

Noirfontaine, Pauline de. *Algérie: Un regard écrit*. Le Havre: Aumale, 1856.

Ockman, Carol. "A Woman's Pleasure: The *Grande Odalisque*." In *Ingres's Eroticized Bodies: Retracing the Serpentine Line*. New Haven: Yale University Press, 1995.

Orif, Mustapha. "Mohammed Racim, inventeur de la miniature algérienne." In *Mohammed Racim, miniaturiste algérien*, ed. Brahim Alaoui. Paris: Institut du Monde Arabe, 3–29 March, 1992, 22–34. Reprinted from *Actes de la Recherche en sciences sociales 75* (November 1988).

Orr, C. C., ed. *Women in the Victorian Art World*. Manchester, England: Manchester University Press, 1995.

Özendes, Engin. *From Sébah and Joaillier to Foto Sabah: Orientalism in Photography*. Istanbul: Yapı Kredi Yayınları, 1999.

Pamukciyan, Kevork. "1867 Yılı Paris Sergisine Katılan Osmanlı Sanatkârları." *Tarih ve Toplum 105* (1992): 35–37.

Parkes, B. R. "The Condition of Working Women in England and France." *English Woman's Journal* 8 (September 1861): 1–9.

―――. "French Algiers." *Waverley Journal* (1857).

―――. "Letter from Paris." *English Woman's Journal* 5 (June 1860): 259–68.

―――. *Mme Luce: A Memoir, with an addendum by Bodichon*. London, 1862.

―――. "Mme Luce, of Algiers." *English Woman's Journal* 7 (May 1861): 157–68; (June 1861): 224–36; (July 1861): 296–308.

―――. "Moustapha's House." *English Woman's Journal* (November 1861): 173–77.

―――[unsigned]. Review of *Algeria Considered*. *English Woman's Journal* 3 (March 1859): 66.

―――. "What Can Educated Women Do." *English Woman's Journal* 4 (December 1859).

―――. "A Year's Experience of Women's Work." *English Women's Journal* 6 (October 1860): 112–21.

Perry, Kate. *Barbara Leigh Smith Bodichon 1827–1891*. Cambridge, England: Girton College, 1991.

Potts, Alex. "Images of Ideal Manhood in the French Revolution." *History Workshop Journal*, no. 3 (autumn 1990): 1–20.

Pouillon, François. *Les Deux vies d'Etienne Dinet, peintre en Islam*. Paris: Baland, 1997.

―――. "Tableaux d'Occident et d'Orient: La synthèse Racim." In *Mohammed Racim, miniaturiste algérien*, ed. Brahim Alaoui. Paris: Institut du Monde Arabe, 3–29 March 1992, 14–20.

Pratt, Mary Louise. *Imperial Eyes: Travel Writing and Transculturation*. London: Routledge, 1992.

"Le premier peintre musulman." *L'Illustration* 4094 (20 August 1921): 162–64.

Printemps dans l'oasis de Gafsa. Paris: Galerie Bernheim-Jeune, 18 February–2 March 1918.

Prochaska, David. *Making Algeria French: Colonialism in Bone, 1870–1920*. Cambridge, England: Cambridge University Press, 1990.

Prunster, Ursula. "From Empire's End: Australians as Orientalists, 1880–1920. In *Ori-*

entalism: Delacroix to Klee, ed. Roger Benjamin. Sydney: Art Gallery of New South Wales, 1997.

Quardfasel, Regina. "Das Thema der Odaliske in der französischen Malerie des 19.Jahr-hunderts." Master's thesis, Hamburg, 1988.

Rabinow, Paul. *French Modern: Norms and Forms of the Social Environment.* Cambridge, MA: MIT Press, 1989.

Raby, Julian. *Qajar Portraits.* London: Azimuth Editions, 1999.

Randau, Robert. "Un maître algérien de la miniature: Mohammed Racim." *L'Afrique du Nord illustrée* 817 (10 January 1937).

Renda, Günsel. *A History of Turkish Painting.* Geneva, Switzerland: Palasar, 1987.

Ricard, Prosper. "Aperçu réligieux, artistique et littéraire." In *Algérie, Tunisie, Tripoli-taine, Malte.* Paris: Les Guides Bleus, Hachette, 1930.

—————. *Les Merveilles de l'autre France: Maroc, Algérie, Tunisie.* Paris: Hachette, 1924.

Richon, Olivier. "Representation, the Harem and the Despot." *Block* 10 (1985): 34–41.

Roberts, Mary. "Masquerade as Disguise and Satire in Two Travellers' Tales of the Ori-entalist's Harem." *Olive Pink Society Bulletin: Anthropology, Race, Gender* 5, no. 1 (June 1993): 23–29.

—————. "Strategic Inversions: Women's Harem Literature and the Politics of Looking." *Australian and New Zealand Journal of Art* 1, no. 2 (2000): 31–41.

Romer, Isabella. *The Bird of Passage; or Flying Glimpses of Many Lands.* 3 vols. London: Richard Bentley, 1849.

Rosenthal, Donald A. *Orientalism: The Near East in French Painting 1800–1880.* Rochester, NY: Memorial Art Gallery of the University of Rochester, 1982.

Rouger, Gustave. "Nos Artistes au Maroc." *L'Art et les Artistes,* n.s. 6, no. 30 (October 1922).

Saavedra, Miguel de Cervantes. *The Captive's Tale.* Ed. and trans. Donald P. McRory. Oxford: Oxford University Press, 1992.

Said, Edward. *Culture and Imperialism.* 1993; London: Vintage, 1994.

—————. "Intellectuals in the Postcolonial World." *Salmagundi,* nos. 70–71 (spring–summer 1986): 44–64.

—————. *Orientalism.* New York: Pantheon, 1978.

—————. "Third World Intellectuals and Metropolitan Culture." *Raritan* 9, no. 3 (1990): 27–50.

—————. *The World, the Text, the Critic.* Cambridge, MA: Harvard University Press, 1983.

Salaheddin Bey. *La Turquie à L'Exposition Universelle de 1867.* Paris: Libraire Hachette, 1867.

Scarce, Jennifer. *Women's Costume in the Near and Middle East.* London: Unwin Hyman, 1987.

Sebbar, Leila. *Les Carnets de Shérazade.* Paris: Stock, 1985.

Şeni, Nora. "Fashion and Women's Clothing in the Satirical Press of Istanbul at the End of the Nineteenth Century." In *Women in Modern Turkish Society: A Reader,* ed. Şirin Tekeli. London: Zed Books, 1995, 25–45.

Serageldin, Ismaïl, and James Steele, eds. *Architecture of the Contemporary Mosque.* London: Academy Editions, 1996.

Smith, Neil. *Uneven Development: Nature, Capital and the Production of Space.* Oxford: Blackwell, 1984.

Soja, Edward. *Thirdspace: Journeys to Los Angeles and Other Real and Imagined Spaces.* Oxford: Blackwell, 1996.

Solomon-Godeau, Abigail. "Male Trouble: A Crisis in Representation." *Art History* 16, no. 2 (June 1993): 286–312.

——. *Male Trouble: A Crisis in Representation.* London: Thames and Hudson, 1997.

Spivak, Gayatri Chakravorty. *In Other Worlds: Essays in Cultural Politics.* 1987; London: Routledge, 1988.

——. *The Post-Colonial Critic: Interviews, Strategies, Dialogues.* Ed. Sara Harasym. New York: Routledge, 1990.

——. "The Rani of Sirmur: An Essay in Reading the Archives." *History and Theory* 24 (1985): 247–72.

——. "Three Women's Texts and a Critique of Imperialism." *Critical Inquiry* 12 (autumn 1985): 243–61.

Steinberg, Leo. *Other Criteria: Confrontations with Twentieth-Century Art.* New York: Oxford University Press, 1972.

Stevens, Maryanne, ed. *The Orientalists, Delacroix to Matisse: European Painters in North Africa and the Near East.* London: Royal Academy, 1984.

Stora, Benjamin. *Histoire de l'Algérie coloniale (1830–1954).* Paris: La Découverte, 1991.

Suleri, Sara. *The Rhetoric of English India.* Chicago: University of Chicago Press, 1992.

The Sultan's Portrait: Picturing the House of Osman. Istanbul: Türkiye İş Bankasi, 2000.

Sweetman, John. *The Oriental Obsession: Islamic Inspiration in British and American Art and Architecture, 1500–1920.* Cambridge, England: Cambridge University Press, 1988.

Terdiman, Richad. *Discourse/Counter-Discourse: The Theory and Practice of Symbolic Resistance in Nineteenth-Century France.* Ithaca, NY: Cornell University Press, 1985.

Tharaud, Jérôme, and Jean Tharaud, *Fez, ou, les bourgeois de l'Islam.* Paris: Plon, 1930.

——. "Si Azouaou Mammeri, Peintre de Rabat." *Art et Décoration* 39, no. 235 (July 1921): 21–24.

Thomas, Huw. "'Race,' Public Policy and Planning in Britain." *Planning Perspectives* 10 (1995): 123–48.

Thompson, James. *The East Imagined, Experienced, Remembered: Orientalist Nineteenth Century Painting.* Dublin: National Gallery of Ireland, 1988.

Thornton, Lynne. *Les Orientalistes: Peintres voyageurs.* Paris: ACR Editions, 1993.

——. *The Orientalists: Painter Travellers, 1828–1908.* Paris: ACR Editions, 1983.

——. *Women as Portrayed in Orientalist Painting.* Paris: ACR Editions, 1985.

Uşaklıgil, Halid Ziya. *Nesl-i Ahîr* (The old generation). Istanbul: Inkilap Kitapevi, 1990; originally serialized in 1908 in *Sabah.*

Vaillat, Léandre. *Le Visage français du Maroc.* Paris: Horizons de France, 1931.

Vicinus, Martha. *Independent Women: Work and Community for Single Women, 1850–1920.* London: Virago, 1985.

von Folsach, Birgitte. *By the Light of the Crescent Moon: Images of the Near East in Danish Art and Literature, 1800–1875.* Copenhagen: David Collection, 1996.

Walker, Lynne. "Vistas of Pleasure: Women Consumers of Urban Space in the West

End of London, 1850–1900." In *Women in the Victorian Art World*, ed. C. C. Orr. Manchester, England: Manchester University Press, 1995, 70–85.

Walker, Mary Adelaide. *Eastern Life and Scenery with Excursions in Asia Minor, Mytilene, Crete and Roumania*. 2 vols. London: Chapman and Hall, 1886.

Weeks, Emily. "About Face: Sir David Wilkie's Portrait of Mehemet Ali Pasha of Egypt." In *Orientalism Transposed: The Impact of the Colonies on British Culture*, ed. Julie F. Codell and Dianne Sachko Macleod. Aldershot, England: Ashgate, 1998, 46–62.

Young, Robert. *Colonial Desire: Hybridity in Theory, Culture and Race*. London: Routledge, 1995.

CONTRIBUTORS

JILL BEAULIEU is an independent art historian based in New York State who specializes in eighteenth- and nineteenth-century French and American landscape painting.

ROGER BENJAMIN specializes in French painting in the Maghreb; he teaches art theory at the Institute of the Arts, Australian National University.

ZEYNEP ÇELIK, Professor of Architecture, New Jersey Institute of Technology, works on cross-cultural topics, most recently on French colonial architecture and urban design in Algeria.

DEBORAH CHERRY is editor of *Art History* and Professor of History of Art, University of Sussex, specializes in British art of the nineteenth to twenty-first centuries, feminist and postcolonial perspectives.

HOLLIS CLAYSON, who has published widely on French art of the 1870s and 1880s, is Professor of Art History at Northwestern University.

MARK CRINSON, Senior Lecturer in History of Art, University of Manchester, specializes in the history of colonial architecture and urbanism.

MARY ROBERTS specializes in nineteenth-century British Orientalism, gender, the culture of travel, and cross-cultural exchange. She is the John Schaeffer Lecturer in British Art at the University of Sydney.

INDEX